Catherine & Christopher,

An addition to your new library
on Arnold Street. The transformation
of the old to the new shows your
vision and talent.'
Love,
Mom (Mary) & Ron
June 2000

# OLD BOSTON IN EARLY

## 174 Prints from the

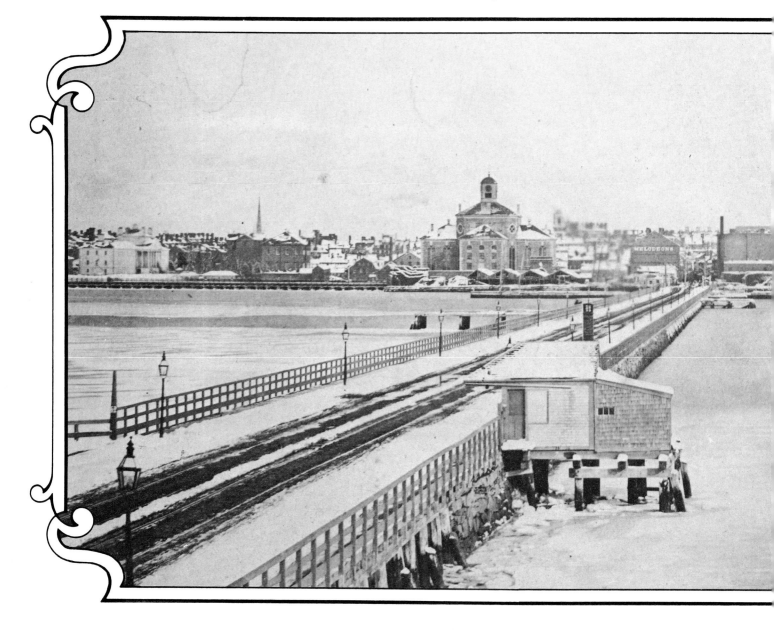

# PHOTOGRAPHS, 1850–1918
## Collection of The Bostonian Society

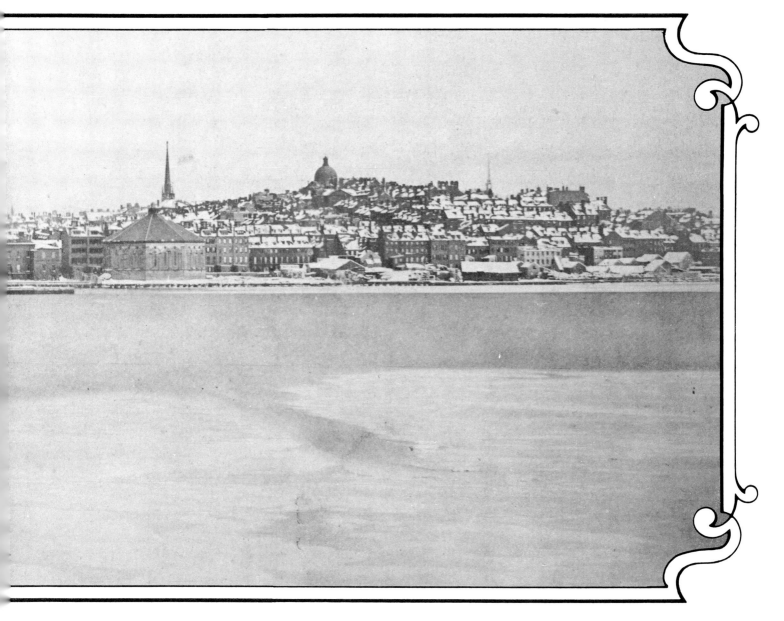

## PHILIP BERGEN
*Librarian, The Bostonian Society*

DOVER PUBLICATIONS, INC., NEW YORK

Published in Canada by General Publishing Company, Ltd.,
30 Lesmill Road, Don Mills, Toronto, Ontario.
Published in the United Kingdom by Constable and Company, Ltd.

*Old Boston in Early Photographs, 1850–1918: 174 Prints from the
Collection of The Bostonian Society* is a new work, first published by
Dover Publications, Inc., in 1990.

Manufactured in the United States of America
Dover Publications, Inc., 31 East 2nd Street,
Mineola, N.Y. 11501

*Library of Congress Cataloging-in-Publication Data*

Bostonian Society.
Old Boston in early photographs, 1850–1918 : 174 prints from the
collection of the Bostonian Society / [compiled] by Philip Bergen.
p.    cm.
ISBN 0-486-26184-0
1. Boston (Mass.)—Description—Views. 2. Boston (Mass.)—
History—1865- —Pictorial works. I. Bergen, Philip. 1947- .
II. Title.
F73.37.B773   1990
974.4′61—dc20                          89-35303
CIP

# LIST OF PHOTOGRAPHS

## Freedom Trail

# Downtown

# Beacon Hill

# Back Bay

# South End

# Lost Squares

# Waterfront

# Neighborhoods

# Introduction

AN ACQUAINTANCE WITH THE photographs in this book colors a walk through the streets of Boston. Going up School Street past the restored Old Corner Book Store, one instinctively looks for buildings that are no longer there—the Tremont House hotel at the corner of Beacon Street has been replaced by an undistinguished office building; across the street the Albion Hotel has given way to a modern skyscraper at One Beacon Street. Elsewhere, turning a corner onto Franklin Street, Boson's most stately thoroughfare in the 1850s, one is struck by disappointment: Instead of the Bulfinch-designed Tontine Crescent, complete with shade trees and central park, there is a curved street, wider than most downtown, but commonplace nevertheless. Few Bostonians realize what they once had, and only through photographs such as those presented here can we recapture what has changed and imagine the city of a century ago.

It is not that difficult to imagine what is gone, for in Boston, perhaps alone among major American cities, the past is always a part of the present. The streets bend and curve in the same fashion; Newspaper Row is more than a generation removed but Washington Street crooks between State and Water Streets the same way, and it is still a vital part of the city. It is easy to recollect the photograph showing people crowded onto the sidewalks, spilling out into the street to block traffic while watching recreations of John L. Sullivan's fight (No. 27). Beacon Street still swoops down beside the Boston Common, gathering momentum for its straight run through the Back Bay toward Brookline. The narrow streets of the North End, the tranquil back of Beacon Hill, the broad sweep of Commonwealth Avenue abruptly ending at the Public Garden—all these are unchanged. If you remove the most noticeable sign of the twentieth century—the automobile—it is possible to imagine Boston in an earlier time, secure in its isolation, unconscious of acid rain or Diet Pepsi. Only in the areas of massive urban renewal, such as Government Center and the West End, have great sections been obliterated. The lost squares of Boston—the much-lamented Scollay and the nearly forgotten Adams and Dock—can only be conjured up by photographic reminders. No landmarks, no city shorthand remains that we can use to fill in the blanks. While skyscrapers abound in the business district and along the spine of the Back Bay, they have not yet destroyed the spatial integrity of the nineteenth-century city.

Boston's historical landmarks are accepted for what they represent, but in typical Yankee fashion they are not fawned over or insulated from the workaday city by protecting walls or artificially created parks. The Old North Church is still a church, its historical relevance coexisting with the requirements of a modern parish. It stands in its neighborhood as it has done since 1723, and tourists must thread their way through impossibly congested streets to reach it, just as Bostonians of 200 years ago did. The Old State House is not cocooned in an Old State House Mall; it sits awkwardly at the junction of Boston's banking street and its commercial street, fully a part of the city, not apart from it. Working for its living, it serves as America's oldest subway entrance; until recently, when the area became a small pedestrian way, trucks would nearly scrape its south wall turning onto State Street. Faneuil Hall still serves as a market and an auditorium, albeit without the produce and meats that served as its lifeblood for two centuries, and the Paul Revere House survives through good fortune: An ordinary residence through the nineteenth century, shoe-horned into tiny North Square, it somehow escaped fire and demolition until it was preserved by the Paul Revere Memorial Association in the early 1900s. Bostonians tend to be blasé about their historic legacies, for these treasures have become such a part of the city that their importance is often overlooked.

The views of Boston in this book cover roughly 70 years, the normal span of a person's life, yet elderly people in the earliest images could have remembered Washington as President, and children in the later ones could still be alive today. Boston itself had seen its bicentennial when the first daguerreotypes were taken. It was the oldest major American city, dating from 1630, and it had weathered uncertain beginnings, British occupation, a siege and a changing economic base to become the commercial center for a rapidly growing New England. By 1850 rail lines linked Boston to its Massachusetts neighbors in Lowell, Worcester and Fall River, and had expanded to New York and beyond. This interior growth would begin to erode the importance of Boston as a port. Manufactured goods from the Merrimack and Blackstone valleys would not have to travel east to the city in order to head south and west. Transatlantic Cunard passenger service to England had been established in 1840, but the great movement of Irish immigrants to Boston occurred on the more plebeian Enoch Train Line from Liverpool to Lewis Wharf starting in 1844. By the early 1900s, Boston's maritime preeminence as a seaport gateway to New England had declined greatly.

Three great changes occurred in the city during the period covered by this book, changes that continue to be felt in the present. Two are physical changes to the streets and buildings—the great upheaval in the city's topography caused by landfills, and the catastrophic fire of 1872, which affected architecture and wealth. The third change, a human one, concerns the emergence of the immigrant as a major force in Boston life. These changes can be observed in the photographs, though perhaps not without some explanation.

Certainly no other American city has undergone so many major alterations in its landmass as has Boston. The undisputed fact that the modern city remains grossly overcrowded only confirms the necessity for what happened throughout the nineteenth century. Perhaps no other prominent city has had less to work with in its location. The isolation so prized by colonial residents—

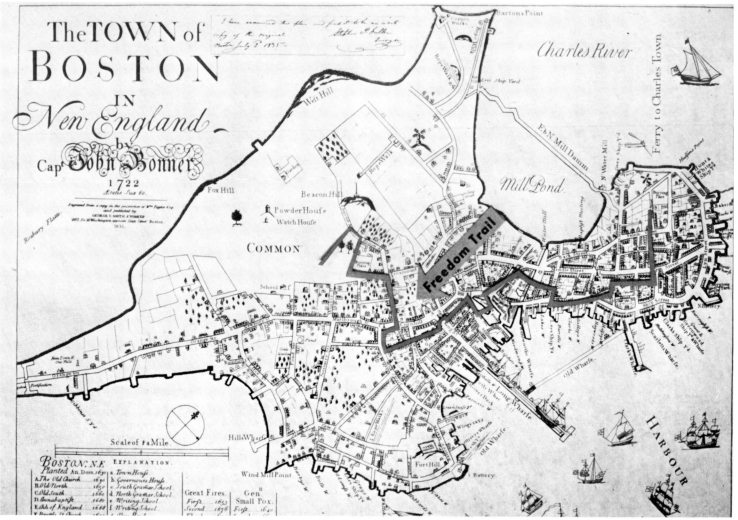

Captain Bonner's 1722 map of Boston with the present Freedom Trail added. Changes in the tourist route include the addition of the Charlestown section (off the map) and the relocation of the Trail along Cornhill—today's Washington Street.

Boston originally being a peninsula with one narrow land entrance—would have made the city uninhabitable today. Imagine a twentieth-century Boston conforming to a seventeenth-century configuration and the folly is evident. Without the various landfills and annexations that took place, Boston would have ceased to flourish or be viable. In addition to the most famous landfill, that of the Back Bay, a variety of topographic changes occurring throughout the nineteenth century broadened the waterfront, filled in coves and increased Boston's mass. The North Station area, the Esplanade sections along the Charles River and much of the South Boston shore were all added to Sam Adams' town. Additionally, the annexation of many of the immediate suburbs to the city provided room for homes and space to grow. Commencing with neighboring Noddle Island (East Boston) and moving through South Boston, Roxbury and Brighton, Boston spread south and west until it swallowed up the Hyde Park section in 1912. A consequence of this topographical expansion was a rapid increase in population. From approximately 20,000 in 1787, the city reached 58,000 in 1825; 136,000 in 1850; 250,000 in 1870; and had more than doubled to 560,000 in 1900. Immigration was, of course, the most obvious source of new population, but one cannot forget the sizable inward flow of New Englanders to Boston, echoing a nationwide pattern as Americans became predominantly a nation of city dwellers.

Boston's topographic change was a gradual and continuing one. The Back Bay was filled in during the most of the last half of the century; for more than 30 years trains laden with fill arrived every 45 minutes around the clock. Using the most modern equipment—the steam shovel—the project slowly moved across the marshy bog, inexorably claim-

ing a new section of the city from the Charles River block by block. In contrast, the Great Fire of 1872 consumed more than $60 million of downtown property in just twenty-four hours and permanently changed the face of commercial Boston, propelling it toward the twentieth century. The fire started at the corner of Summer and Kingston Streets near the central business and retail district on the evening of Saturday, November 9, and was fanned by high winds to spread nearly as far as Fort Hill in one direction and the Old State House in another. Although only 65 acres were burned, they represented the heart of commercial Boston. Firemen from all over eastern Massachusetts and four other New England states eventually conquered the blaze, which had acquired new life from a gas explosion on Monday morning.

Not only did the fire change Summer Street from a residential to a business location, but it also destroyed much of the Boston that had survived from the eighteenth century. The disaster provided the busy city with the opportunity to redevelop much of its most important real estate using improved construction methods. The time of wooden buildings had ended. Taller, safer structures would replace them. A year earlier, Chicago's famous fire had irrevocably changed the Midwest's leading city; Boston's fire, concentrated in the heart of an older city, was in some ways even more devastating, but also more purging.

The arrival in vast numbers of immigrants from other countries was not a change unique to Boston. As the closest American port to Europe, Boston served as an important entryway into the United States, and it received many of the early waves of Western Europeans. In the 1830s and 1840s in particular, the arrival of Irish laborers who were too poor to move inland once they reached America

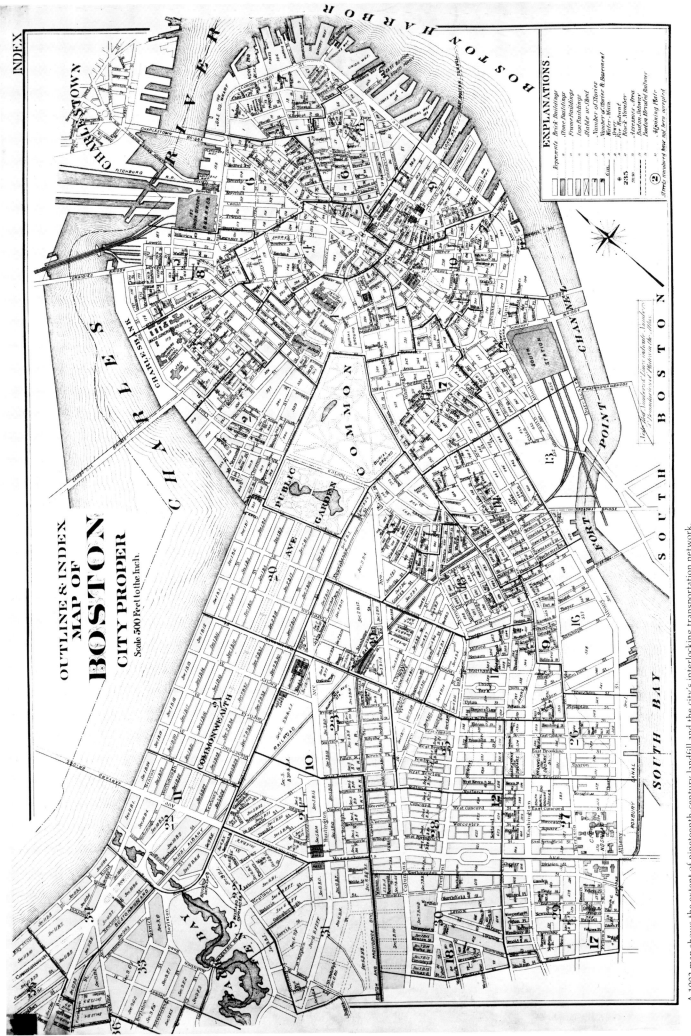

A 1902 map shows the extent of nineteenth-century landfill and the city's interlocking transportation network. Only the demands of twentieth-century automobiles would alter this map to any great extent, through the creation of the Charles River Esplanade and the downtown Central Artery highway.

provided the city with a sizable working class comprised mainly of Roman Catholics, a most important distinction to the overwhelmingly Protestant community. Settling first in the North End and Fort Hill close to downtown, the Irish migrated first to Charlestown, South Boston, the South End and Dorchester upon achieving some measure of stability. Their migration was also caused by pressure from the next wave of European immigrants—Italians and Jews. Being the first immigrant nationality in Boston, the Irish faced the brunt of discrimination and antiforeign sentiment; they were also the first group to be assimilated successfully into mainstream Boston, particularly into its political life. If old-line Brahmins still controlled the city's finances and businesses, by 1885—with the election of Mayor Hugh O'Brien—the Irish had achieved a political strength that they would be loath to relinquish. Significantly, there have been no Italian mayors. Boston by 1900 was a city of new arrivals.

And what can we make of the Bostonians who are caught by the camera, frozen in time crossing a street or leaning against a building? Despite the relatively recent advent of photography, most adults were familiar with at least the rudiments of the process; there were a large number of photographic studios and commercial firms making cartes de visite, portraits and street scenes. There was a definite sense of recording oneself and one's surroundings for posterity, making a mark, a tangible item that said, "I was here," "This is my business," "Here is the street I live on" or "This is what happened." Photography had reached the stage at which events, or at least their aftermath, could be recorded. Civil War battlefields and the Boston fire ruins (which look like the devastated streets of Richmond) were swarmed over by cameramen who were used by popular newspapers and magazines to provide a preliminary image for the final engraving or woodcut that actually reached people's homes. The invention of the stereoscope in the early 1850s and its subsequent popularity fueled the natural inquisitiveness of Americans to see what a locale actually looked like, and the street scenes of Boston are products of this curiosity. Recent studies of Boston's photographers of the late nineteenth century indicate that there were 73 studios in the city by 1870 and over 140 by 1900. It was a transitory business; only one-third of the studios managed to remain in business for over four years, and tracing the "family tree" of a studio involves an ever-changing variety of partnerships and addresses. Even successful firms such as Whipple & Black lasted only three years as an entity. These photographers, working out-of-doors as well as in their studios, recorded Boston as a conscious exercise of their skill. Most of the photographs included here were deliberate attempts to record the city. The state of the medium at this time precluded spontaneous shooting, so that most photographs have a static appearance. Carrying around a cumbersome camera and working with glass plates, the photographer on the street was a highly recognizable (and immobile) figure. Fortunately, this meant that many views were taken from windows or roofs, out of harm's way, and the elevated vantage point was quite common. Boston's streets and buildings are therefore recorded with some distance between the camera and the subject. Framing and field are clearly defined and the formality of a street view is typical. The pictures that intrigue us with their unexpected vibrance—a ball game with crowded stands, children in an immigrant slum—are the exceptions, but every view included here gives the modern reader a real sense of life in Boston in the past.

What you will see is thus both history and photography, each feeding from the other. The sociologist Michael Lesy, who uses photography as the medium for his observations of our culture, has discovered the parallels between Clio and the literal image of the camera:

> It seemed to me that history and photography were more deeply linked than the specialists who practiced them knew. Both enabled their practitioners to enter the river of time, temporarily stop its flow, and scrutinize it. Both disciplines allowed their practitioners to fuse their methods of inquiry with the workings of their imaginations and, by that fusion, to take advantage of coincidences between their own preoccupation and the events that swirled around them—coincidences that enabled the best of historians to find a needle of data in a haystack of facts, and the best of photographers to be in the right place at the right time, camera in hand. [The Forbidden Zone, Farrar, Straus and Giroux, New York, 1987.]

## THE FREEDOM TRAIL

The book's first section documents a walk along the Freedom Trail as it might have existed a century or more ago. Keep in mind that the Freedom Trail was only created in the 1950s—an artificially concocted path linking historical tourist sites through downtown Boston, the North End and Charlestown. One hundred years ago, many of the sites did not exist as strictly tourist attractions, but as functioning buildings, and "Old Ironsides" did not anchor in the Charlestown Navy Yard. By following Boston streets to familiar locations, the twentieth-century armchair traveler can appreciate the changes that have occurred. The photographs were not all taken at the same time and reflect changes in the art of photography as well as in the cityscape.

The Freedom Trail covers only certain areas of downtown and Charlestown, excluding much of Beacon Hill and all of the Back Bay, South End and the annexed neighborhoods. This volume includes views of these sections in the second half of the book, along with tantalizing glimpses of Boston's lost squares and the waterfront. Maps of Boston from the period are included to help locate unfamiliar sites.

## SOURCE NOTES

The photographs in this book come from the pictorial archives of The Bostonian Society, the city's historical society. With few exceptions, its more than 9000 views have been donated by members and other persons interested in preserving the visual record of the city's heritage. Arranged by street location or by neighborhood, they represent one of the most extensive collections of historical photographs that can be found in the city. While the majority of pictures come from 1880–1920, earlier and later images are also part of the collection, which is available for research and use by the public.

The Bostonian Society was founded in 1881 "to promote the study of the history of Boston and the preservation of its antiquities" by a group of citizens concerned with the impending loss of the Old State House. Originally organized to protect the building, its mandate was accompanied by the creation of a research library and a museum collection of objects relating to all aspects of Boston's history. Both the library and museum continue to acquire Bostoniana and the Society remains an active historical organization committed to interpreting a complete spectrum of its city.

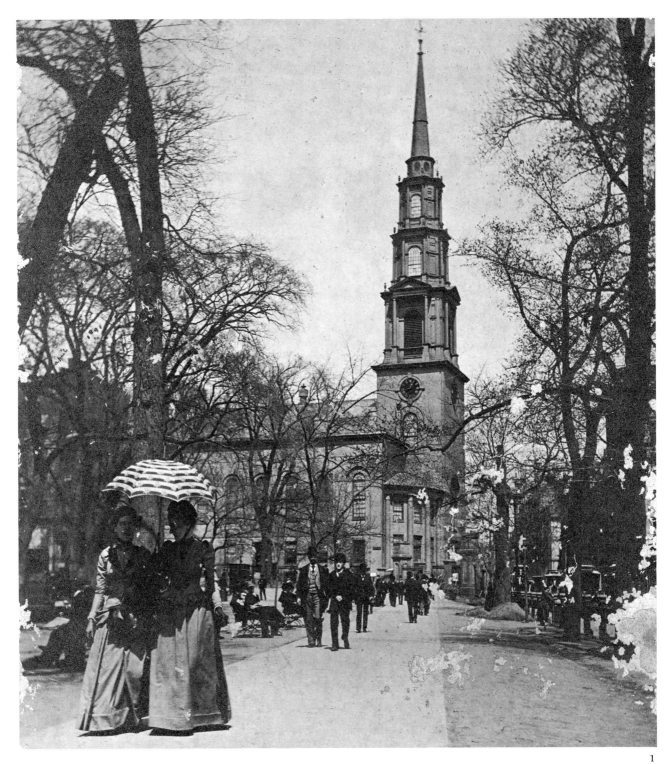

1

**1. Park Street Church, Tremont Street Mall, ca. 1890.** The promenade along the Boston Common side of Tremont Street had been created as early as 1740, when Joseph Bennett noted in his diary, "For their domestic amusements, every afternoon, after drinking tea, the gentlemen and ladies walk the Mall." Originally, the Common had been relatively treeless, but a row of greenery had been planted along the borders in the 1720s and 1730s. The Park Street Church was painted a light gray when this view was taken. Its handsome brick walls were not exposed until World War I. As with other supposedly permanent landmarks in town, the church (designed in 1809 by Peter Banner) came close to being torn down to be replaced by an office building. Although the church was eventually saved, its finances were such that part of its basement was rented out to serve as a tearoom. This section of the Common was soon to be torn up and permanently changed with the construction of the Park Street subway station. Two large entrances would sit in the center of the picture and quiet promenades along the Mall would be lost to progress.

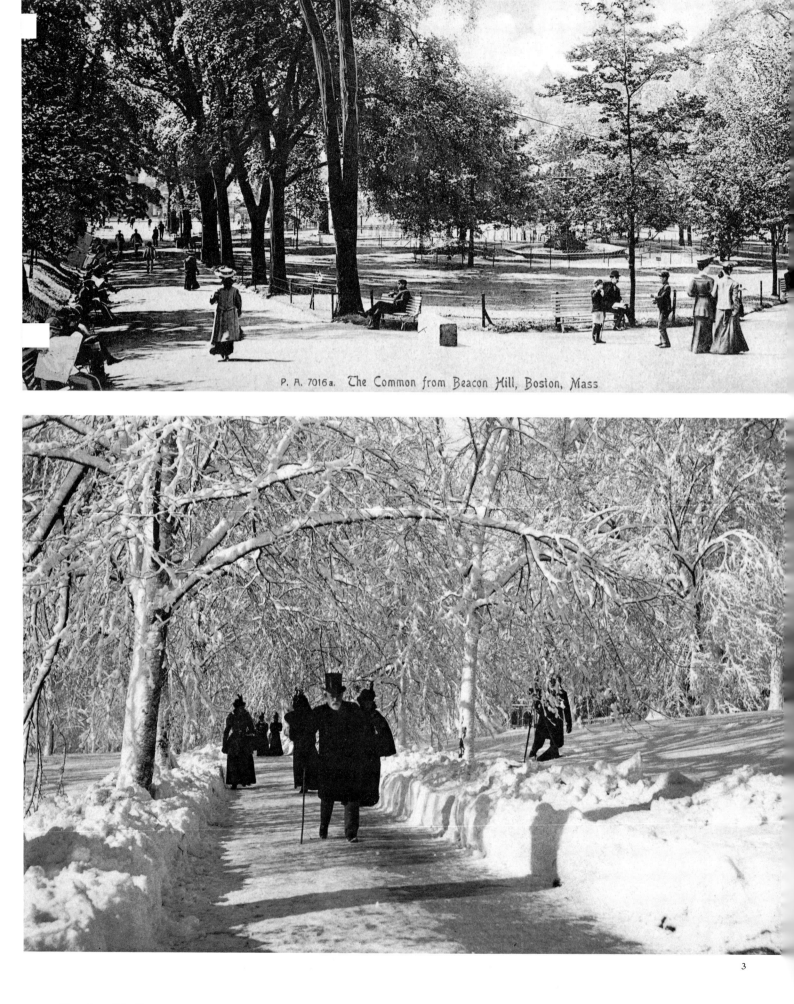

P. A. 7016a. The Common from Beacon Hill, Boston, Mass

3

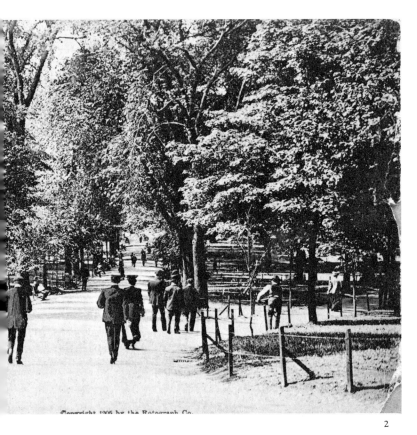

**2. Boston Common, 1905.** New York's Central Park was larger, but Boston's Common was more conveniently located to both business and residential neighborhoods. It is also the oldest park in the United States (1634). For over 300 years it has been the city's area of quiet repose within the bustle of a thriving community. Even by the time of this early twentieth-century view, hay was still being cultivated on the Common, continuing a tradition going back to the 1630s. The pathway at the left heads toward Tremont Street; the right-hand path leads to Boylston Street from the State House. The 1867 Gardner Brewer fountain is a bronze version of a French original, which has been a fixture on the Common since the mid-1870s. Long a source of civic embarrassment because of a plumbing problem that frequently reduced its flow to drips and dribbles, it was repaired in the early 1970s.

2

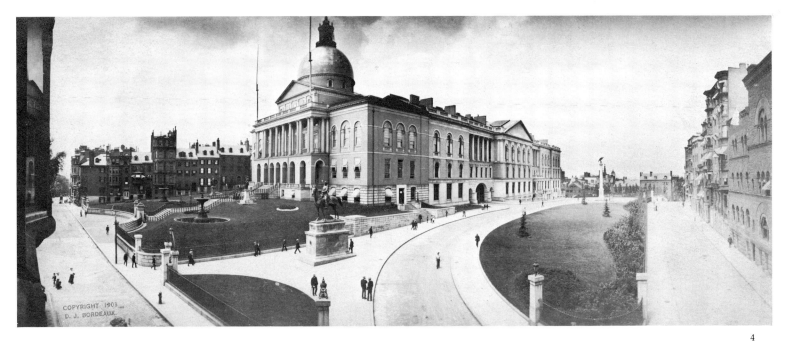

**3. Winter Scene, Boston Common, ca. 1895.** Making his way up the path adjacent to Beacon Street, a venerable Bostonian braves the ice and snow in the period prior to down coats, snow blowers and quartz heaters. Boston Common's long sloping paths traditionally served as a runway for countless toboggans and sleds. James D'Wolf Lovett recounts Sunday afternoons when sleds named "Raven," "Santiago" and "Whiz!" raced each other before multitudes of the curious. Boston legend has it that a group of Revolutionary youths approached occupying British General Gage and brazenly reasserted their right to coast on the Common, which was serving as the encampment site for His Majesty's troops. The amazed Gage complied, and English soldiers soon became eager participants in one of Boston's first sporting competitions.

**4. Massachusetts State House, Beacon Street, 1903.** A wide-angle view of the southeast corner of the State House grounds shows a short-lived park and curving roadway adjacent to Bowdoin Street (right). The park replaced brick town houses that had stood on the extended Mt. Vernon Street, which originally curved down to Beacon Street. Clearly visible is the rear section of the State House added in the 1890s after designs by Charles Brigham. (The original structure had been designed by Charles Bulfinch and built 1795–97.) Until the wings of the structure were added in 1914–17, the enlarged building was horribly out of proportion. The Beacon Hill monument (right center) is a reconstruction of the Bulfinch original which, standing at the summit of Beacon Hill from 1790 to 1811, was the country's first monument to the Revolution. Re-erected in 1898, it stands close to the site of the original signal, which stood on ground 60 feet higher prior to the hill's excavation.

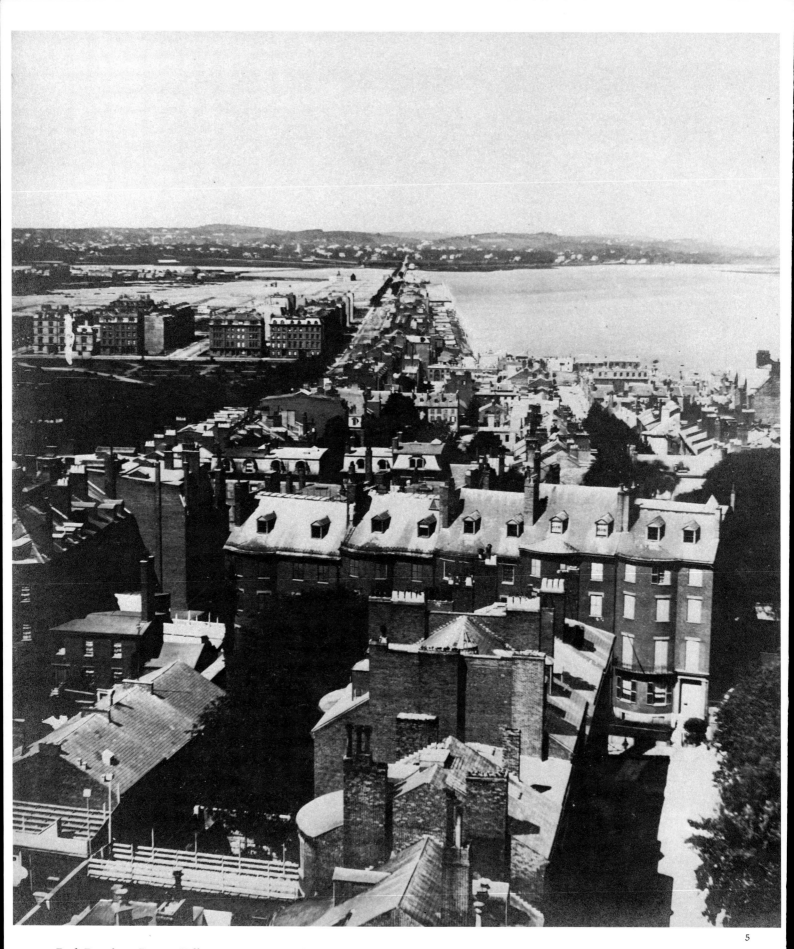

**5. Back Bay, from Beacon Hill, ca. 1875.** Because the State House cupola was the highest point in downtown Boston, many early photographs were taken from it during the latter half of the nineteenth century. Unlike today, the cupola was open to the public and was a popular tourist attraction for a generation unaccustomed to aerial views. This panorama, looking westward, was a favorite, as the filling in of the Back Bay produced an ever-changing shoreline. In this view, partway into the process, Beacon Street heads straight out toward the hills of Brookline, producing a clear division between the bay (left) and the Charles River (right). Buildings on Arlington Street at the edge of the Public Garden carry over to Commonwealth Avenue (on the left). The low roofs of Beacon Hill descend gradually to the river.

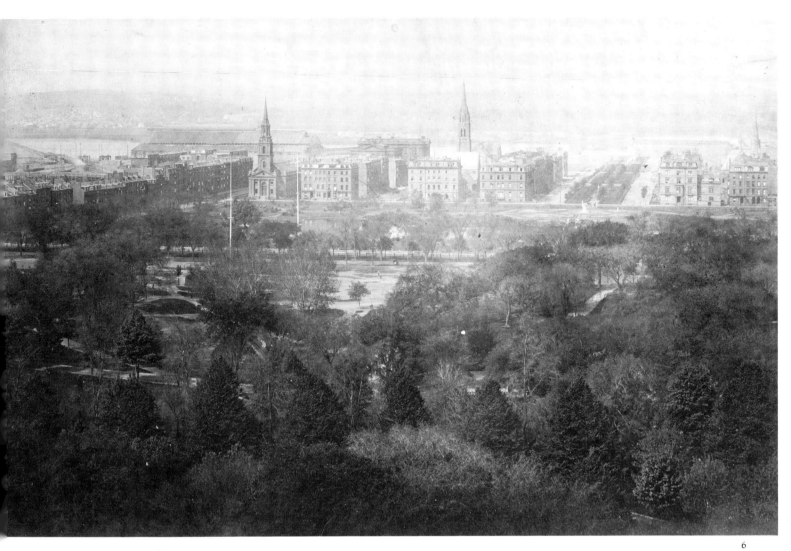

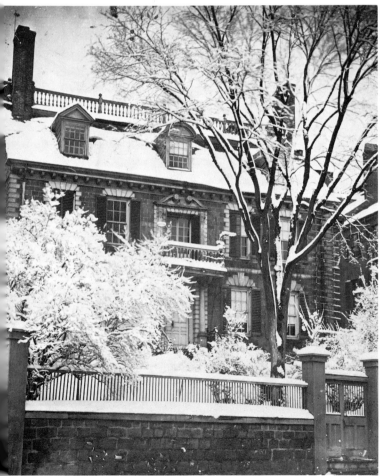

**6. Panorama, Southwest from the State House, ca. 1870.** Nearly a decade of continual filling has produced the first three blocks of the Back Bay. Commonwealth Avenue's broad boulevard design would set it apart from other streets in the area. It has reached Clarendon Street in this image and would eventually link the downtown green space with that of the Fenway. The Public Garden's orderly horticulture shows maturity of space and planning beyond that of the Boston Common. The Peace Jubilee Coliseum, on the site of the Copley Plaza Hotel, is the massive shedlike structure directly beyond the Arlington Street Church spire. Early Back Bay is already showing evidence of the regularity that would characterize the entire neighborhood. The hills of Roxbury are faintly visible in the background.

**7. Hancock Mansion, Beacon Street, ca. 1860.** Directly to the west of the State House stood the Hancock Mansion, Boston's finest house on Boston's finest location. Originally built by the merchant Thomas Hancock in 1737, it passed to his nephew John following his death in 1764. The house served as a Governor's mansion during John Hancock's term as the Commonwealth's first chief elected official. Its elegance and air of wealth reminded Bostonians daily that the Hancock family was the town's richest. By the early 1860s the house had fallen into neglect, and was torn down in 1863 despite belated cries for its preservation. Although this particular fight was lost, the Hancock Mansion served as the first effort in Boston to save buildings of historic importance—an effort that would bear fruit 20 years later with the preservation of the Old South Meeting House and Old State House. Considering the length of Boston's snow season, winter views from this period are relatively rare.

7

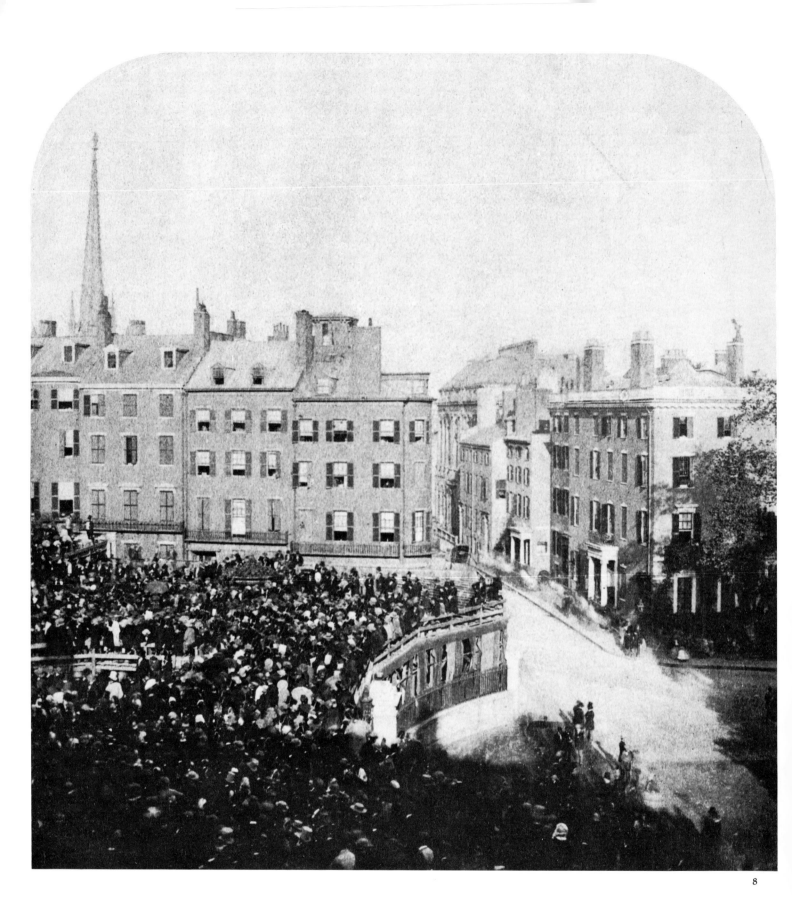

**8. Dedication of the Daniel Webster Statue, State House, September 17, 1859.** It may be difficult to understand today how great was Daniel Webster's influence in his adopted state of Massachusetts, but within three days of his death in 1852 a committee of 100 influential citizens had met to consider "what memorial of the services of Daniel Webster is due themselves and the country." Hiram Powers was commissioned to create a statue of Webster. Walter Muir Whitehill relates that it was lost at sea, and a second statue was required. After being placed on display at the Boston Athenaeum for nine months, it was moved up the street and placed on the grounds of the State House. Though much of the nearby area has changed, the view contains elements that are still familiar to Bostonians today. Up Beacon Street, on the right, is the Amory-Ticknor House at the corner of Park Street, recognizable today, though somewhat altered. The venerable Boston Athenaeum a few doors up Beacon Street (the building set back a bit from the curb) remains relatively unchanged. The spire of the First Baptist Church on Somerset Street is a common landmark in many nineteenth-century views.

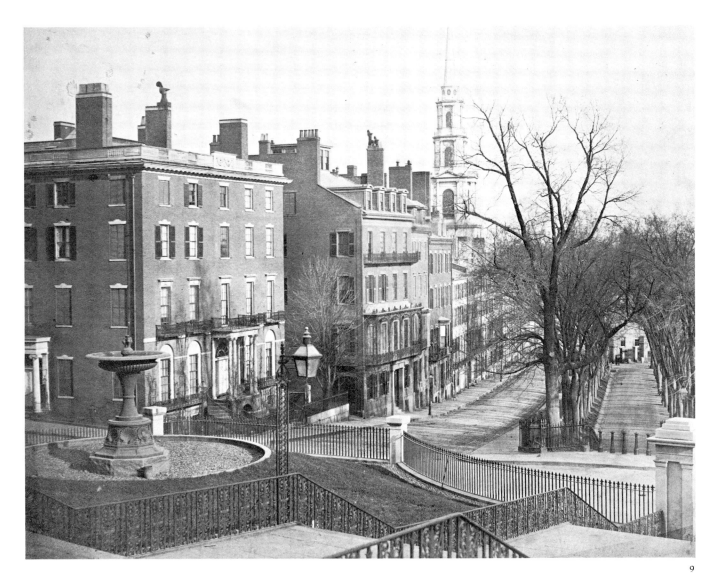

9

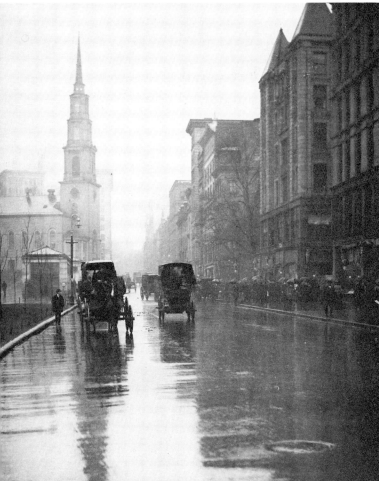

10

**9. Park Street, Looking from the State House toward Tremont Street, ca. 1858.** The Amory–Ticknor House (at the far left), at the corner of Beacon and Park Streets, was designed by Charles Bulfinch for wine merchant Thomas Amory, and completed in 1804. Unfortunately, Amory went bankrupt shortly thereafter, in part because of the cost of the house, which then became a boardinghouse for Massachusetts state officials working across the street at the State House. The building was then purchased by educator George Ticknor, owner of one of the largest private libraries in America. The Amory–Ticknor House stands on the site of the Boston Almshouse, one of a series of public buildings on early Park Street, including the jail, pound and insane asylum. When this photograph was taken, Park Street was entirely residential. Its fortunate homeowners enjoyed an unmatched view of afternoon sunsets over the Boston Common (right).

**10. Tremont Street on a Rainy Morning in April, ca. 1915.** Not all photographs taken of Boston show lively street scenes. This softly muted view, looking up Tremont Street toward the Park Street Church, produces a shimmering Impressionist look at one of Boston's most familiar corners.

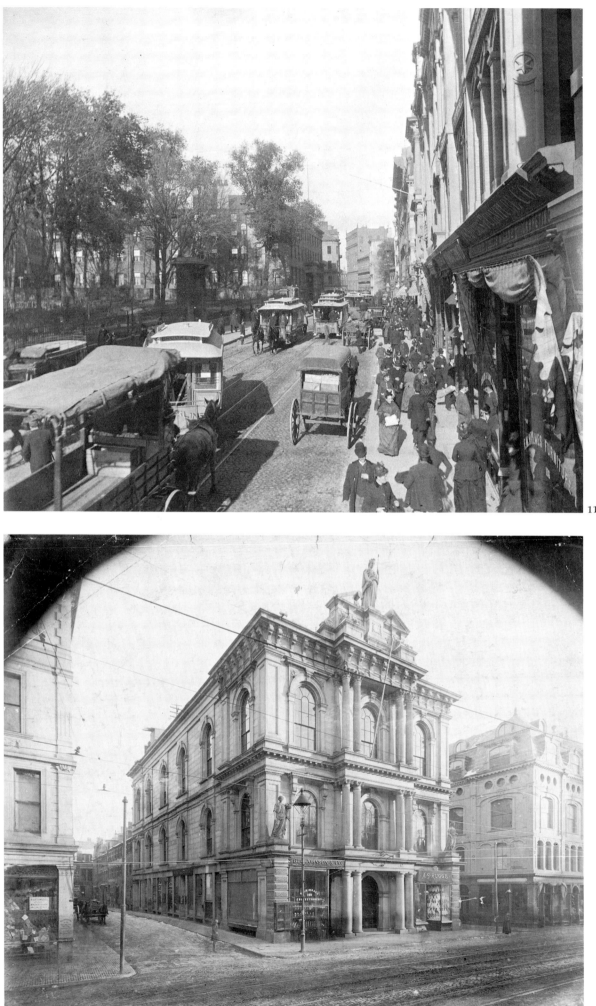

11

14

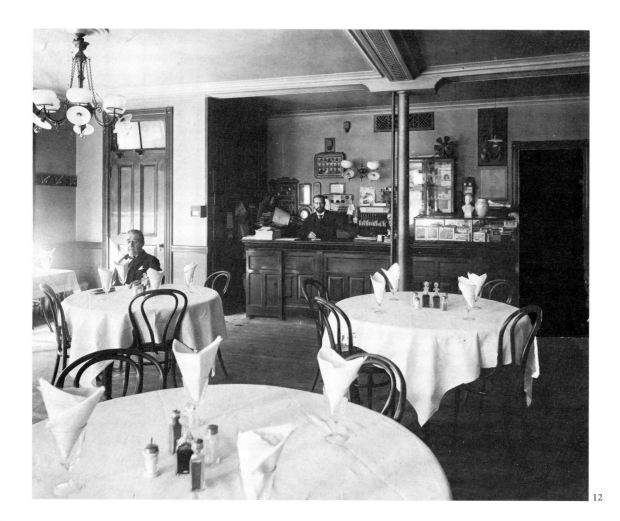

12

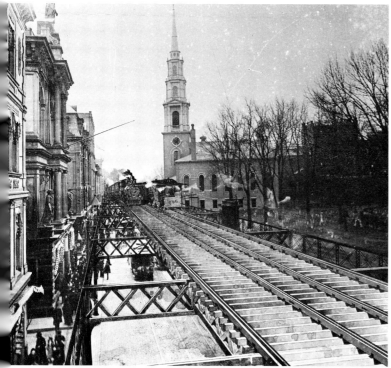

13

**11. Tremont Street, Looking toward Scollay Square, 1893.** Not quite nineteenth-century gridlock, but certainly an example of why America's first subway would soon run below busy Tremont Street. As a major link between downtown Boston and the northern section of the city, Tremont Street (a two-way route in those days) was simply not wide enough to handle the wagon, streetcar and pedestrian traffic forced upon it by its importance to the city. The Old Granary Burying Ground, first used in 1660, is on the left in this view taken near the corner of Park Street.

**12. Billy Park's Restaurant, Bosworth Street, 1893.** Just a block away from Tremont Street, Billy Park's was a popular lunch spot for the business crowd, appealing primarily to a male clientele. "The lawyer who has not found his way to Bosworth Street, and banished the annoyances attendant upon his mind with a tankard of "Musty,' and Broiled Live Lobster or Brace of Chops, has something to live for!" ran the ad in the 1893 *Boston City Directory*. Mr. Park is seated at the left.

**13. Tremont Street, Looking toward Park Street, ca. 1892.** This is not a view of Boston long gone by, but a piece of propaganda created to defeat the proposal for an elevated railway down Tremont Street. The illustration of smoke-belching trains, like New York City's, and steel girders marching down sedate Tremont Street past the graves of Paul Revere and Samuel Adams was too much for Bostonians to imagine and America's first subway was the result.

**14. Horticultural Hall, Tremont Street at Montgomery Place, 1891.** One of the more elaborate buildings on Tremont Street was designed by Gridley J. F. Bryant and built in 1865 for the Massachusetts Horticultural Society to serve both as its headquarters and as an income raiser. Bryant shrewdly put commercial stores at street level to produce revenue and used the upper two floors for the Society's offices and meeting room. Following the trend of other cultural institutions, the Horticultural Society moved far out in the Back Bay at the turn of the century and settled at the corner of Massachusetts and Huntington Avenue, across from Symphony Hall.

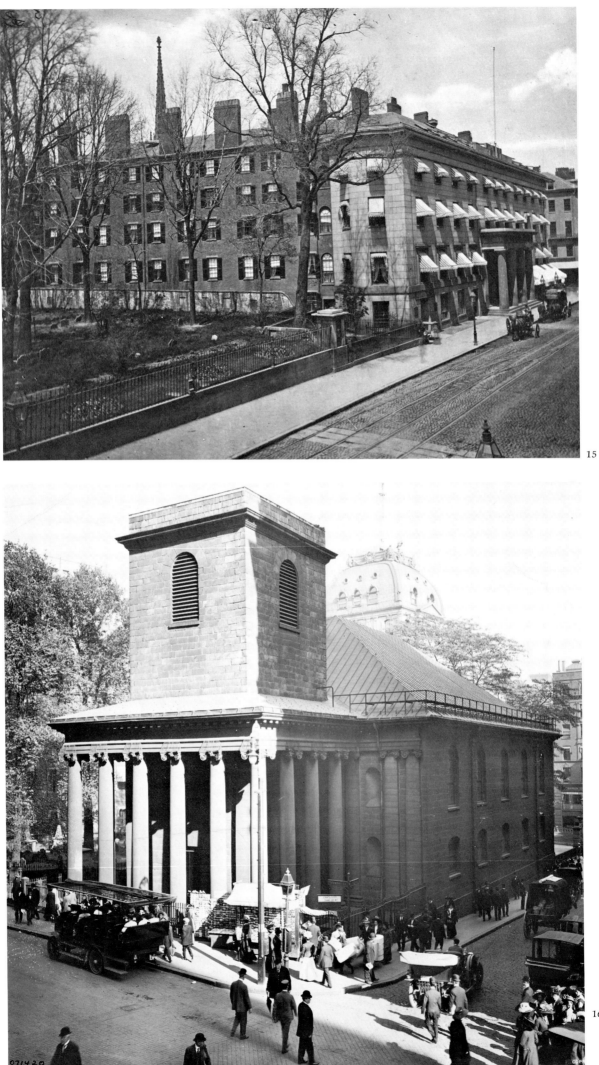

15

16

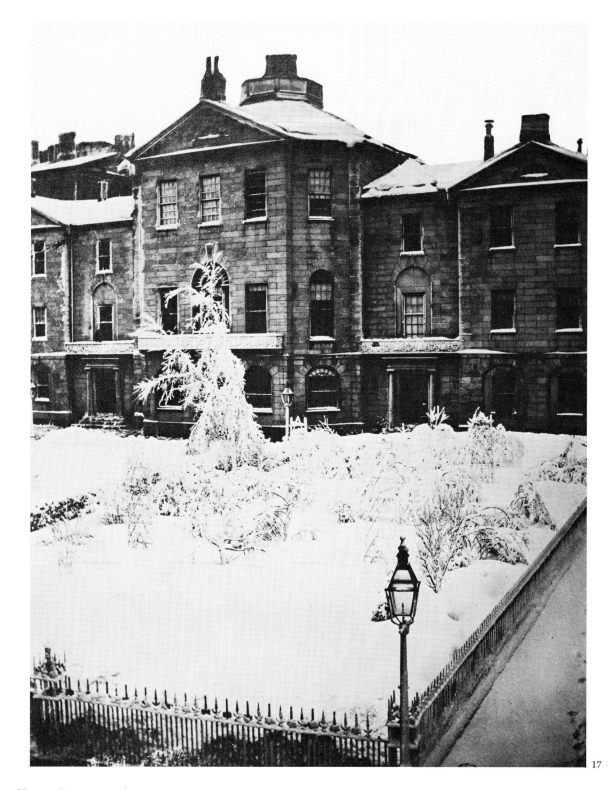

17

**15. Tremont House, Tremont Street, ca. 1870.** Boston's premier hotel for much of the nineteenth century, the Tremont House provided Tremont Street with an undeniable cachet. Designed by Isaiah Rogers and built in 1828, it replaced the Exchange Coffee House on Congress Street as Boston's luxury hostelry and quickly became the place where celebrities such as Charles Dickens, Andrew Jackson, William Thackeray and Alexis de Tocqueville stayed while in the city. It could hold 250 visitors and accommodate them with such modern amenities as interior baths and toilets, and gaslit public rooms. Although it was somewhat inconvenient because of its distance from the train stations and piers, the Tremont House lived up to its claim to be America's first luxury hotel. It remained important in the city until its destruction in the mid-1890s.

**16. King's Chapel, Tremont Street at School Street, ca. 1907.** King's Chapel lays claim to being America's oldest Unitarian church. Designed in 1749 by Peter Harrison and opened in 1754, it replaced a small wooden structure built on the same site in 1688. It had been constructed when the parish was Church of England, but its members voted to adopt Unitarianism after the Revolution. Its adjacent cemetery, to the left, the oldest in Boston (1630), is the final resting place of Massachusetts colonial governors John Winthrop and William Shirley. The mansard atop Old City Hall is in the background.

**17. Suffolk County Court House (later Boston City Hall), School Street, ca. 1860.** Designed by Charles Bulfinch, this impressive and nearly forgotten structure was built in 1810–12, serving as the Suffolk County Court House until it was taken over by Boston as its City Hall. It was the home of city government from 1841 to 1862, when it was replaced by the Bryant and Gilman building that stands today. Constructed of Chelmsford granite, it was more appropriate to the area than its successor.

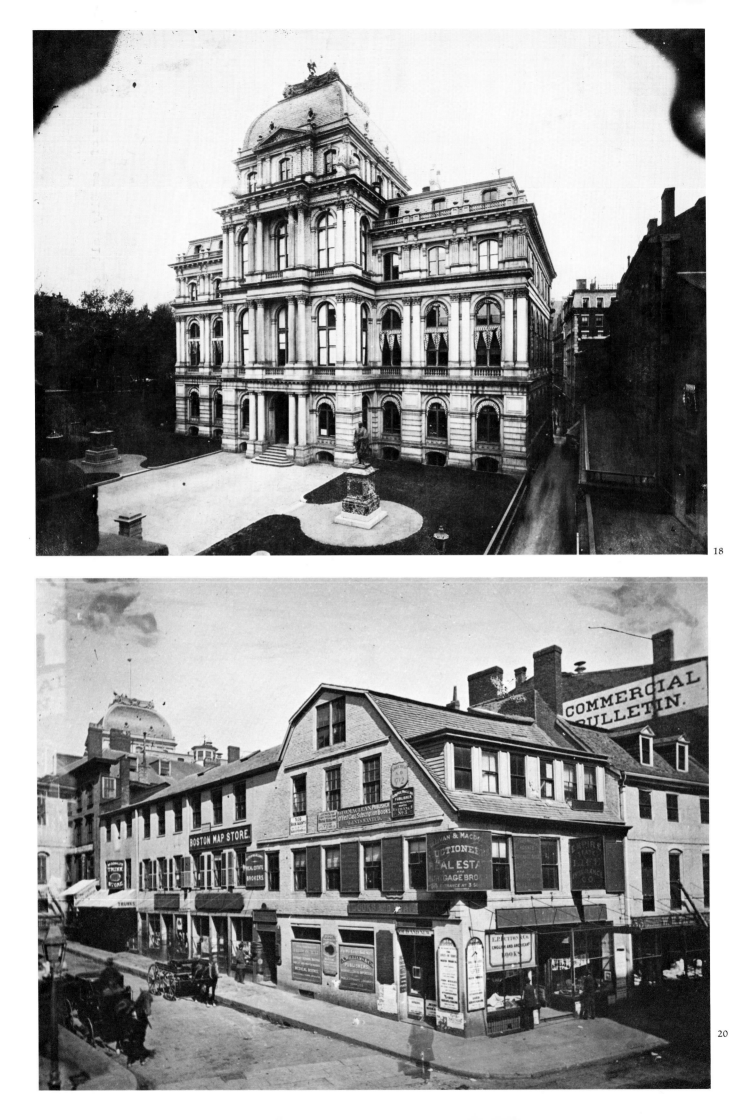

18

20

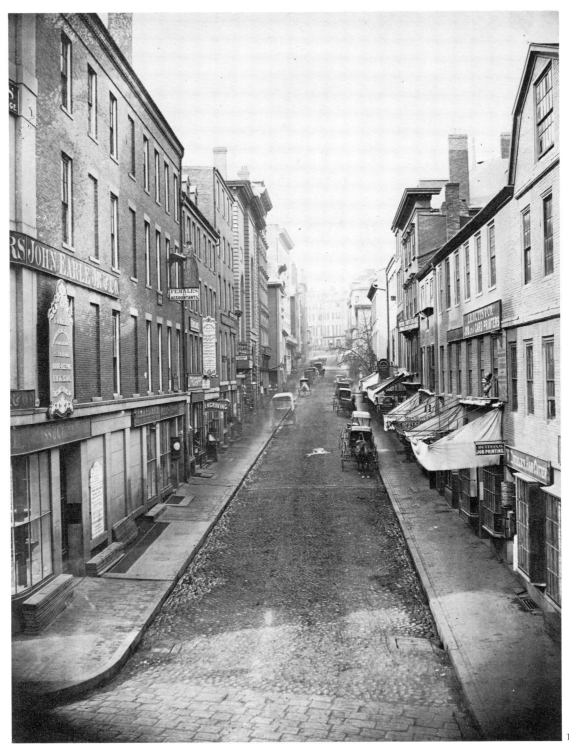

19

**18. Old City Hall, School Street, ca. 1895.** Built during the Civil War, the Old City Hall served for more than a century before being replaced by the Government Center structure designed by Kallman, McKinnell and Knowles. The large statues in front are Richard Greenough's 1856 study of Benjamin Franklin (left), Boston's first portrait statue, and *Josiah Quincy* by Thomas Ball. Quincy, the second mayor of Boston, was responsible for the construction of Quincy Market. By the late 1960s, when Old City Hall was vacated, the local climate for preservation was such that the building was saved. Its renovated interior houses a variety of offices, including, appropriately, that of the Boston Preservation Alliance.

**19. School Street, from Washington Street, 1858.** Looking up School Street, the small-business nature of the "ladder streets" running between Tremont and Washington Streets is evident. Originally named for the Boston Latin School, which held its first sessions on its path, School Street has seen the City Hall, Province House (the home of the British Governor) and the Old Corner Book Store come and go (and come again in the last-named case).

School Street changes its name to Beacon Street at the Tremont Street intersection, seen midway up in the picture. This delightful Boston contrariness also occurs nearby, where Winter Street becomes Summer Street—a change of names as sudden as the abrupt change of seasons in New England.

**20. Old Corner Book Store, Washington Street at School Street, 1869.** The present structure, dating from the 1710s, stands on the site of the home of Anne Hutchinson, who was banished from Massachusetts Bay in 1637 for religious heresies. It was not until 1828 that it became a bookstore, and throughout the nineteenth century it was the center of literary Boston. The publishing house of Ticknor & Fields was located here, and the store became a city meeting place for Emerson, Longfellow, Julia Ward Howe and the rest of the considerable circle of authors unmatched by any other American city at that time. Rescued from demolition in the 1960s by Historic Boston Incorporated, it has been restored and again serves as a bookshop. Old City Hall rises on the left, just up School Street.

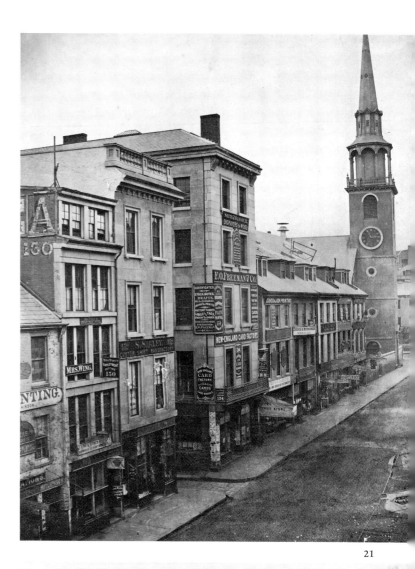

**21. Washington Street, Looking South from Water Street, ca. 1856.** The Old South Meeting House, at the corner of Milk Street, was still an active parish. Even in the 1850s, the commercial heart of Boston was Washington Street, originally the only road out of town across Boston Neck. It had been renamed Washington Street after President Washington's 1789 journey to Boston, when he rode into town over that route. No beautification prohibitions against store signs were in effect. They were frequently the only means of advertising available to shopkeepers. The narrow indentation on the left is Spring Lane.

**22. Old South Meeting House, Washington Street at Milk Street, 1876.** Dating from 1729 (its congregation goes back 60 years earlier), the Old South matches the Old North in historical significance. Built by Bostonians Joshua Blanchard and Nathaniel Emmes, it was used both as a house of worship and, as its name suggests, as an early town auditorium. From its pulpit was given the signal for the Boston Tea Party; British soldiers subsequently used the building for a riding academy— an act of desecration that particularly infuriated residents. Benjamin Franklin was baptized in the earlier Old South Church that stood on this site (the Franklin family lived just around the corner down Milk Street). At the time of this view, however, the building was used as a post office. The congregation had moved to Copley Square and the future of the building was in jeopardy because of the desirability of its location. Posters proclaiming the need for its preservation are visible; thanks to the Old South Preservation Committee it was accomplished and Boston's enduring legacy of saving historic buildings for educational purposes had commenced.

**23. Washington Street, Looking South from Milk Street, 1858.** Seen from the head of Milk Street looking toward Franklin Street in the central portion of retail row, this was one of three blocks on Washington Street lost in the 1872 fire, the corner at the far left marking a boundary of the conflagration. Only heroic work by local citizens who climbed on the roof of the Old South Meeting House with hoses kept the flames from jumping Milk Street. The small businesses of Washington Street can be seen in this pre–Civil War view; the patchwork effect of a variety of styles and heights was typical of that time.

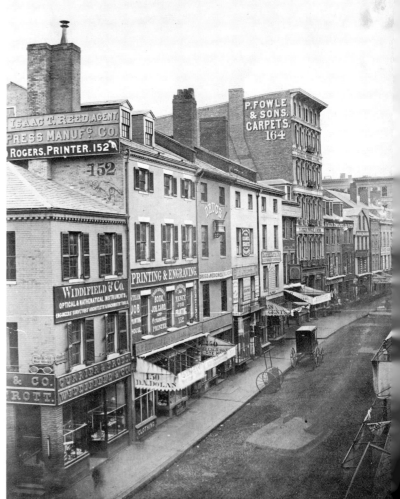

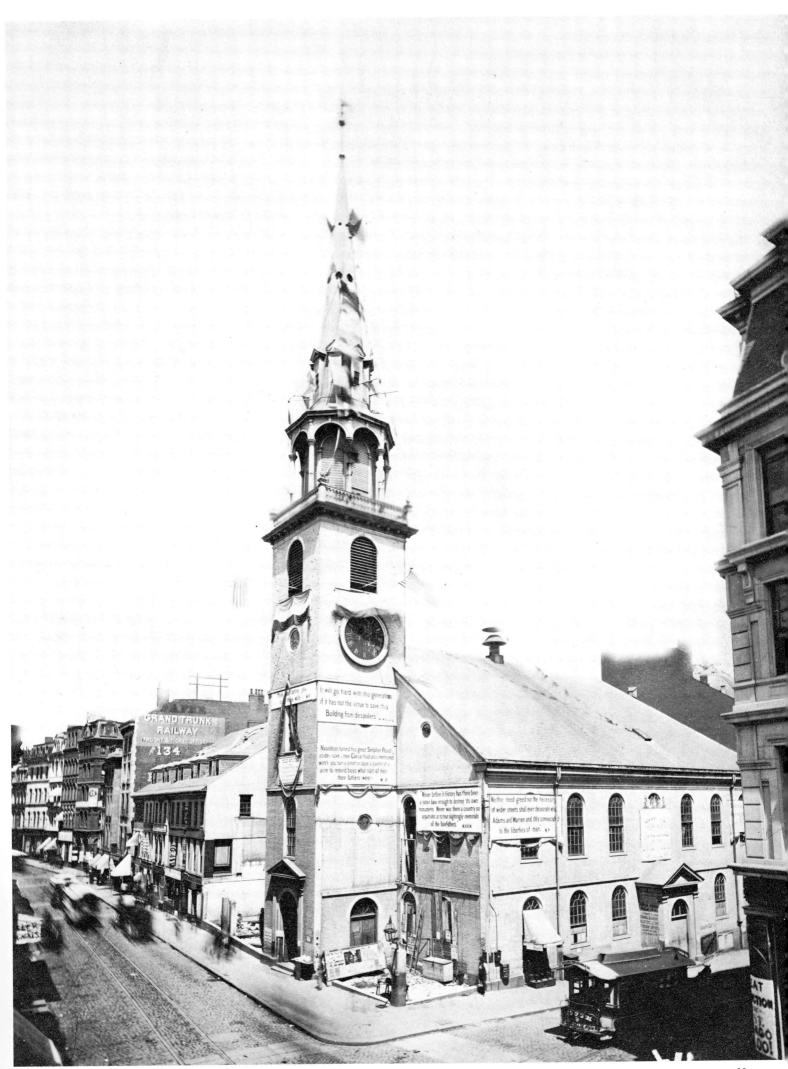

**24. Spring Lane, from Devonshire Street, ca. 1914.** Too narrow for auto traffic, the alleyway still runs between Washington and Devonshire Streets and is a contemporary reminder of Boston's fabled crooked cowpaths. Like its smaller neighbor, Pi Alley, it serves as a shortcut for Bostonians in the know; it cuts down on time spent on crowded sidewalks. Spring Lane has a distinguished past that belies its size. One of Boston's earliest thoroughfares, it was the location of Governor John Winthrop's house in the 1630s near the source of fresh water that gave it its name.

**25. Boston *Herald*, Washington Street, ca. 1869; 26. Boston *Globe*, Washington Street, ca. 1877.** The stretch of Washington Street between State and School Streets became the center of most of the publishing houses and newspapers in the city. Day and night this section moved to the noise of presses and rush of deadlines, creating an around-the-clock excitement that made it a unique center of activity. Across the street from one another, the Boston *Herald* and *Globe* competed for the pennies of the newspaper-reading public along with a variety of other journals. More than a century later, they have outlasted all their competitors along the Row, and share the market for local news almost exclusively. The decline in competition and movement of newspapers to more accessible locations wrote "30" to Newspaper Row in the 1950s.

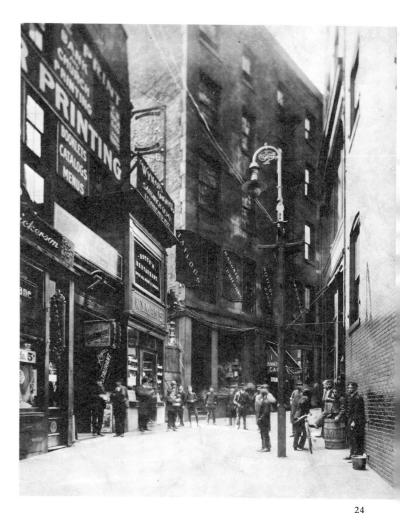

24

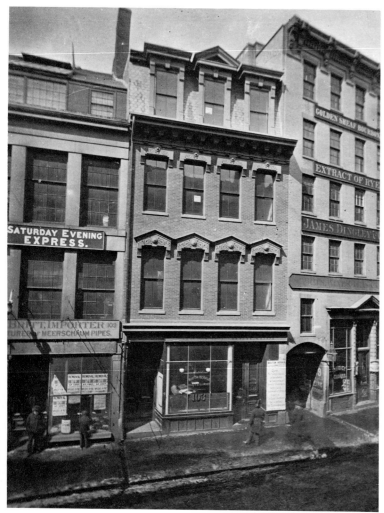

25

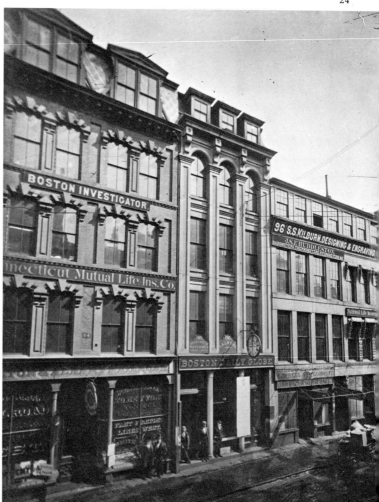

26

16   Freedom Trail

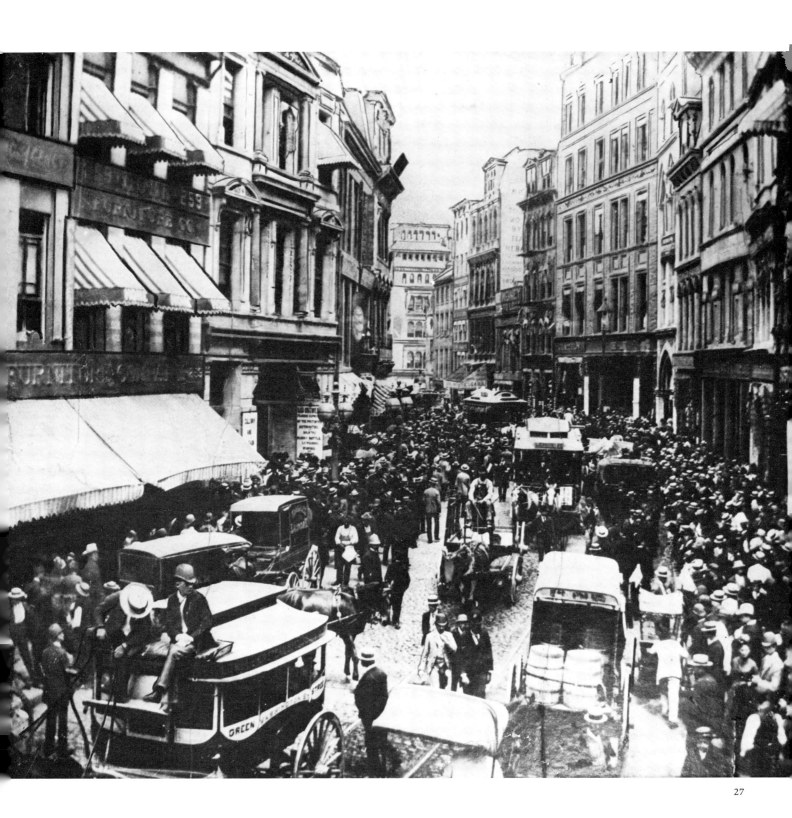

**27. Newspaper Row, Washington Street, 1889.** Crowds begin to gather in front of newspaper offices to receive telegraphed accounts of the John L. Sullivan–Jake Kilrain boxing match on July 8, 1889. Traffic was stopped and horsecars diverted as much of the male population of the city congregated to root for the hometown boy. They were not disappointed. Sullivan knocked out Kilrain in the seventy-fifth round of the last bare-knuckle heavyweight championship fight.

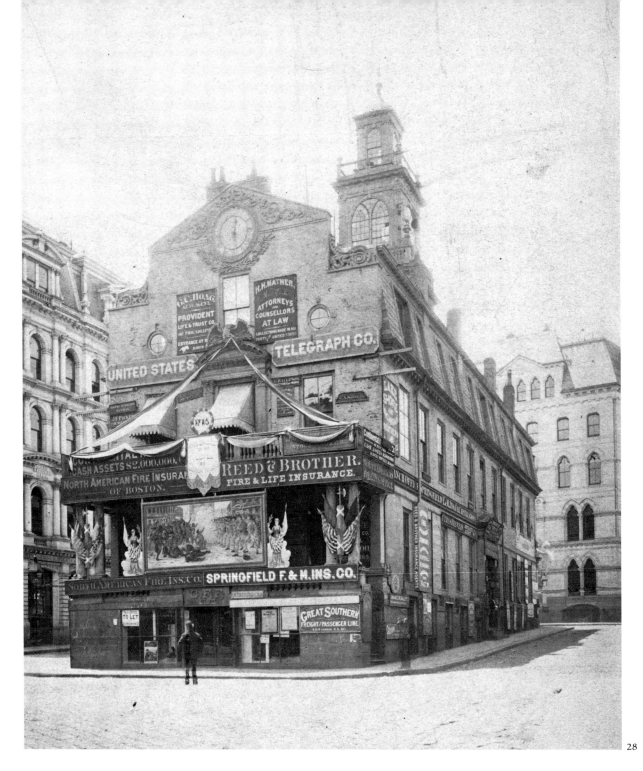

28

**28. Old State House, State Street at Devonshire Street, 1875.** The oldest surviving public building in the city had become a rather shabby office building when it was decorated for the centennial of the Battle of Bunker Hill, the addition of a mansard roof, advertisements and extended porch suggesting a decline from its past role in Boston's history. The building was erected in 1712–13 (undergoing several subsequent alterations) and served as the home for Massachusetts government for over 80 years. Massachusetts' first state house was replaced by Bulfinch's State House in 1798, and the structure was used as Boston City Hall in the 1830s. The open area in front of the Old State House was, in 1770, the scene of the Boston Massacre as British soldiers fired into a crowd of unarmed citizens, killing five. Not until 1880, when Chicagoans suggested dismantling the Old State House and reassembling it in Lincoln Park, did Boston citizens appreciate its worth as a tangible reminder of the city's past. As a result, the building was preserved and the city leased the upper two floors to The Bostonian Society for use as a museum.

**29. State Street, Looking East from Washington Street, ca. 1862.** This remarkable view, taken from a perspective unusual for its

time, shows State Street, which had become the financial center of New England and the direct gateway to the harbor. Banks, importers and trading companies lined State Street and relied on the cargo and income moving up from Long Wharf (center distance). At the head of the street, the Old State House (right foreground) had become an office building, surrendering its governmental tasks for those of business. Directly behind the British unicorn on the Old State House is the top of the Merchants Exchange.

**30. State Street, Looking West toward the Old State House, 1870.** This image shows an improvement in street construction but little change in traffic. The central building with the pilasters is Isaiah Rogers' Greek Revival Merchants Exchange which, constructed in 1842, was the first of two temples to commerce built on that location. It was replaced half a century later by Peabody & Stearns's Stock Exchange Building which perpetuated the solid appearance of financial stability. Today, the glass skyscraper at 53 State Street commands that block. The Old State House, complete with mansard roof, extended porches and billboards, is seen here at its worst.

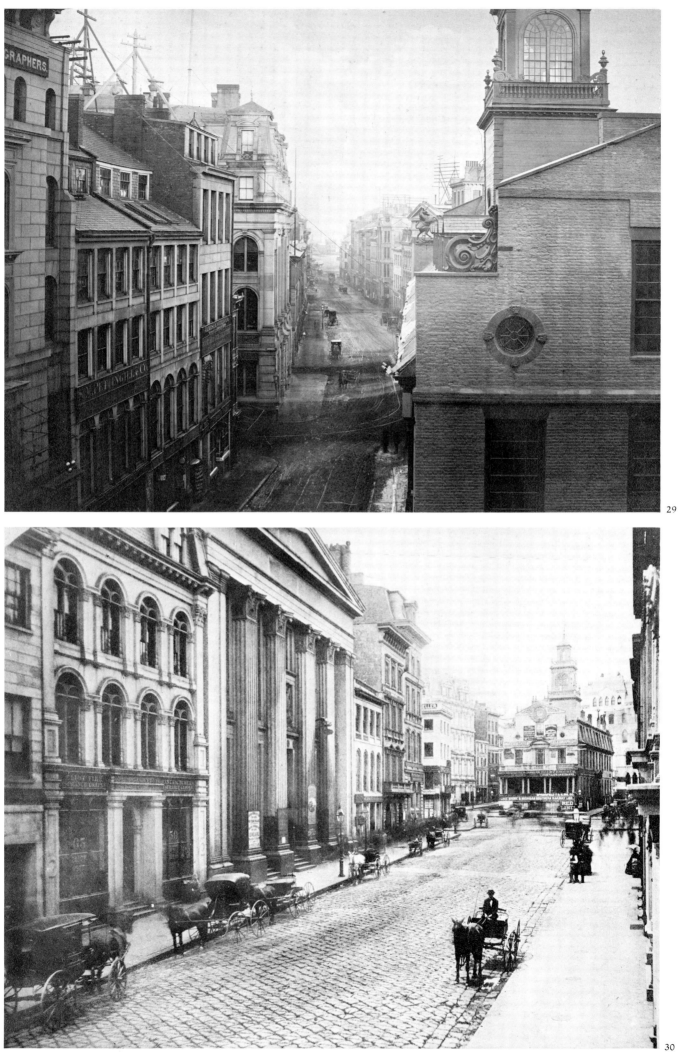

29

30

**31. Christmas Party, Boston Stock Exchange, State Street, 1896.**
The interior of the Peabody & Stearns structure of 1891 gives
some idea of its grand scale and elaborate detail. Only the facade
remains, incorporated into the 53 State Street skyscraper.

**32. Hancock House Tavern, Corn Court, 1901.** Nestled in the
middle of a series of alleyways near the market district, the
venerable Hancock tavern, an establishment dating from 1636
(with change of name), survived until 1903. It catered to a varied
clientele, but retained a century-long popularity with farmers and
merchants doing business at nearby Faneuil Hall and Quincy
Market. Washington and Franklin dined there and the tavern was
also popular with French émigrés who stayed in Boston. Popular
historian George Weston cites the patronage of Talleyrand and
the future King Louis-Philippe.

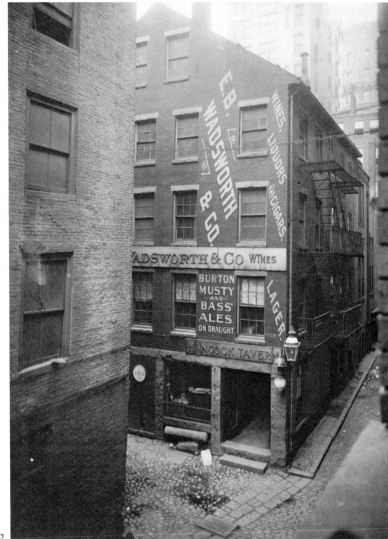

32

31

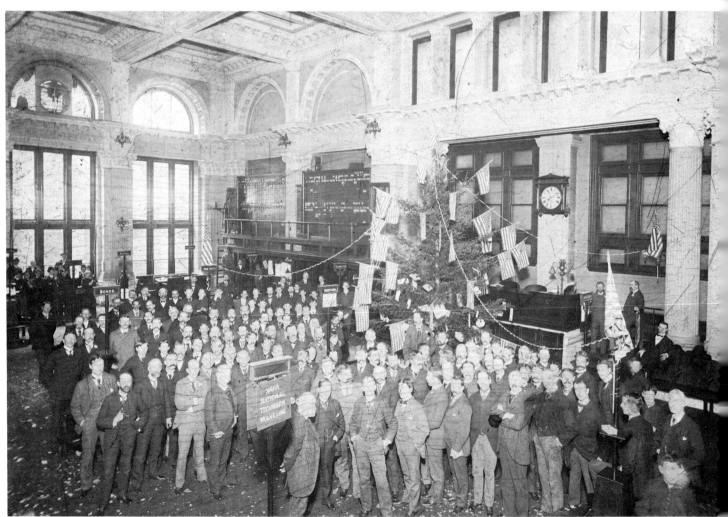

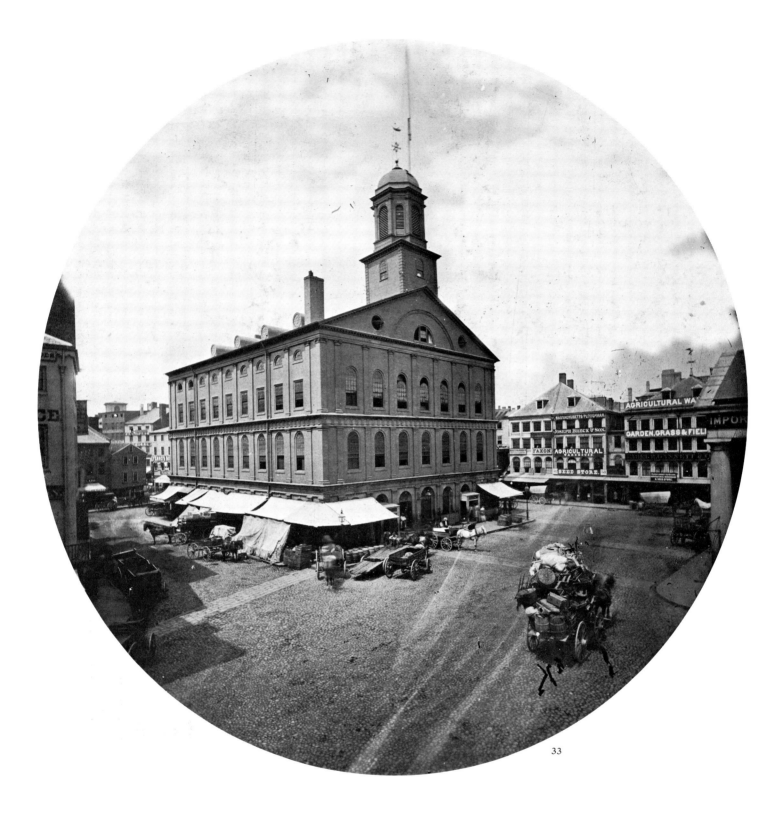

33

**33. Faneuil Hall, Faneuil Hall Square, before 1872.** Faneuil Hall as it was—without tourists, gelato stands and T-shirt vendors. The building, a gift to the town from Huguenot merchant Peter Faneuil in 1742, was enlarged by Bulfinch to its present size in 1805–06. It served as supermarket, business exchange and unofficial town-meeting site—in the course of a day's time many segments of the town's population would pass through the building or its broad plaza. In the tradition of British marketplaces, a space for a large public auditorium was placed upstairs. So many patriotic speeches were given there before the Revolution that the hall was given the title "Cradle of Liberty." Deacon Shem Drowne's copper grasshopper weathervane, one of Boston's most enduring pieces of public art, stands atop the cupola. Knowledge of the grasshopper by a sailor abroad stamped the mariner as a true Yankee.

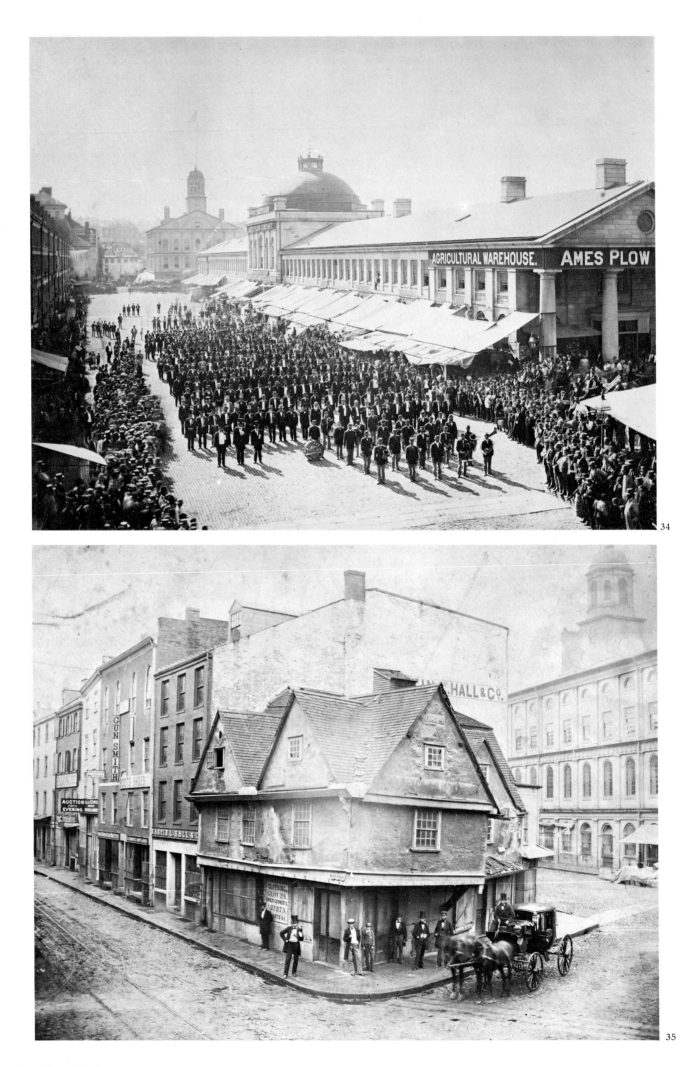

34

35

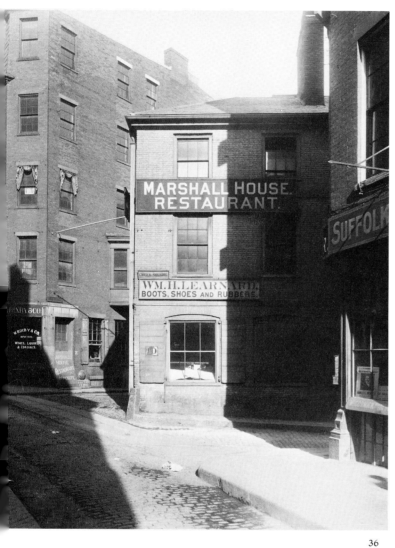

36

37

**34. Quincy Market, South Market Street, 1876.** Celebrating the first 50 years of its existence, the merchants of Quincy Market pose with Brown's Brigade Band along the south side of the building. A dinner following the parade honored the four surviving original proprietors. Alexander Parris designed the simple Greek Revival building and it was constructed of local Quincy granite. (The Market was named for Boston mayor Josiah Quincy.) Faneuil Hall sits beyond. Proving that not everything from the nineteenth century was tasteful, during the 1840s a covered walkway connected the upper floors of the Hall and Market. Mercifully, it had been removed by 1855.

**35. Old Feather Store, Dock Square, 1857.** A link between the seventeenth and nineteenth centuries, the Old Feather Store was built in 1680, more than 50 years before Faneuil Hall (right). With its gables and overhanging second story, it was typical of the period, serving both as a residence and as a commercial building. Very much an anachronism by the time of its destruction in 1860, it was fondly recalled by generations of Bostonians. Fortunately, it lasted into the age of photography.

**36. Ebenezer Hancock House, Marshall Street, 1885.** The Blackstone Block, adjacent to Faneuil Hall, remains as one small area of today's Boston where one can picture its colonial past. The Boston Stone (to the right of the street-level Marshall House sign) served as milepost zero in colonial times. Dating from 1737 as a mileage marker representing the center of town, it had been used originally by painter Thomas Child to grind pigments. William Learnard's shoe store occupies the ground floor of the Ebenezer Hancock house. Ebenezer, John's brother, was a paymaster for the Continental American Army; the house was used for patriotic meetings and activities prior to the Revolution.

**37. North (formerly Ann) Street, 1881.** Despite its peaceful appearance here, Ann Street was notorious in the 1800s for its dangerous taverns, brothels, "jilt shops" (establishments frequented by "B-girls"), and other worldly diversions which beckoned curious sailors from nearby Dock Square. Ann Street, which ran across an early drawbridge into the North End, was a chief means of access to that section of town. Hoping to improve its image and assuage North End residents, the city changed Ann Street's name to North Street in 1852; economic needs of the community eventually cleaned up the area—something that has subsequently happened to other Boston red-light districts.

39

38

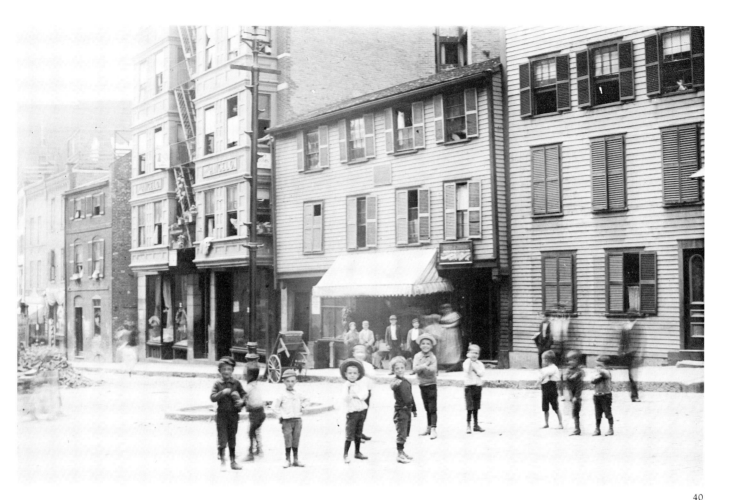

40

**38. Hanover Street, Looking North from Court Street, 1900.**
Hanover Street was an extremely busy route from the North End
into downtown, through Scollay Square. Although it still exists
today, Hanover Street no longer comes into downtown, having
been truncated by highway construction and the Government
Center urban-renewal project during the 1950s and 1960s.
Everything in this lively picture is gone without a trace. The
neighborhood was a textile and dry-goods center. Jordan Marsh
department store, a Boston shopping institution, started from a
small store at 168 Hanover Street. Even in its shortened form,
Hanover Street remains the commercial hub of the North End.

**39. Mechanic Street, ca. 1895.** Mechanic Street was not really
much of a street at all, but a half-block alleyway off of Hanover
Street, ending in an open courtyard. This is the front of a three-
story frame building of uncertain origin, probably inhabited by
recent arrivals to America. Quite likely the language heard that
day was not English; possibly Italian, Yiddish, German or Gaelic.

**40. Paul Revere House, North Square, 1895.** A short distance
down North Street, in front of the unrestored Paul Revere House,
neighborhood youngsters greet the photographer with a timeless
gesture. Surrounded by tenements, the Paul Revere House
appears unremarkable before its restoration, but its value to
Boston's history is considerable. Revere lived here during the
1770s (he left from this house to begin his midnight ride); the
house is acknowledged as the oldest building to survive in
downtown Boston, having been built around 1680. It sits on the
site of Increase Mather's house, which was destroyed by fire in
1676. The Revere House's longevity is partly due to loving
restoration undertaken by the Paul Revere Memorial Association,
but it is equally due to chance. The house survived more than a
century of nearby fires, home improvements and neighborhood
changes to arrive in the twentieth century in the state seen in the
picture.

**41. Hurdy-Gurdy Man, North Street, ca. 1890.** Children growing
up in the North End at the end of the century had a multitude of
entertainments with which to amuse themselves. A hurdy-gurdy
man performs before a small group of onlookers in the pre-
dominantly Italian section.

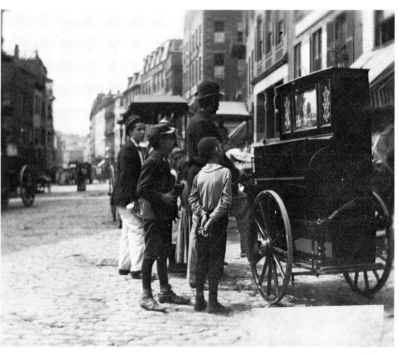

41

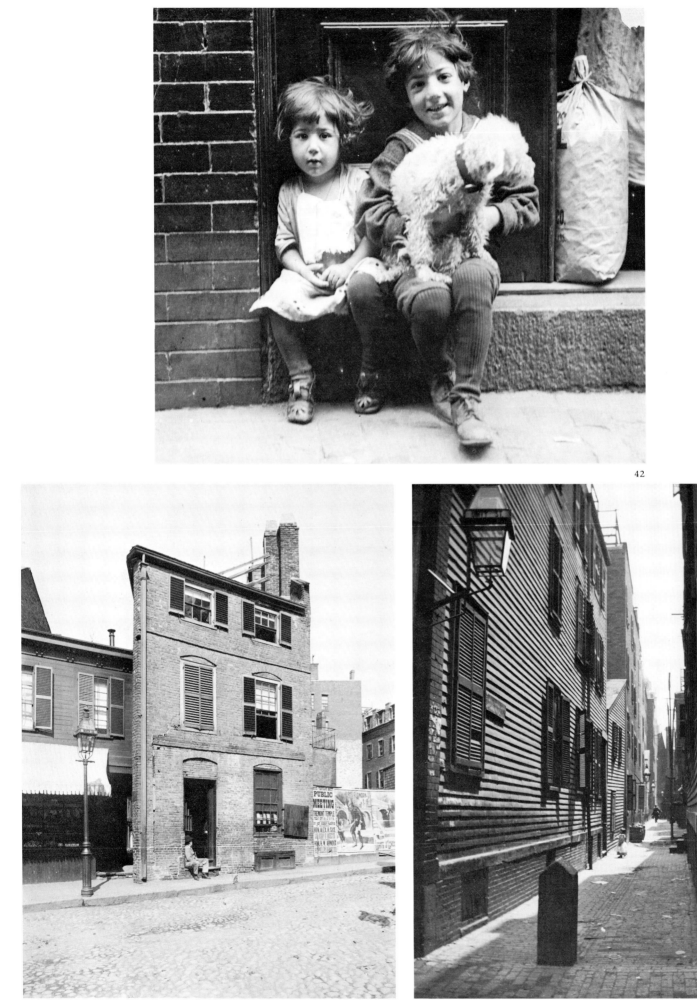

42

43

45

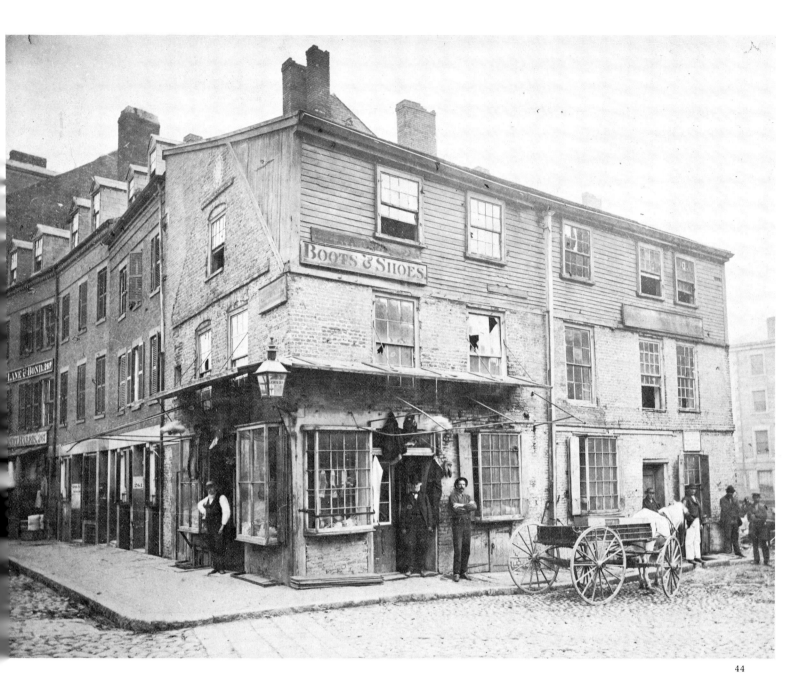

**42. Children with Dog, North End, ca. 1910.** More obliging to the photographer than the young boys in No. 40, two children pose on the stoop of a neighborhood store with their dog.

**43. Pierce–Hichborn House, North Square, 1902.** Although not as well known as the neighboring Paul Revere House, the Pierce–Hichborn residence is an interesting example of early-eighteenth-century brick architecture. Constructed ca. 1711, it is the oldest brick residence in Boston. The original owner, Moses Pierce, was a glazier and his concern for detailed brickwork is evident. Nathaniel Hichborn was Revere's cousin and a shipbuilder, and the two homes are adjacent, separated only by a walled garden. Here the wall serves as a billboard.

**44. King's Head Tavern, North Street at Lewis Street, ca. 1868.** North Street curves to the left; Lewis Street is a narrow lane, one block in length, that runs down to Lewis Wharf. The venerable building on the corner is the site of the King's Head Tavern, built during the reign of Charles II and the namesake of a popular London establishment. "A maiden dwarf, fifty two years old" was exhibited in 1771 next to the King's Head. The building came down, a victim of North End renewal, in 1870.

**45. Webster Avenue, North End, ca. 1895.** Boston is known for its narrow, cramped streets, and in the North End they were most in evidence. Although taken in the 1890s, this view of Webster Avenue could have been dated virtually anytime between the 1870s and the 1930s. Incredibly, smaller alleys radiated from Webster Avenue, a block-long "street" that ran from Hanover to Unity Streets at the rear of the Old North Church. Closely lined with tenements filled with first- and second-generation Americans (usually Italian, but also Irish or Jewish, depending upon the period), Webster Avenue served as Boston's melting pot. It exists today only in photographs, for it was torn down in the mid-1930s for the Paul Revere Mall, which features the much photographed equestrian statue by Cyrus Dallin of the North End's favorite son.

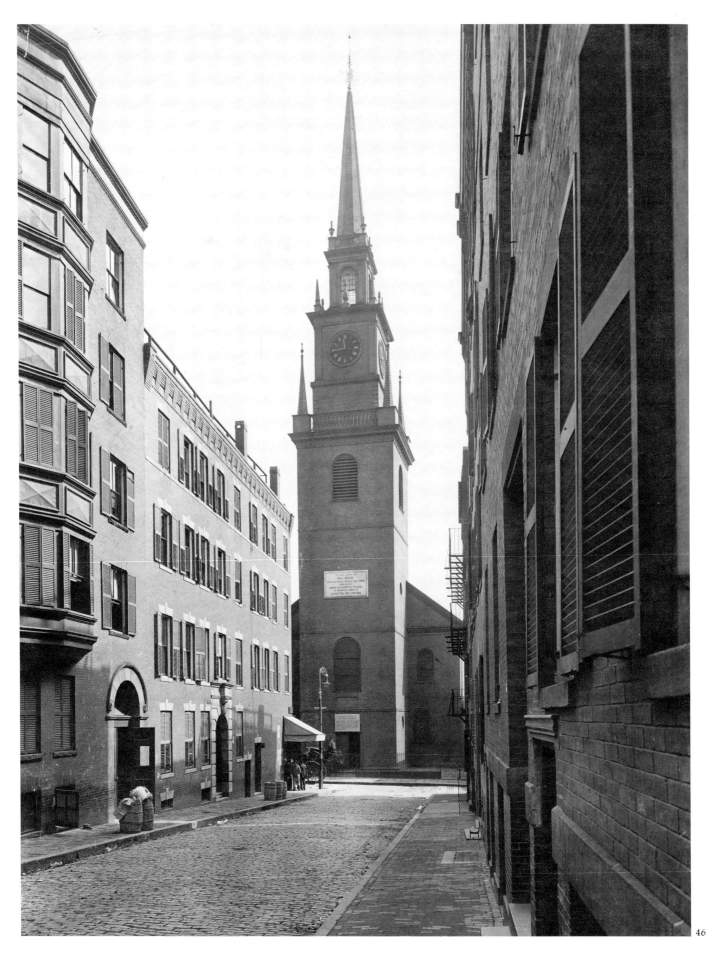

46

**46. Christ (Old North) Church, Salem Street, ca. 1903.** One example of a Boston landmark that is still an integral part of its neighborhood, Christ Church has a niche in the city's history that would be secure even without having displayed the signal lanterns for Paul Revere. Standing since 1723, it is the oldest extant church in the city. From its steeple, the highest point in the North End, British General Gage is said to have viewed his troops' attack on Bunker Hill in 1775. The steeple was lost to storms in 1804 and 1954. Its set of bells, cast in 1744, was the first set brought to America. Christ Church continues to function as an Episcopal parish.

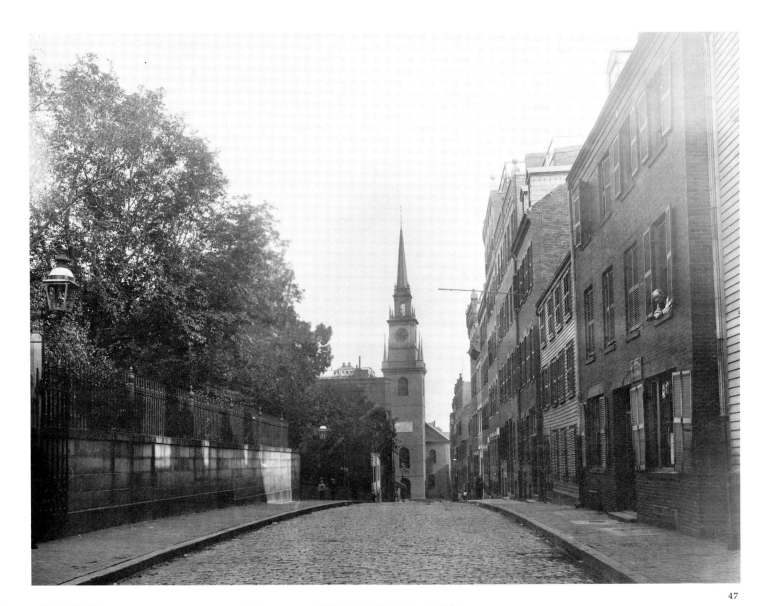

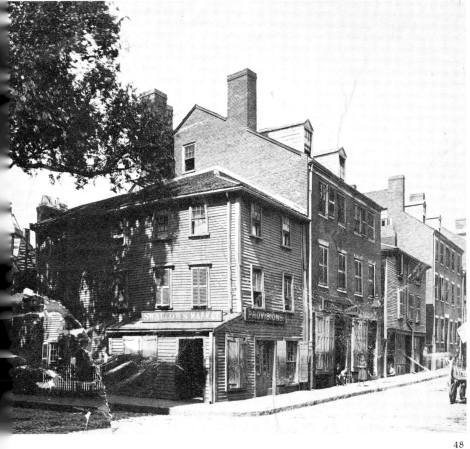

**47. Hull Street, Looking toward Christ Church, 1906.** Copp's Hill Burying Ground is on the left. Christ Church anchors one end of Hull Street, which runs over Copp's Hill toward Charlestown. Perhaps the most unappreciated of Boston's historic burying grounds, Copp's Hill contains the graves of the religious Mather family (Samuel, Cotton and Increase); sexton Robert Newman, who hung the "two if by sea" lanterns from Christ Church; Deacon Shem Drowne, whose grasshopper weathervane is a mile away atop Faneuil Hall; and William Copp himself, the original settler. Some of the houses along Hull Street date from the Revolutionary period and were used to quarter occupying British troops, but this view shows the amalgam of periods and styles common to the North End.

**48. Swallow's Market, Prince Street at Thacher Street, ca. 1870.** Despite being extremely close to downtown Boston, the North End tended to retain its insularity. A variety of buildings and services indicates the district's great age and self-reliance. Addison Swallow's grocery at the corner of Thacher Street was shaded on summer afternoons by a tree—a sturdy reminder of the less-crowded days when the North End seemed more like a village. Prince Street later became notorious as the location of the 1950 Brink's payroll robbery. The take of $2.7 million (including $1.2 million in currency) was one of the largest in American history.

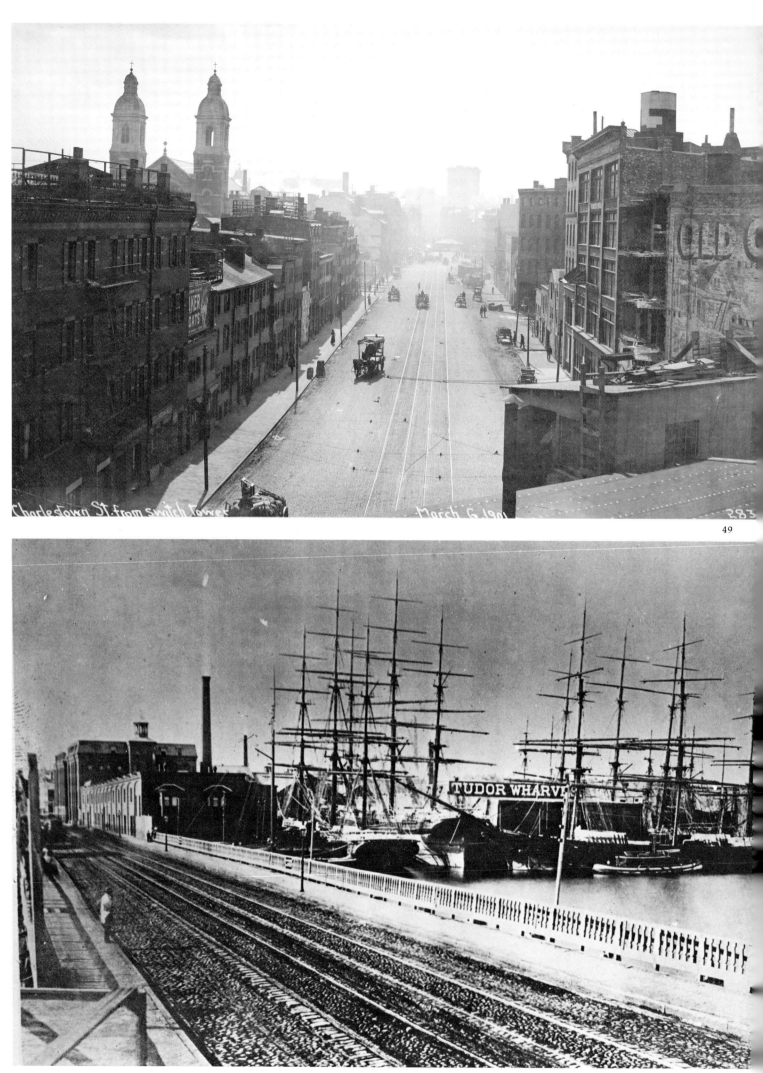

Charlestown St. from switch tower                    March 6, 1901        283

TUDOR WHARVES

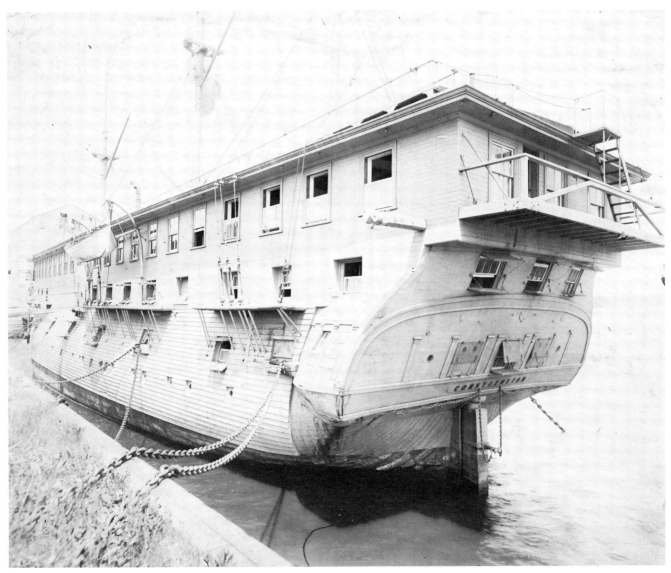

**49. Charlestown (now North Washington) Street, Looking toward Haymarket Square, 1901.** Charlestown Street was the direct route out of town heading north to the Charlestown Bridge. Unusually wide for any Boston street, its proximity to the cramped North End made it appear even larger. There was, however, no attempt at beautification—it was an avenue of commerce and purpose, not a boulevard. The twin towers of St. Mary's Catholic Church on Thacher Street rise up on the left. This view was taken from atop the elevated train structure.

**50. Charlestown Bridge, Charlestown, ca. 1874.** The first bridge out of Boston ran to nearby Charlestown, the city's closest land link and predecessor as settlement in 1630. John Hancock and others funded the bridge in 1786; upon its completion it was America's longest. Straddling the mouth of the Charles River where it flowed into the harbor, the Charlestown Bridge provided access to the towns immediately north of Boston. Later, it also provided a useful route for rapid transit—elevated trains crossed the bridge by 1901. The Charlestown Navy Yard lies just to the right of the image. Tudor and Hittinger's wharves handled part of

the vast daily traffic in and out of the harbor. Wharves were not confined to downtown Boston, but stretched around the harbor to include Charlestown, East Boston and South Boston.

**51. U.S.S. *Constitution*, Charlestown Navy Yard, 1897.** "Old Ironsides" here sits in Charlestown, directly across the harbor from its birthplace at Hartt's shipyard in the North End a century earlier. Barely recognizable and perilously close to oblivion, the *Constitution* had been towed from the Portsmouth (New Hampshire) Navy Yard, its rotten planking covered with stopgap patching. The barnlike superstructure had served as a transient barracks for seamen; the Navy had even suggested that the ship be used for target practice as a means of scuttling her. Public outcry at such an ignoble end saved the vessel, beginning its long-neglected restoration to its former glory. This was the second such reprise for the *Constitution*. Seventy years earlier, Oliver Wendell Holmes's "Aye, tear her tattered ensign down" began a poem that roused Americans to save the frigate for the first time, its epic battles against the Barbary Pirates and British men-of-war having become national legend.

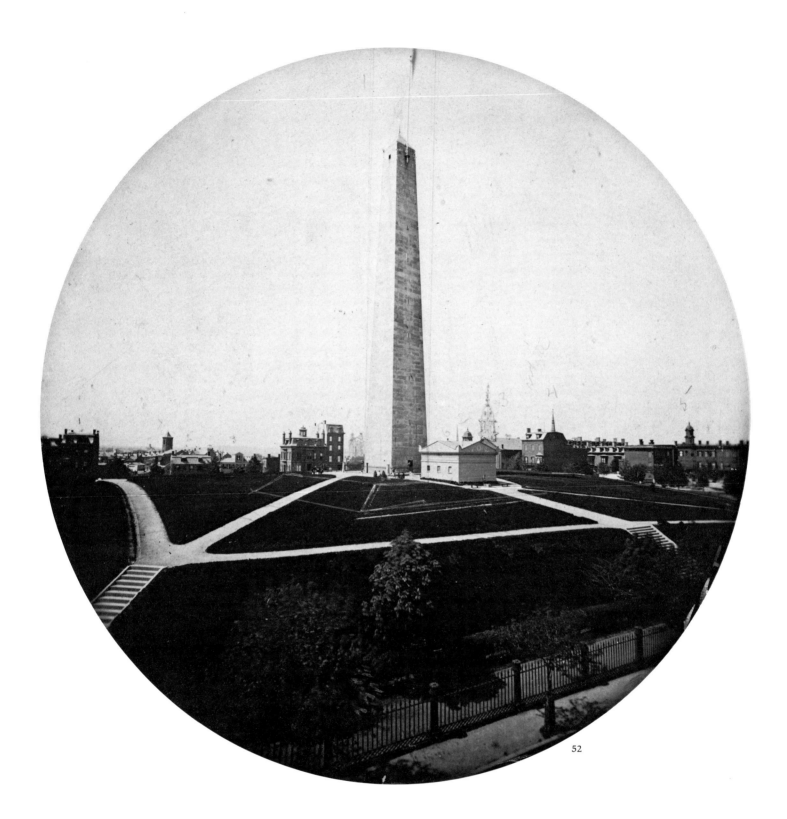

52

**52. Bunker Hill Monument, Monument Square, Charlestown, ca. 1870.** Eighteen years in the making, the Bunker Hill Monument celebrates one of America's great battles. Using nearby Quincy granite, which was shipped to Charlestown and hoisted to the summit of Breeds Hill, the 221-foot landmark (designed by Solomon Willard and built by the elder Gridley Bryant) had its cornerstone laid by the aging Lafayette in 1825 and was dedicated with a speech by Daniel Webster in 1843. The formal setting of Monument Square surrounding the park became the neighborhood for Charlestown's wealthiest inhabitants, who enjoyed an excellent view of Boston.

# Downtown

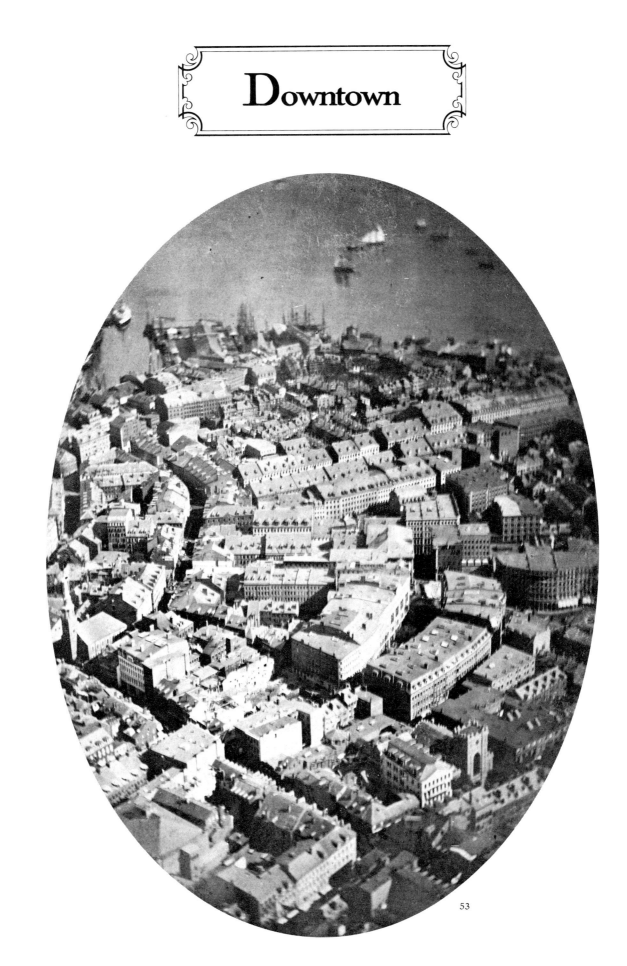

53

**53. Boston from a Balloon, October 13, 1860.** The oldest aerial photograph taken in America, this view of mid-century Boston is one of the most important images of the city ever taken. Shot by the daring photographer James W. Black, it captures much of commercial Boston that would be destroyed 12 years later by the Great Fire. The familiar Old South Meeting House at the left provides bearings. Although the buildings have changed, the paths of Boston's streets remain relatively unaltered. Milk Street, next to Old South, hooks down to the harbor, while Franklin Street in the center is recognizable by its width.

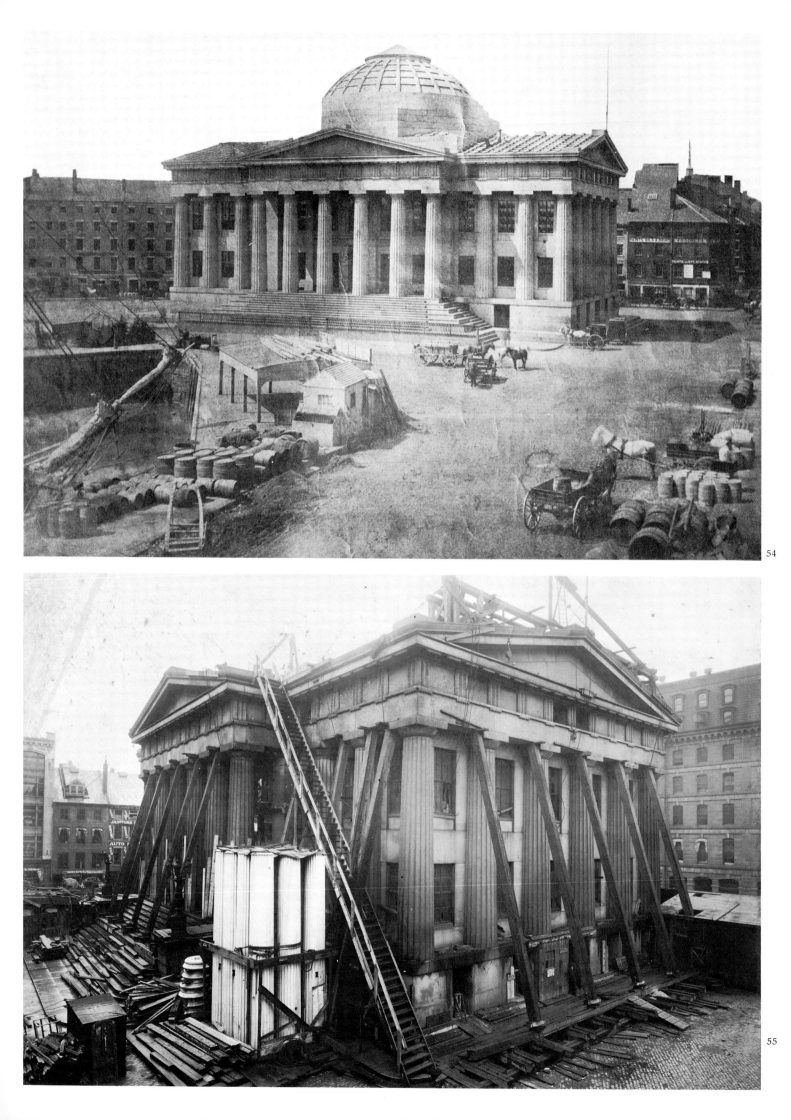

54

55

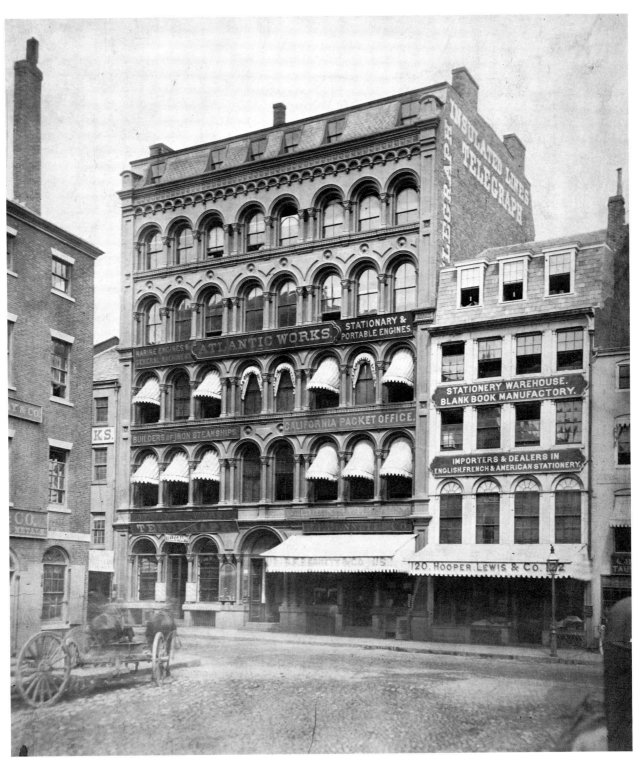

56

54. **Custom House, India Street, ca. 1850.** Before the creation of Atlantic Avenue at the harbor's edge, ships could tie up just outside the front door of Ammi Burnham Young's 1847 Greek Revival Custom House. The Hingham packet boat, an early "commuter" vessel, is berthed at the left. It predates a contemporary attempt at providing daily passenger trips for Boston's South Shore communities. On the right, State Street heads off through the financial district. The significance of Boston's wealth arriving at the docks, coming up State Street and into the pockets of wealthy businessmen along the way was not lost on Bostonians of the time, who cynically claimed that State Street's prosperity came from excess goods that slipped off wagons as they pulled away from the docks. The dome of the rotunda on the Custom House was covered by the tower built by Peabody & Stearns in 1913–15. In many ways, the original structure was more impressive.

55. **Custom House Renovations, India Street, 1913.** Surrounded by scaffoldings and props, the Custom House is readied for its renovation and the addition of the tower. The original 1847 base

was constructed on 3000 piles that support the weight of the massive granite pillars, each of which weighs 42 tons. The structure was a Federal building until it was sold to the City of Boston in 1987. Current plans project a sports museum on the bottom floors, with the tower to be developed by private real-estate interests.

56. **Richards Building, State Street, ca. 1869.** The oldest standing cast-iron building in downtown Boston, dating from about 1860, the Richards Building is more typical of New York City construction methods of the period. Architecturally significant for its early "prefab" method of construction—its facade was made in Italy and pieced together in Boston—it was also one of the city's tallest buildings for its time. Other buildings of this type were destroyed by the 1872 fire which threatened, but did not reach, State Street. Somewhat changed today, including the addition of two more stories, the Richards Building appears to have weathered the worst and it is now regarded as one of Boston's most charming office buildings.

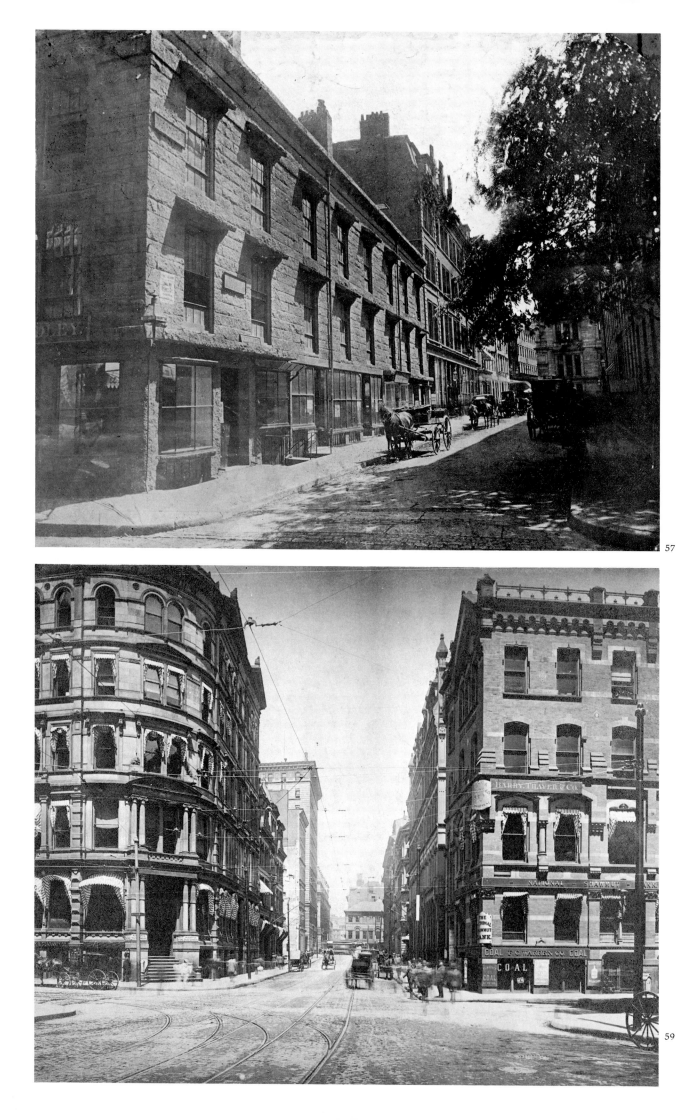

57

59

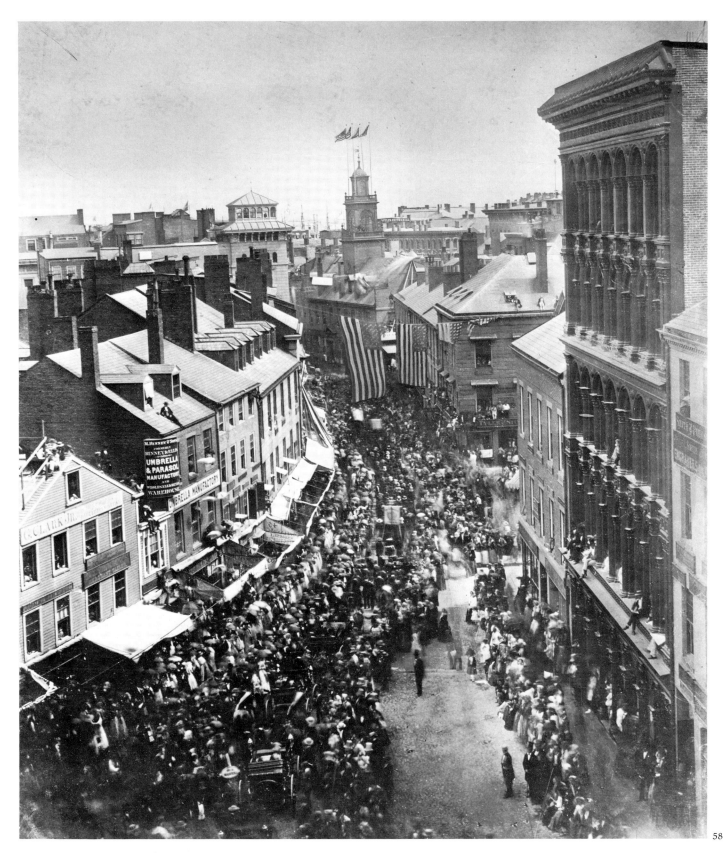

**57. Court Square, Looking from Court Street, ca. 1870.** This placid scene looking toward the rear of City Hall (right background) features one of the few trees that existed in downtown Boston outside of a public park. The Suffolk County Court House is on the right corner on the site of the current School Committee headquarters. Its successor, a massive, gloomy building built in 1886–95, obliterated many of the handsome town houses on nearby Pemberton Square. The Tudor Building (left), here looking indestructible, was demolished ten years later for the expansion of Young's Hotel.

**58. Court Street, from Scollay Square, 1856.** Boston turns out on the sesquicentennial of Benjamin Franklin's birth in a parade that leads to the dedication of his statue in front of City Hall on School Street. Flags fly from the cupola of the Old State House in the distance, its height a reminder that Boston was then a city of three-to-five-story structures. Scollay Square and Court Street are unusually well represented in early Boston views; several photographers had their studios there.

**59. Congress Street, Looking North at Water Street, 1889.** The view was taken from the edge of Post Office Square looking up Congress Street toward State Street in the heart of the financial district. The block closest to the camera marks the northernmost extent of the 1872 fire, and the architecture reflects the rebuilding that occurred immediately thereafter. Naturally, the areas adjacent to the fire were also caught up in the building boom that resulted.

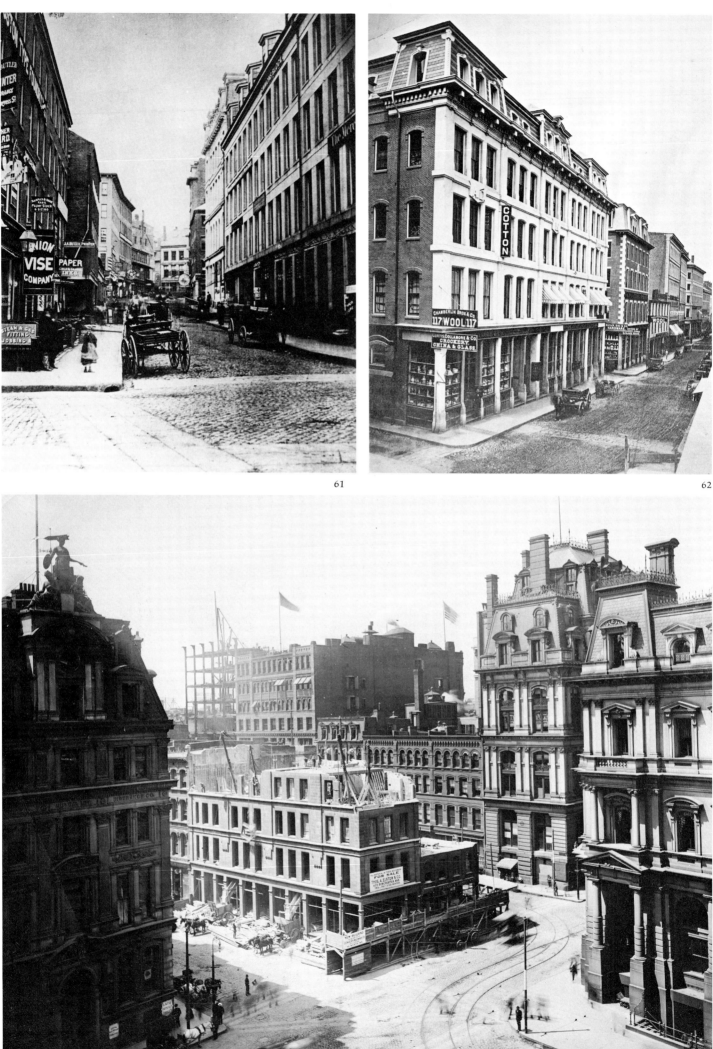

61

62

60

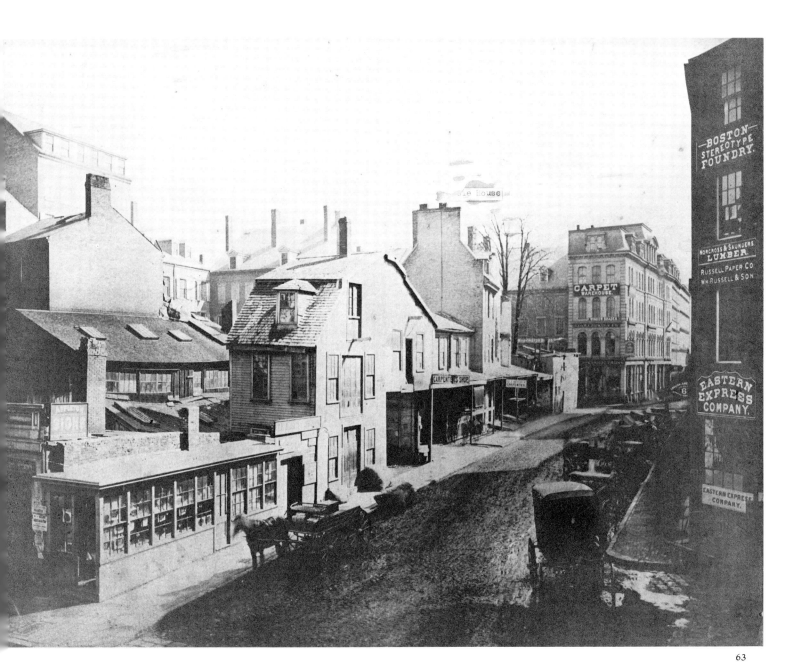

**60. Post Office Square, Corner of Congress and Milk Streets, 1903.** Some of Boston's most notable examples of Victorian architecture lined the triangular junction of Congress, Pearl and Milk Streets and surrounded the open areas of Post Office Square. The New England Mutual Life Insurance Building, on the left at the corner of Milk and Congress Streets, was designed by Nathaniel Bradlee in 1874. Combined with Arthur Gilman's Equitable Building (right center) at Federal and Milk Streets, it created an elegance of location unusual for the Boston of that period. The Post Office Square Building, under construction in the center, was named for the 1872 Alfred Mullett monument of Victorian design at the far right.

**61. Water Street, Looking toward Washington Street, ca. 1865.** The photograph was taken from the intersection of Congress Street. The buildings on the right nearest the camera were destroyed in the 1872 fire. Boston's new Post Office by Mullett rose on the left side of Water Street; its successor stands on the same site. Carriages parked at the curbside made Water Street difficult to negotiate. One-way downtown streets were still largely unknown.

**62. Federal Street, from High Street, 1867.** A textile-and-china importing center in 1867, Federal Street was five years away from a major change in its fortunes. Totally destroyed in the Great Fire, it was reborn as one of Boston's financial centers. Originally called Long Lane, it was the location of the meeting house in which Massachusetts representatives met to ratify the Federal constitution—not an easy task in a state that was bitterly divided between rural and town interests. Bostonians celebrated its passage in 1788 by changing the street name, continuing an earlier tradition that had seen the names King and Queen Streets changed to the more patriotic State and Court Streets.

**63. Devonshire Street, between Water and Milk Streets, 1870.** Although by the mid-nineteenth century Boston had fewer reminders of its past as a town, an occasional block would remain relatively untouched by progress. This group of shops, stables and houses stood on busy Devonshire Street (originally Pudding Lane). Even at the time this image was taken, it had become a prime target for development and shortly thereafter was chosen as the site of Alfred Mullett's Post Office.

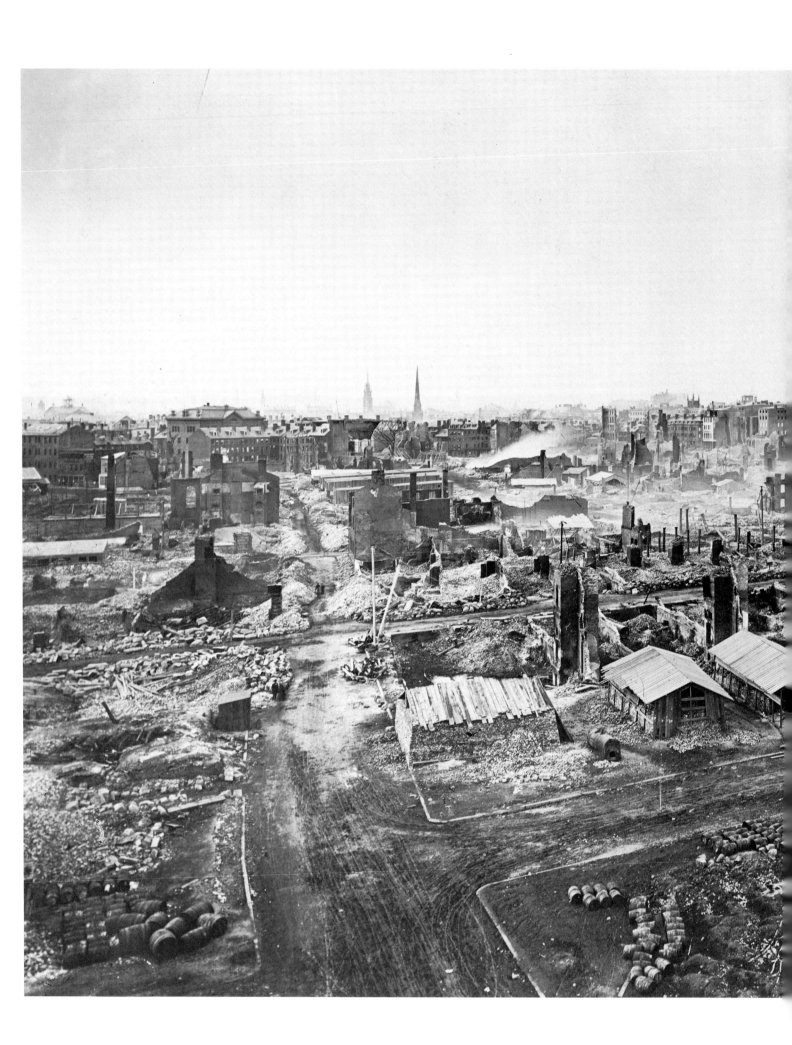

**64. Aftermath of the Great Fire, Pearl and Purchase Streets, 1872.**
So many references have been made to the devastation of the
Great Fire throughout this book that only a panorama can reveal
the damage and extent of the blaze. Sweeping from Summer
Street nearly to State Street, and from Washington Street to the
waterfront during November 9–10, 1872, the fire changed the
face of Boston as did no other event. The scene looks more like a
Mathew Brady view of devastated Richmond than the heart of a
major Union city. Bostonians began to assess their losses while
smoke still hung over the ruins. The steeple at the far right is that
of the Old South Meeting House, which was saved by the heroic
work of citizens and firemen. Just to the right of center stands the
ruin of Trinity Church on Summer Street. Trinity parishioners,
already disenchanted with their downtown location, would move
to Copley Square and H. H. Richardson's masterpiece constructed
for the congregation.

64

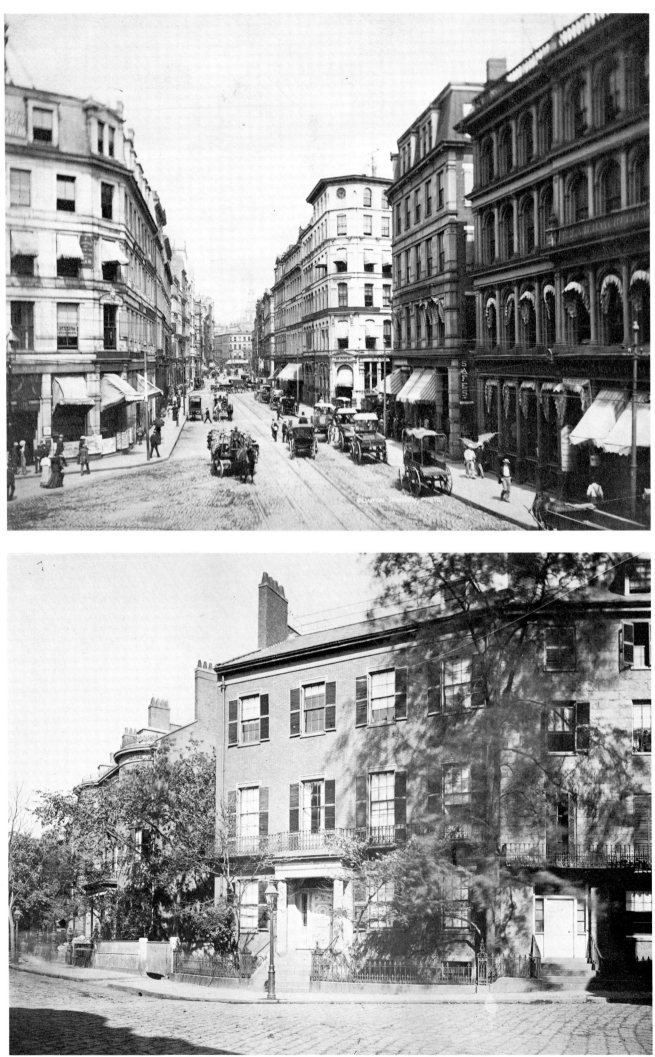

65

66

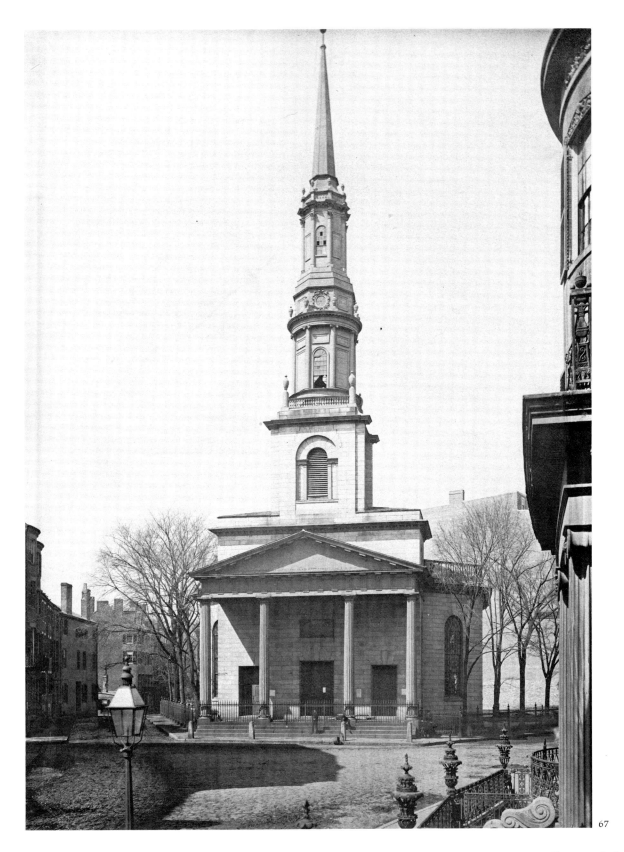

67

65. **Summer Street, from Bedford Street, ca. 1895.** The triumph of commerce is complete. After the fire Summer Street became a thoroughfare of small stores and light textile manufacturers in a row that ran to the bridge leading to South Boston. The Trinity Church congregation has moved to its new church on Copley Square, and all of the buildings in view are from the post-fire boom, which created a Boston that would remain until well into the twentieth century.

66. **Daniel Webster House, Summer Street at High Street, ca. 1860.** Summer Street is probably as typical a Boston street of the period 1850–1900 as one could find. Daniel Webster's comfortable Greek Revival home bespoke the elegant houses that dotted the neighborhood. The great orator and Massachusetts' favorite son lived here during the 1820s and 1830s. Halfway through the

nineteenth century, Summer Street was still a very fashionable location, with large homes, chestnut trees and some of the city's most prominent citizens in residence. Summer Street's closeness to the commercial pulse of Washington Street prompted businesses to move onto it. It was ground zero in the 1872 fire, which destroyed what residences were left.

67. **New South Church, Church Green, ca. 1860.** The first stone church built in Boston after King's Chapel had opened in 1754 was the Bulfinch-designed New South Church, constructed in 1814. At the junction of residential Summer Street (at right) and Bedford Street, it faced an awkward triangular space grandly called Church Green. The church did not survive the commercialization of the area and it was demolished in 1868.

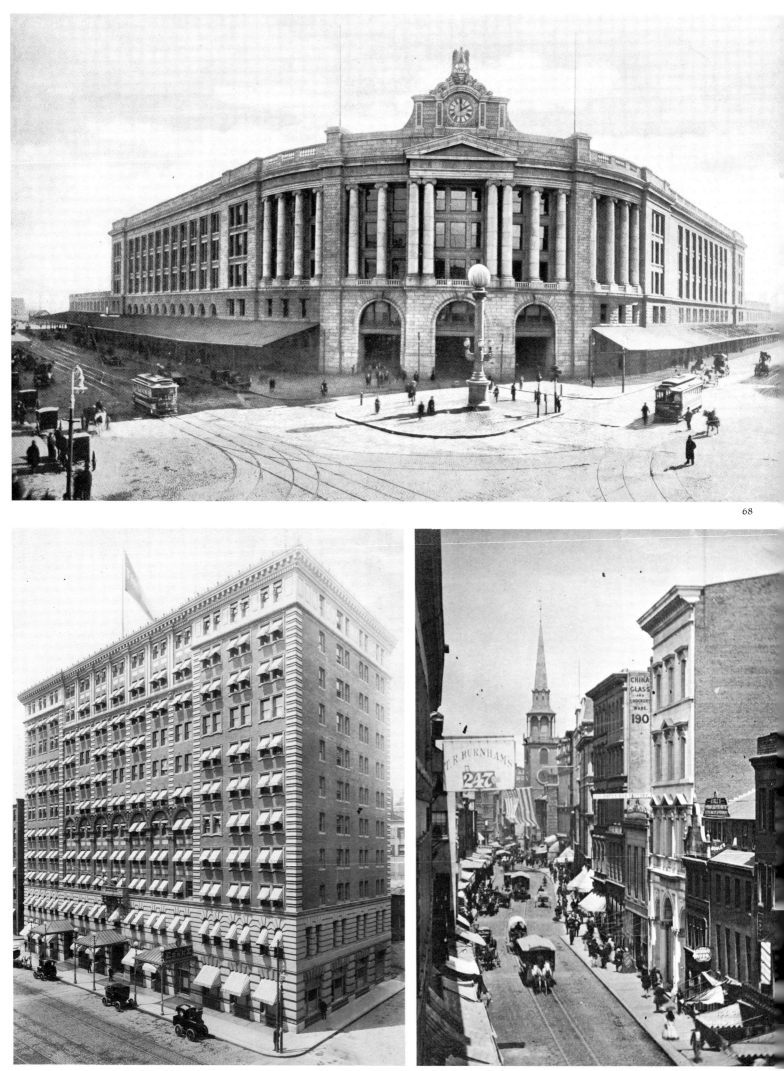

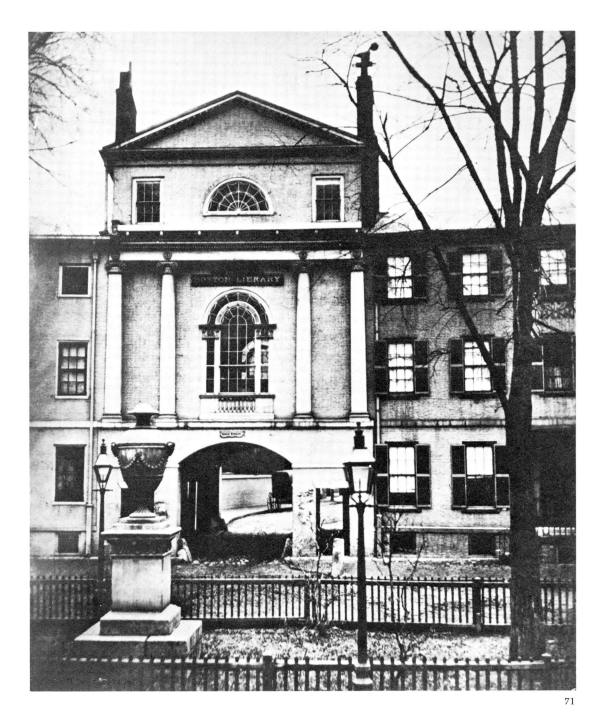

71

**68. South Terminal Station, Summer Street and Atlantic Avenue (Dewey Square), 1902.** When it was completed at the turn of the century, Boston's South Station was the world's largest and served trains running both west and south. Before its construction, railroads had had to build their own terminals, an expensive system that had proved uneconomical. This consolidation freed land elsewhere in the city for other development, most notably in Park Square. The massive building, designed by Shepley, Rutan and Coolidge, was the first of the combination train station and office buildings. Its success encouraged other construction in the nearby Leather District and Church Green/Summer Street areas. Dewey Square, named for the hero of Manila Bay, was soon transfigured by the Atlantic Avenue elevated line. The facade of the South Station remains basically unchanged, although recent renovations have totally altered the interior.

**69. Hotel Essex, Atlantic Avenue and Essex Street, 1899.** Designed by Arthur Bowditch and built in 1899 across the street from the new South Station, the Essex greeted travelers too tired or too timid to venture farther into Boston. One of the earliest steel-frame structures in the Leather District, in 1901 its facade was altered with the opening of the Atlantic Avenue elevated directly in front. The Essex declined; when it closed in the mid-1980s, it was inhabited mainly by transients and people down on their luck.

**70. Washington Street, 1864.** Boston's main commercial row, Washington Street has existed under many names. During colonial times, sections were called Cornhill, Marlborough Street, Newbury Street and Orange Street. President Washington rode along its length when entering the city in 1789, and it was eventually named for him during the visit of Lafayette to the city in 1824.

**71. Franklin Street at Arch Street, ca. 1853.** Charles Bulfinch's first and most foresighted civic project was Boston's first townhouse block. Built on a former swampy fishpond in 1794, it bankrupted Bulfinch, forcing him to treat architecture as a profession rather than approaching it as a dilettante, as he had done previously. (Originally, Bulfinch had hoped to finance the development with a tontine, a system in which shares held by partners pass from the dead to the living until the sole survivor inherits the entire amount. Although the state did not allow the tontine to be formed, the development was given the popular name of Tontine Crescent.) Arch Street passes through the center of the Crescent; the rooms above the arch were occupied by the now venerable Massachusetts Historical Society and the Boston Library Society. The enclosed central garden in the foreground, a British touch, contains a memorial urn honoring Benjamin Franklin, born a block away on Milk Street.

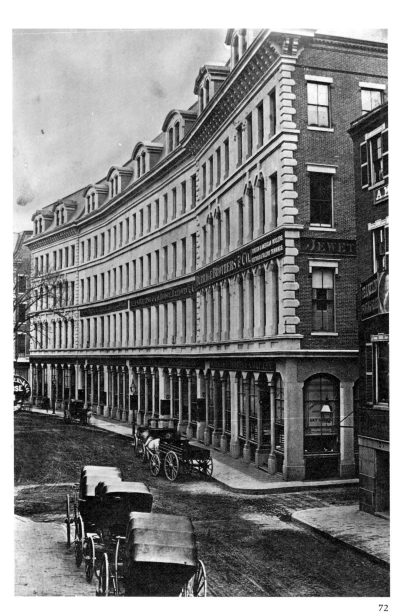

72

73

**72. Franklin Street from Hawley Street, 1860.** Despite Bulfinch's reputation today as America's first great architect, his work was not always appreciated in his hometown. Both of his great designs for urban living, the Tontine Crescent and Colonnade Row on Tremont Street, did not survive for long. The Tontine Crescent was destroyed in 1858 as the street took on a commercial cast, and the Tontine was replaced by Gridley J. F. Bryant's block, which remained true to Bulfinch's curve. Despite their appearance of permanence, these buildings came down in the 1872 fire.

**73. Boylston Market, Washington Street at Boylston Street, ca. 1882.** Another Bulfinch building, the Boylston Market was the

South End's counterpart to Faneuil Hall at the other end of town. Like Faneuil Hall, it featured a public auditorium upstairs. It was used for musical performances, lectures and school drills. When the building was constructed in 1809–10, it was considered to be on the outskirts of town, and Boylston Market provided an anchoring building for business and residential development along that section of Washington Street. Today its location is in the center of the notorious "Combat Zone," an adult-entertainment district that flourished during the 1970s. Boylston Market was taken down in 1888.

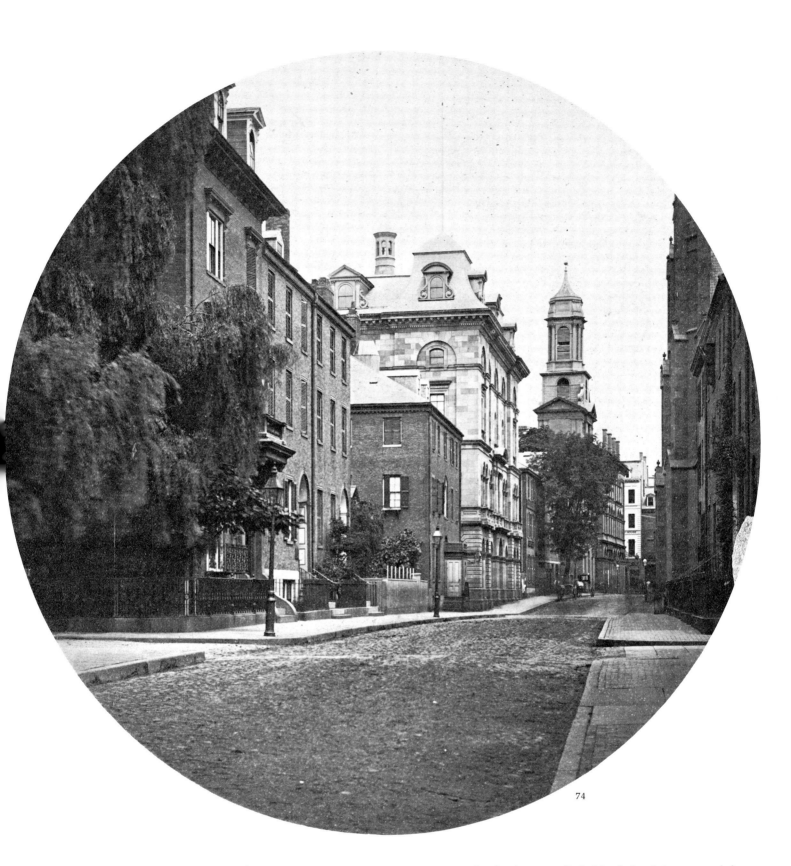

74

**74. Chauncy Street, 1860.** A decidedly unremarkable street today, Chauncy Street was a fashionable residential district with a distinctly British flavor. The tower of Asher Benjamin's First Church is prominent. It had been built in 1808 and housed the congregation until the move to Back Bay later in the century. The Chauncy Hall School is partially hidden behind the tree and the Massachusetts Charitable Mechanics Assocation building is the large structure in the center. It was vacated in 1881 when Mechanics Hall opened on Huntington Avenue.

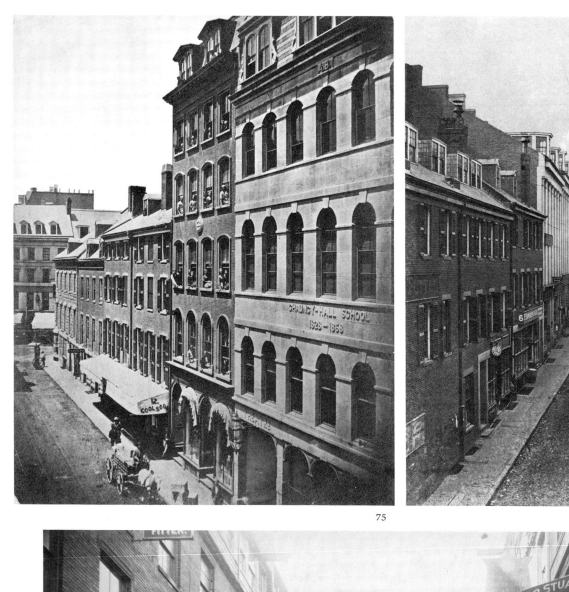

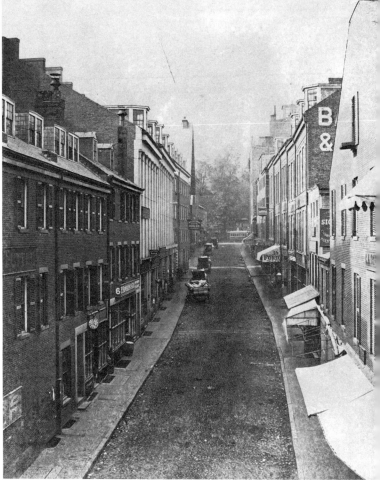

75

76

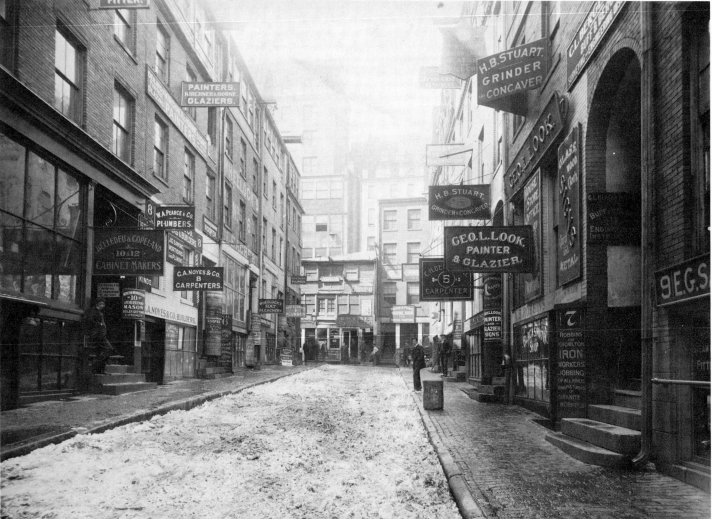

77

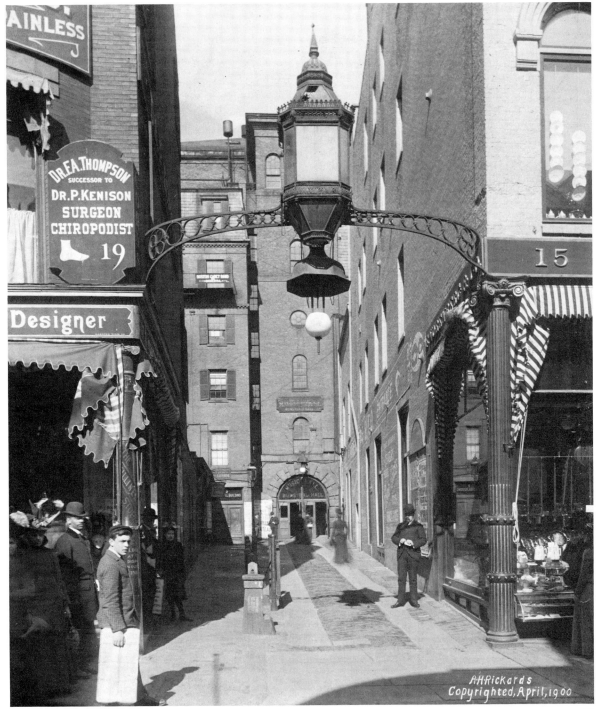

78

**75. Essex Street, Looking North toward Washington Street, ca. 1870.** Evidently the opportunity to be photographed has lured most of the work force to the window on a sunny summer day. The progression in height of the Essex Street buildings marks the push of commercial structures moving south from Washington Street. The corner of Washington and Essex was a gathering spot for Boston's patriots prior to the Revolution, and the location of the Liberty Tree. According to legend, when the tree was chopped down by occupying British soldiers, its falling branches killed two of the axmen in a final patriotic act of defiance. The Chauncy Hall School, at the right, was an early private school in the city, dating to 1828. It moved to the Back Bay in 1873.

**76. Bromfield Street, 1859.** One of the vital "ladder" streets connecting Washington and Tremont Streets, Bromfield Street was a locale of printing and publishing shops, small garret lofts and tiny shops offering a variety of services. A Tremont Street horsecar passes in front of the Old Granary Burying Ground at the end of the street. The Bromfield House, one of Boston's oldest hotels, sits midway down the block on the left. Although the Bromfield House has long been a memory, much of the block remains relatively unchanged.

**77. Province Court, 1899.** A wonderful testimony to free enterprise greeted the turn-of-the-century visitor to tiny Province Court, which made up in signage what it lacked in length. A one-block-long dead end off narrow Province Street, it provided services and employment to many and was indicative of just what could be found in the back streets of the city. Nearby was the site of the Province House, the official home of the British Royal Governor prior to the Revolution.

**78. Music Hall Place Entrance to the Boston Music Hall, 1900.** Boston's leading public auditorium during the late nineteenth century was designed by George Snell and built in 1852. With admirable Yankee frugality, the Music Hall was constructed at the end of two alleyways, thereby eliminating the necessity for elaborate external decoration around the whole building. On its stage the Boston Symphony Orchestra first performed in 1881. Such luminaries as Emerson, Jenny Lind and Booker T. Washington also appeared here.

**79. Music Hall Entrance, Hamilton Place, 1896.** As befitting an entrance to a temple of culture, Hamilton Place contained several book, print and music shops. The B.S.O. left for the wilds of Huntington Avenue in the Back Bay at the turn of the century, and Bostonians know the Music Hall today as the Orpheum Theatre, which had undergone an interim conversion as a motion-picture palace.

**80. Winter Street, Looking toward Summer Street, ca. 1860.** The intersection of Washington, Winter and Summer Streets, Boston's busiest a century later, is rather placid in this view. Upstairs residences proliferate along Winter Street, then as now a locale for small stores. In the distance the original Trinity Church (built in 1829) can be glimpsed on Summer Street.

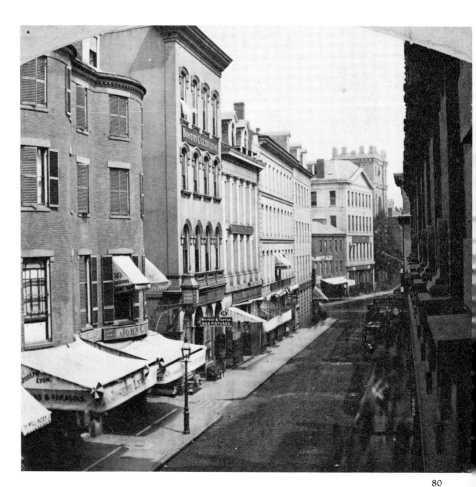

80

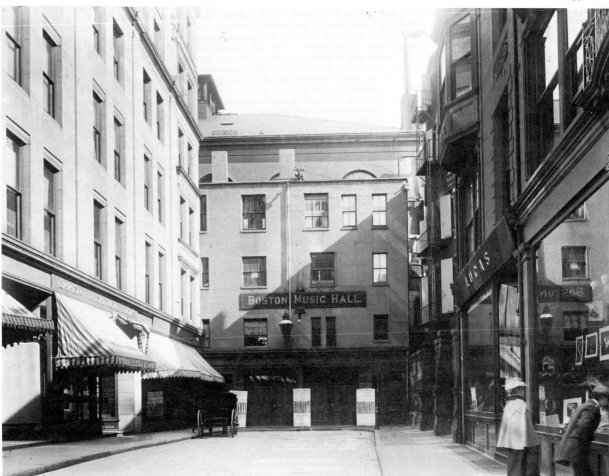

79

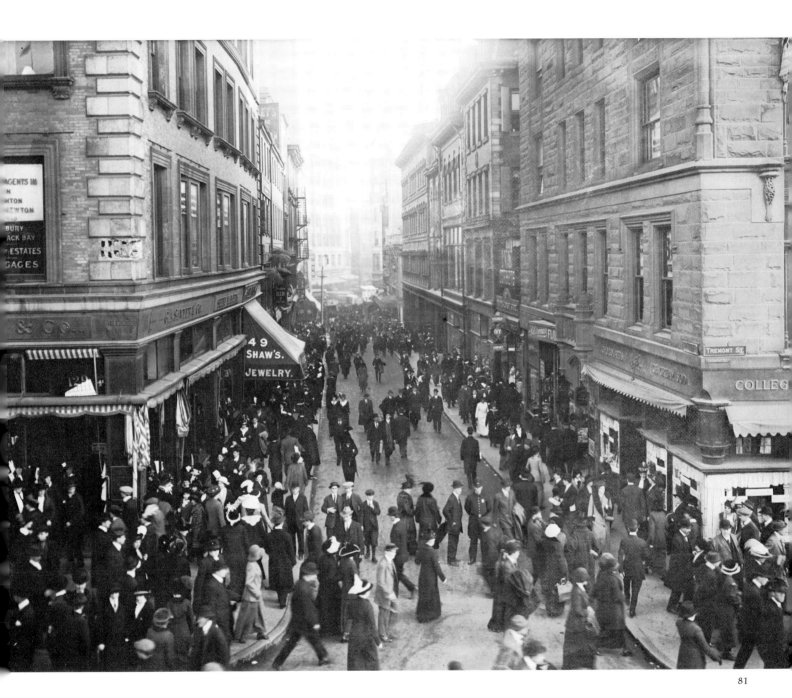

**81. Winter Street, from Tremont Street, 1913.** Moving half a block back, and ahead a half-century in time, the difference between this view of Winter Street and the previous one helps illustrate the commercial change wrought during the late 1800s. Boston's Downtown Crossing pedestrian mall was not officially instituted until the 1970s, but no one has ever accused local jaywalkers of being timid. Winter Street's trade appealed to both sexes: it was a leading neighborhood for ladies'-clothing shops, while Boston's bastion of male dining, Locke-Ober's restaurant, is in an alley halfway down the right-hand block.

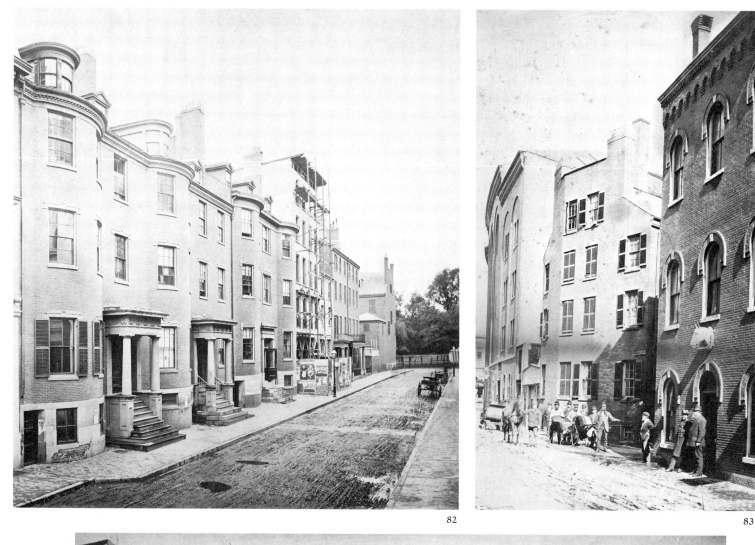

82

83

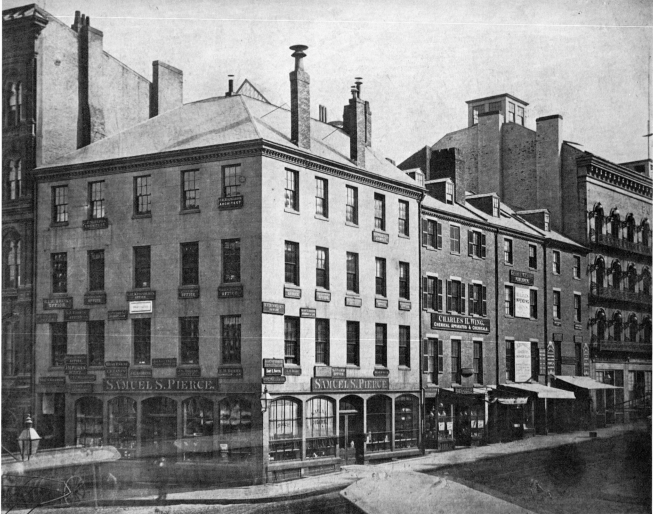

84

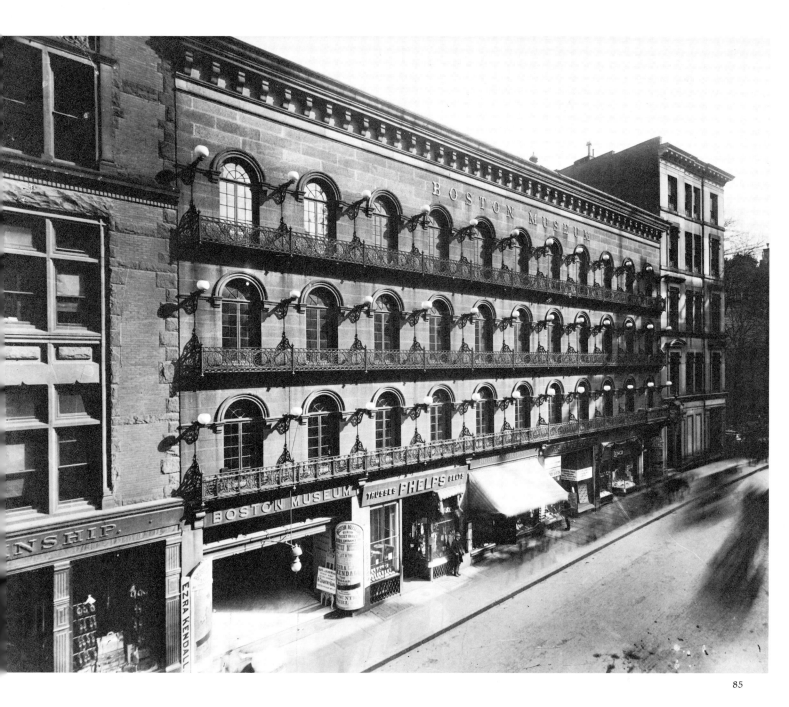

**82. Temple Place, ca. 1865.** One of the several block-long streets running between Washington and Tremont Streets, Temple Place was a well-to-do residential neighborhood in the 1860s. Its proximity to the stores of Washington Streets and the sylvan Boston Common made Temple Place a sought-after location for those downtowners unwilling to move to the Back Bay. Its name was changed to Autumn Street in 1865 in an effort to fill in the seasons (Winter and Summer Streets were a block away) but was changed back to Temple Place a week later, after its residents objected.

**83. Mason Street, 1867.** Mason Street runs parallel to Boston's two busiest streets, yet it managed to remain relatively tranquil, being used as a service road for Tremont and Washington Street establishments. As a result of the necessity to quarter horses and carriages in the city, Boston's earliest "garages" were located on convenient side streets such as Mason. Workers at Nims's stable at the right (under the horse's head) display sleighs that have been repaired or stored. The stage entrance to the massive Boston Theatre on Washington Street is visible on the left. Nearby entertainment palaces were also good sources of customers for the stables.

**84. Tremont Street at Court Street, 1856.** One of Boston's most famous and varied streets began at Scollay Square. Its name had

earlier appeared as Tra Mount, Trimount, Trimountain, Treamount and Tremount—all variations of an early name for Boston. It passes historic cemeteries and churches, runs alongside the Boston Common, becomes the main street of the South End district and a principal roadway in and out of town. America's first subway runs below it for several blocks downtown, and Tremont Street provides a straight road to Lower Roxbury, before it winds up near the hospital complex at Huntington Avenue. Samuel S. Pierce outgrew this corner grocery store in later years, the firm of S. S. Pierce becoming Boston's leading provisioner catering to the well-to-do. The name still exists as a food wholesaler to commercial eateries.

**85. Boston Museum, Tremont Street, ca. 1900.** Just up Tremont Street from Scollay Square stood the Boston Museum, where plays were produced for more than 50 years. With perfect Bostonian logic, the building was called a museum to reassure patrons reluctant to patronize something as vulgar as a theater. "Many of the habitués of the Boston Museum," wrote Kate Ryan, "fondly believed they were not attending a regular playhouse." Built in 1846 and designed by Hammatt Billings, it seated over 1200 people at prices that ranged, in the 1880s, from 35 cents to a top ticket of one dollar. It was torn down for a business block in 1903.

**86. Temple Place at Tremont Street, ca. 1860.** The elaborate Masonic Temple that stood at the corner facing the Boston Common prompted the street's name. After the Masons moved down to Boylston Street and newer quarters, the building became the Federal Court House. A part of Saint Paul's Episcopal Cathedral, an 1820 Alexander Parris building, is visible on the left.

**87. Colonnade Row, Tremont Street near West Street, ca. 1850.** It is difficult to understand the short life span of Colonnade Row, considered by some to be Charles Bulfinch's greatest work. In 1817, cultural savant Shubael Bell described the Row as "grand, uniform and chaste," and avowed that it was "surpassed by nothing of its kind . . . in the United States." Built in 1812 as a real-estate investment project (by 1813 fewer than half of the 19 units were in the hands of their original owners), its uniform height and style at the beginning created a unique expanse bordering on the Common, and the Row was quickly inhabited by some of Boston's best families. By the time this view was taken, many of the facades had been altered and the Row was in decline. Torn down in 1855, it was replaced with a variety of offices, stores and undistinguished buildings. The face of Tremont Street was irretrievably changed. A student of Boston's history could not overestimate the importance of Bulfinch's great plan for urban housing, both historically and architecturally.

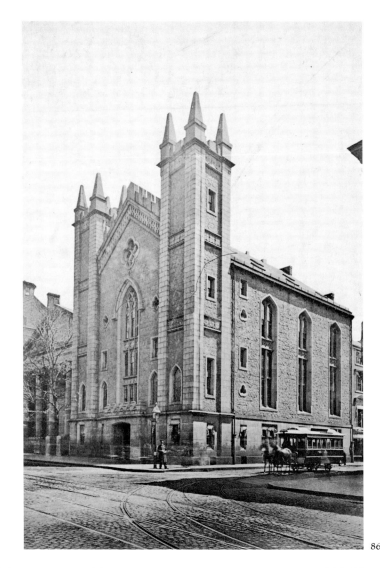

86

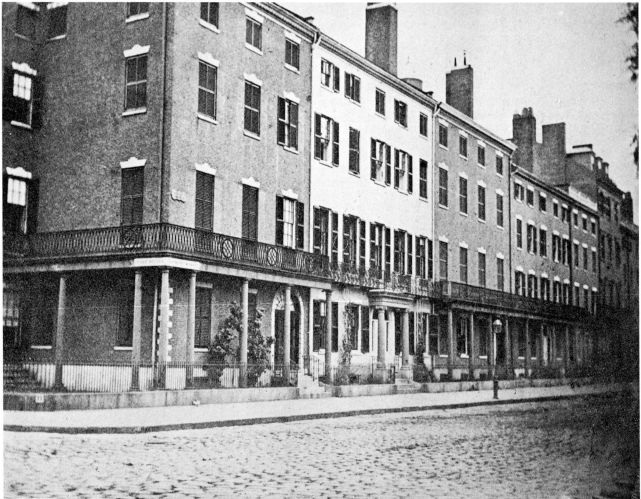

87

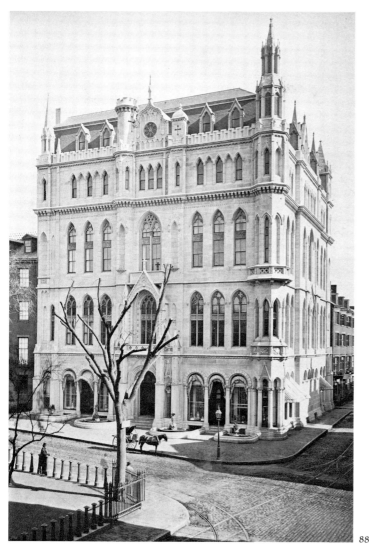

**88. Masonic Temple, Tremont Street at Boylston Street, 1868.** The newly dedicated Masonic Temple, designed by Merrill Wheelock, gleams in the sun at the uncharacteristically sleepy corner of Boylston and Tremont Streets. Constructed in an elaborate Neo-Gothic style that was not repeated elsewhere in downtown Boston, the building lasted until 1899. The lot is still owned by the Massachusetts Grand Lodge; another Temple commands the corner today.

**89. Hotel Pelham, Tremont Street at Boylston Street, ca. 1860.** Built in 1857 at a key corner of Boston Common diagonally across from the Central Burying Ground, the Hotel Pelham, not a hotel at all, was what has been called the first apartment house in the East. All of its suites were flats, and the novelty of such an arrangement proved an enormous success. Its French-inspired design by Alfred Stone paved the way for other similar designs in the city. In 1869 the building was slid off its foundation and moved westward 30 feet to accommodate the widening of Tremont Street. Today the corner is the site of the Little Building.

88

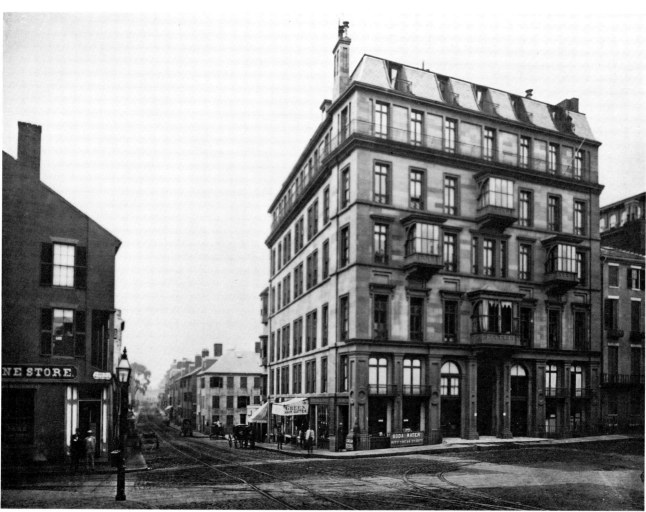

89

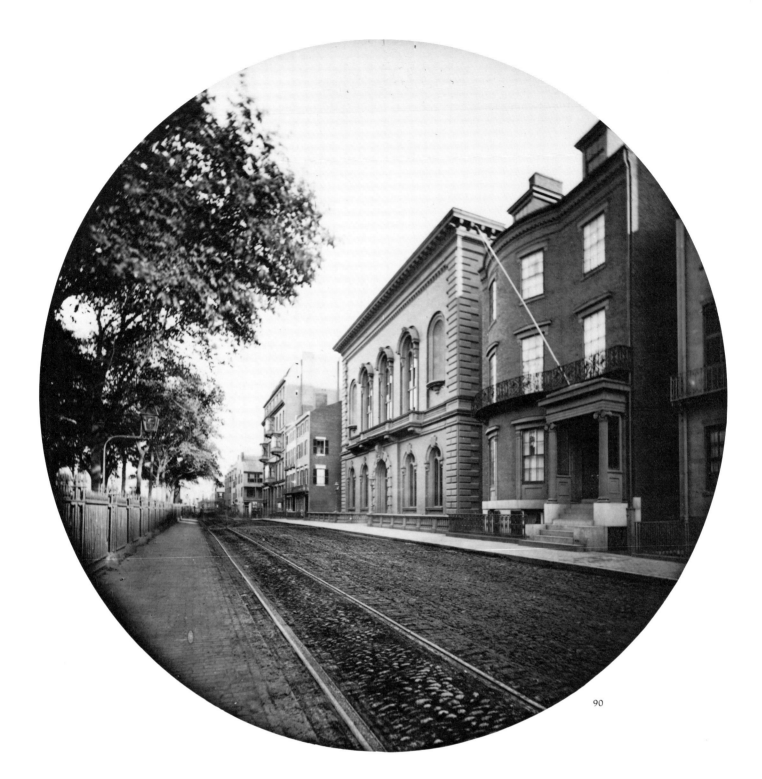

90

**90. Boston Public Library, Boylston Street, 1870.** After only four years on nearby Mason Street, in 1858 the Public Library moved to more spacious quarters facing the Boston Common (left) on the present site of the Colonial Theatre. Charles Kirby's design incorporated separate reading rooms for men and women, "although the high standard of decorum among users of the library made such segregation of the sexes unnecessary," according to historian Walter Muir Whitehill. Midgely's *Guide to the Stranger* (1858) reported that "the library contains thirty three thousand volumes and is *free* to all of good reputation residing in the city." British author Matthew Arnold, observing a barefoot newsboy reading quietly in a public room, was moved to observe, "I do not think that I have been so impressed with anything else that I have seen since arriving in the country." The next stop for the oft-moved Library would be Copley Square.

**91. Tremont Street at Eliot (now Stuart) Street, 1869.** After passing the Hotel Pelham and heading south, Tremont Street dropped in grade and was also diminished in the style of neighborhood. It became more working-class, more Irish and more susceptible to change in the early twentieth century. At the Eliot Street intersection there was no indication of the theater district that flourished there a century later, by which time its name had been changed.

**92. John Crane House, Tremont Street, ca. 1896.** As the twentieth century drew near, Boston streets presented an interesting amalgam of new and old, with early steel-skeletoned skyscrapers close by wooden buildings that dated, in some cases, to colonial times. Although the streets of the North End retained their quaintness longer, no one section of downtown had a monopoly on the older structures. The General John Crane house on lower Tremont Street near Hollis Street, set perpendicular to the heavily trafficked roadway, is an example of a building that had outlived its time. Crane, a Son of Liberty, was knocked unconscious by a falling tea chest during the Boston Tea Party. Left for dead under a nearby pile of wood shavings, he recovered and served with distinction during the Revolution as a general. Today the Shubert Theatre occupies the site of his house.

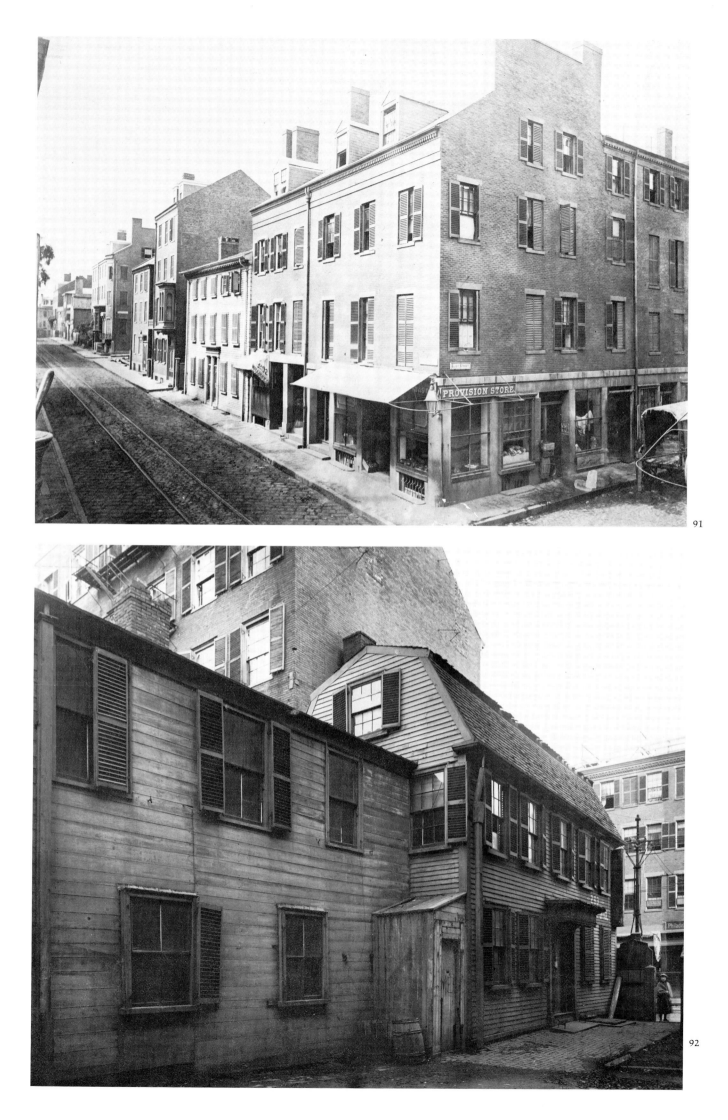

91

92

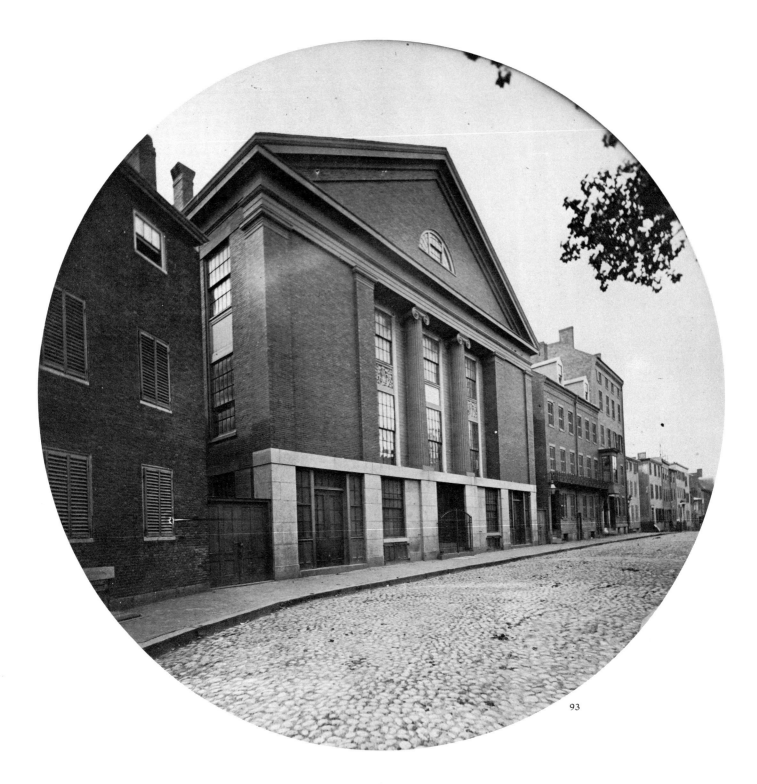

93

**93. Fifth Universalist Church, Warrenton Street, ca. 1868.**
Originally built in 1839 as a Universalist church, this versatile
Asher Benjamin building also served as a synagogue for Boston's
first Jewish congregation and a Scotch Presbyterian house of
worship. It was designed with street-level shops to provide
income for the parish. Still standing today, it has become familiar
to present Bostonians as the Charles Playhouse—the most recent
example of a religious building's adaptation for entertainment
functions.

**94. Boston, from Cambridge, 1864.** The West Boston bridge was
opened in 1793. It and its successors, including the current 1907
Longfellow Bridge, which is located at approximately the same
location, have provided the quickest route to Cambridge and
Harvard Square from Boston. When frozen, the Charles River
provided another means of crossing. On the Boston shoreline are
(from left to right): the Massachusetts General Hospital (the light
building on the far left), followed by the outline of the Charles

Street Jail. To the right of the bridge sits the Massachusetts Eye
and Ear Infirmary, and the large octagonal structure to its right is
the "gasometer" (gasworks) of the Boston Gaslight Company.
The dome of the State House crowns Beacon Hill, and the First
Baptist Church is indicated by the large steeple above the
gasworks.

**95. Canal Street Incline, 1908.** Transportation, both local and
long-distance, is the theme of this view of Boston under construc-
tion. Taken by an intrepid cameraman leaning over the elevated
structure, it shows the Canal Street trolley loop being built. Canal
Street (left) leads to Causeway Street and the grandiose Union
Station, whose arched entrance is partially visible. Designed by
Shepley, Rutan and Coolidge and opened in 1893, it was the
forerunner of the present North Station/Boston Garden complex.
The elevated station survived a bombing in 1959 and remained
until the mid-1970s.

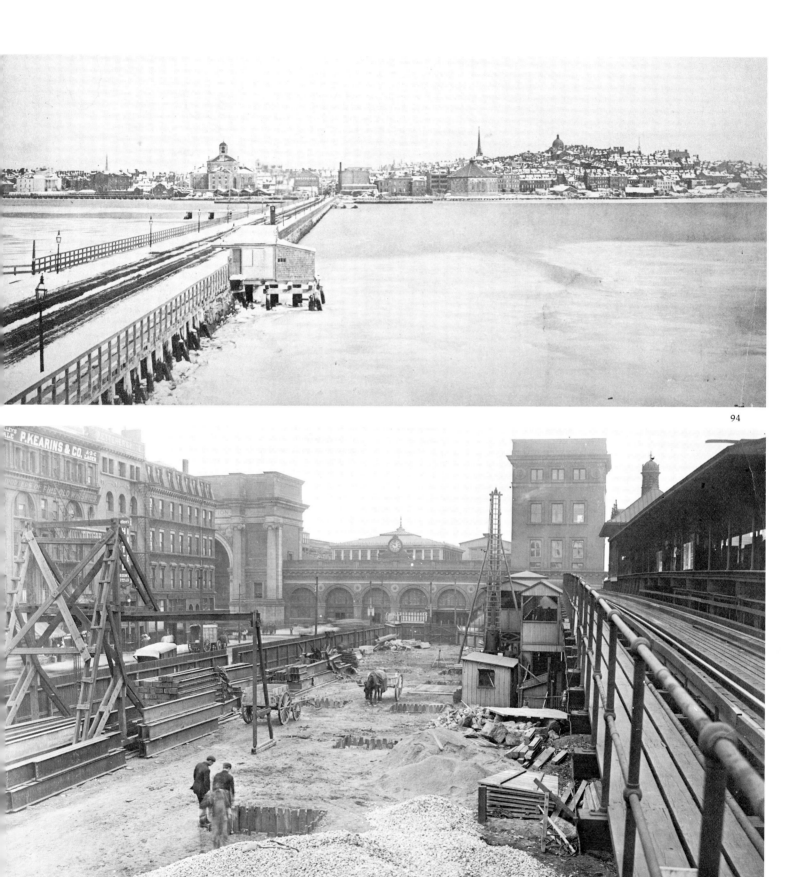

94

95

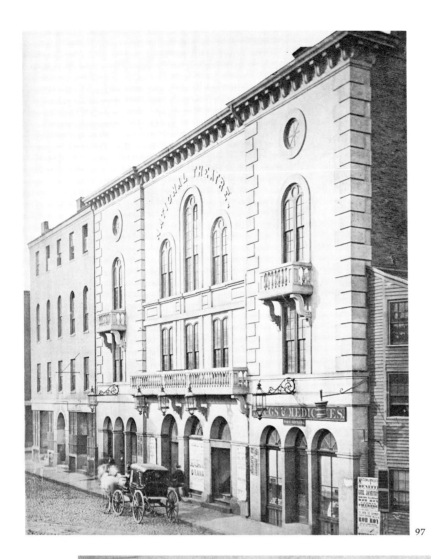

**96. Charlestown (now North Washington) Street, Haymarket Square, 1867.** These sturdy granite structures were typical of the massive manufacturing and warehouse blocks built near the waterfront in the mid-nineteenth century. Craftsmen in wood created a strong New England market for locally made furniture in an industry that did not head south until the 1920s. Seemingly indestructible, this block was lost to Central Artery highway construction after World War II. The truncated street that remains is now called North Washington Street, although it does not connect to Washington Street itself.

**97. National Theatre, Portland Street, ca. 1860.** Designed by Joseph Billings and Fred Sleeper and erected in 1852 on the site of a previous National Theatre, the new National had a life span of little more than a decade. According to theater historian Donald King, it seated over 2400 patrons and had a 38-foot-high proscenium. But its location near Haymarket Square was removed from other entertainments, and it was not rebuilt after being destroyed by fire in 1863.

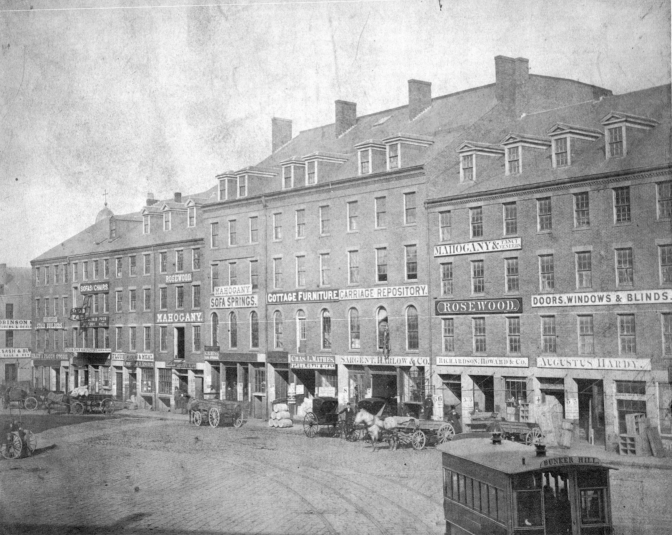

# Beacon Hill

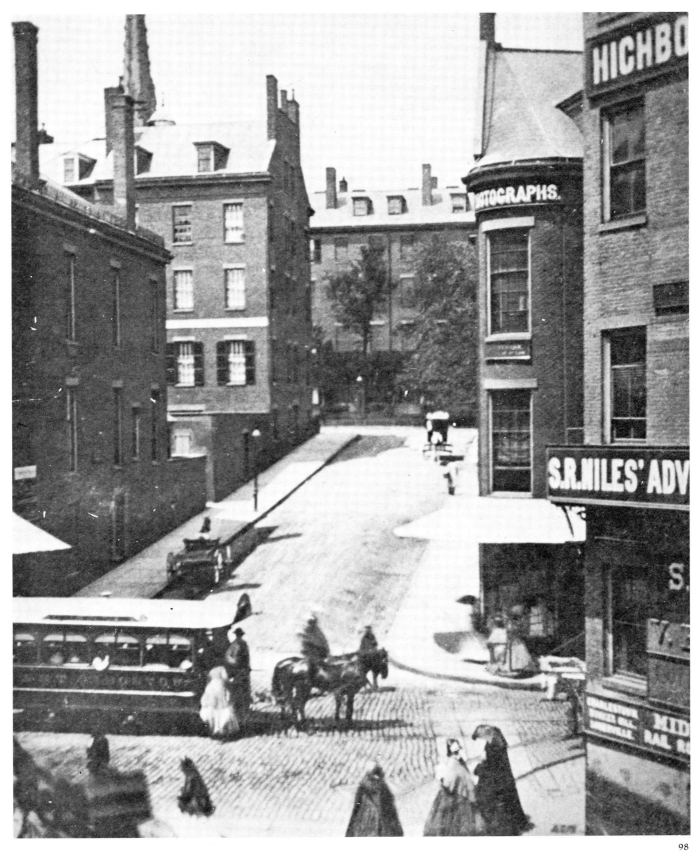

98

**98. Looking toward Pemberton Square, Scollay Square, ca. 1860.**
Although only one short block from teeming Scollay Square, Pemberton Square was a "tranquil oasis" and Beacon Hill's eastern

mate to Louisburg Square. The original Scollay Building is at the far right, and the corner of Tremont Row (with the upstairs photographic studio) can be seen.

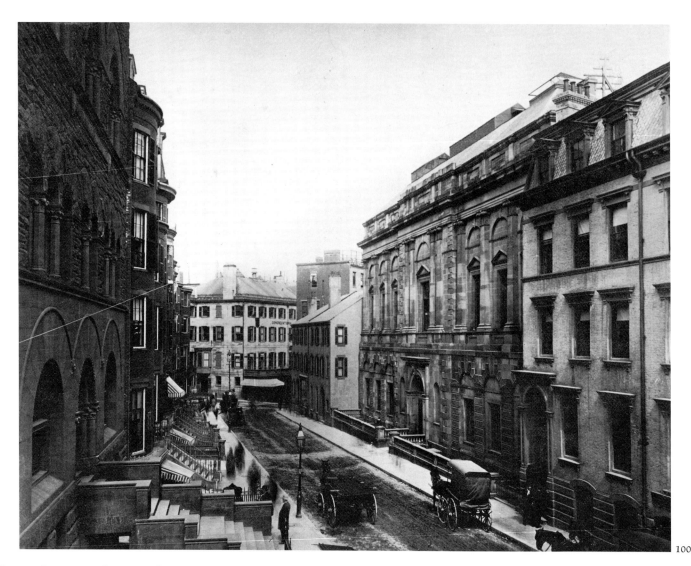

100

**99. Pemberton Square, Looking South, ca. 1875.** At the top of
the hill the change was remarkable. Built from the Gardiner
Greene estate, which had occupied the eastern slope of Beacon
Hill, Pemberton Square was intelligently designed by Patrick
Jackson and represented the best of Boston's residential squares.
Quickly settled by wealthy Boston merchants, it became one of
the city's more notable addresses. Today its site is an open plaza
between the front of the Suffolk County Court House (built in
the 1880s) and the rear of Center Plaza, erected 80 years later.
Pemberton Square's quiet charm and proximity to commercial
Boston makes its loss all the more painful.

**100. Beacon Street, from Bowdoin Street to Somerset Street,
1889.** Today, immediately east of the State House, Boston's
business section interrupts what was once a residential street. In
the nineteenth century, brick row houses predominated as
Beacon Street began its eastward descent to its connection with
School Street. The Boston Athenaeum, still a landmark of
culture and refinement, is set back slightly on the right.
Designed by Edward Clarke Cabot in 1847 and expanded by
Henry Forbes Bigelow in 1913-14, it had moved from Pearl
Street downtown. A private subscription library with an unpar-
alleled collection of historical volumes, it houses much of George
Washington's private library and, strangely, a leading collection
of Confederate documents.

**101. Somerset Street, from Howard Street, 1884.** Morning
sunlight plays down Somerset Street on the east side of Beacon
Hill. Part of the area to the left, adjacent to Pemberton Square,
had since been cut down and used to fill in the North Station area
near Causeway Street. The Somerset Street Baptist Church
(center) with its 200-foot spire was built in 1853, but by the time
this picture was taken, the congregation had moved to Com-
monwealth Avenue in the Back Bay.

99

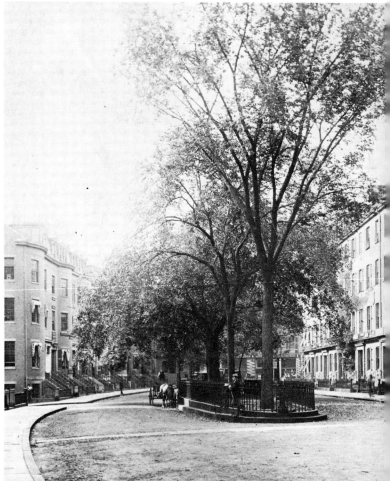

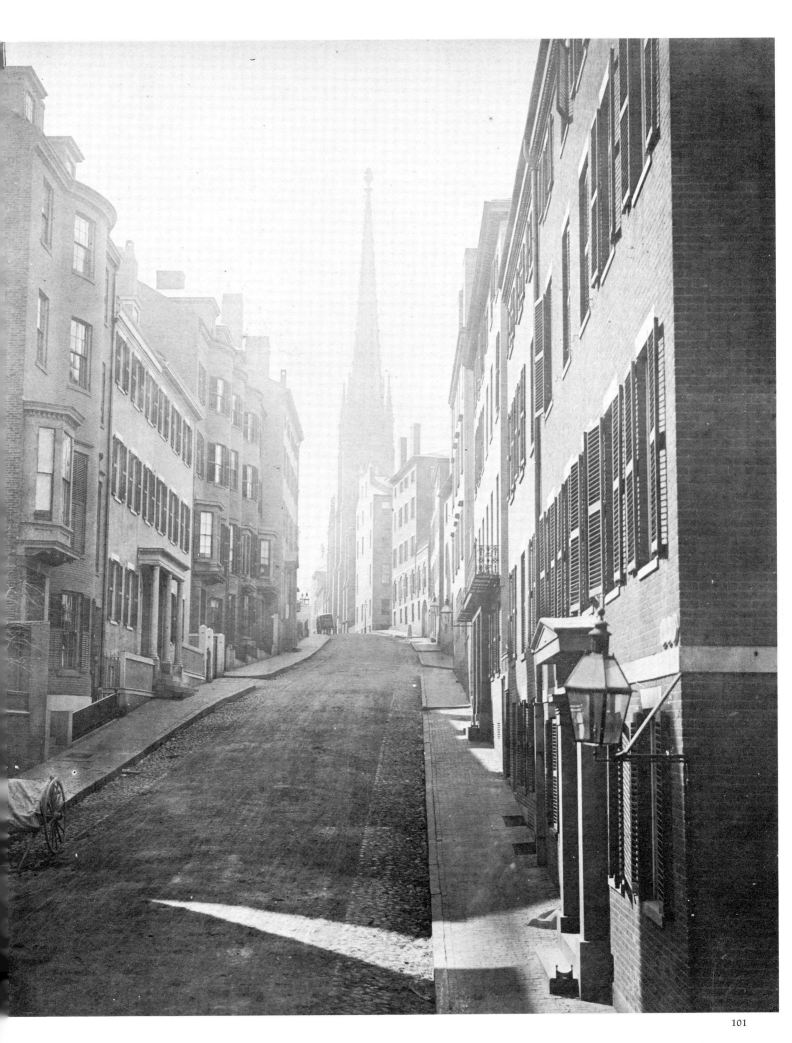

101

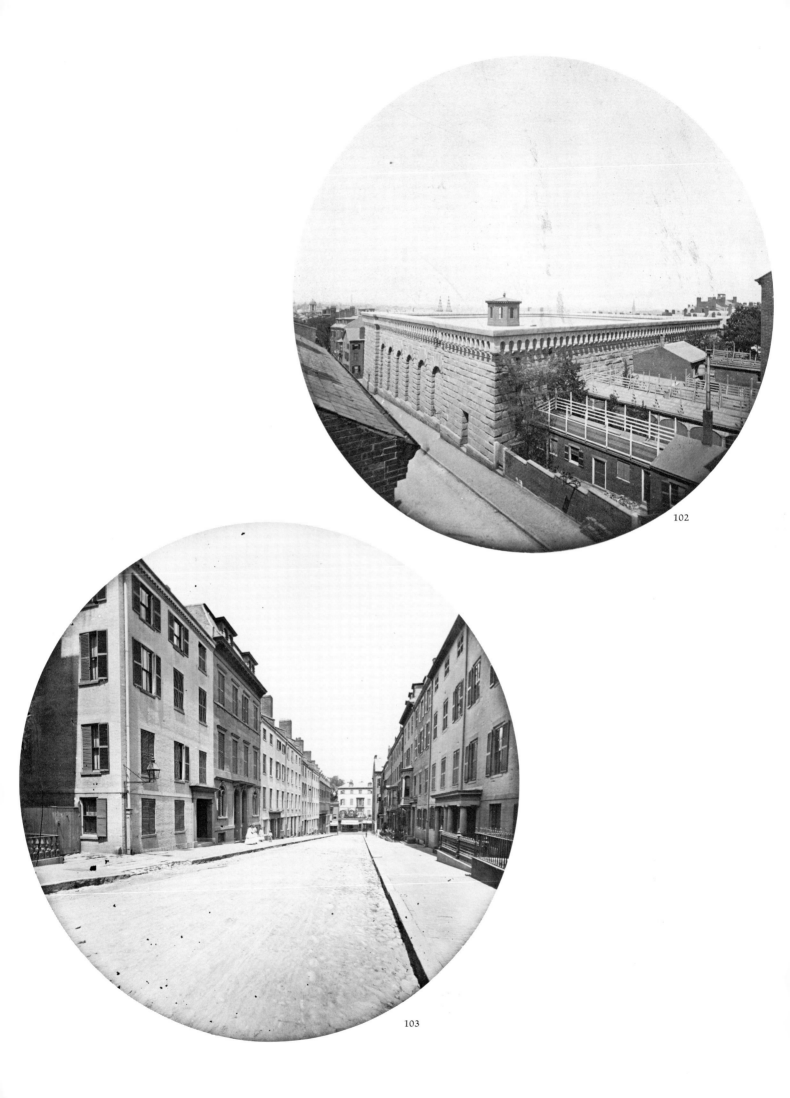

102

103

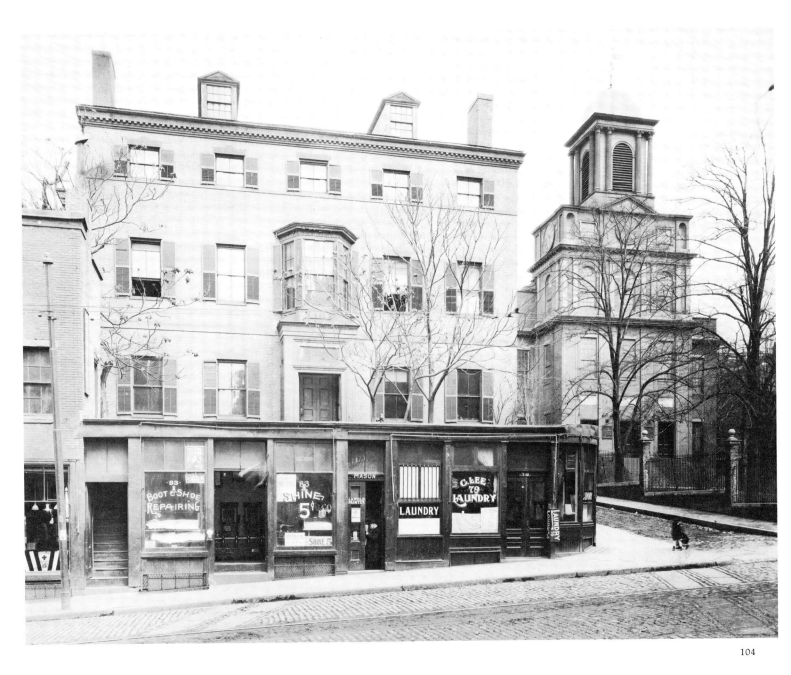

104

**102. Beacon Hill Reservoir, Hancock Street, ca. 1868.** Boston's greatest public-works project prior to the Back Bay landfill was the creation of a city water supply, completed in 1848. Water was pumped 15 miles from Lake Cochituate in Natick to the downtown terminus, a large reservoir, improbably located on top of Beacon Hill, immediately behind the State House. The reservoir, which was bounded by Hancock, Derne, Bowdoin and Mt. Vernon Streets, was removed in 1888 when the State House was extended northward across Mt. Vernon Street. The Old West Church on Cambridge Street is visible on the left.

**103. Hancock Street, Looking North toward Cambridge Street, ca. 1865.** Taken by Boston photographers Southworth and Hawes and looking directly toward Bulfinch's first Harrison Gray Otis House (1795–96), this view indicates that the north slope of Beacon Hill possessed less charm than the south slope. Senator Charles Sumner's house is the second doorway on the right. Sumner, a leading voice for emancipation prior to the Civil War, was attacked at his desk in the Senate chamber by South Carolinian Preston Brooks. Clubbed into unconsciousness, Sumner eventually recovered and returned to Washington. Hancock Street, originally

called George Street, was an early road north from Boston Common. It bisected Beacon Hill and Mount Vernon, which was popularly known as Mount Whoredom due to the libertine behavior of its residents.

**104. Cambridge Street, Harrison Gray Otis House and Old West Church, 1916.** Boston has not always been kind to its legacy from the past. Harrison Gray Otis inhabited this house for only four years. It underwent many subsequent changes, reaching its nadir in the early twentieth century when it served as a rooming house hidden behind an ugly extension that included a cobbler's shop and a Chinese laundry. The 1806 Asher Benjamin–designed West Church had become a public library branch. Its congregation had moved away and the immigrant population that had moved into the nearby West End district had changed the formerly fashionable neighborhood. In this instance, the story has a happy ending. The restored Otis House currently serves as the headquarters of the Society for the Preservation of New England Antiquities, while the church is being used as a Methodist house of worship. Many other structures in the city have not been so fortunate.

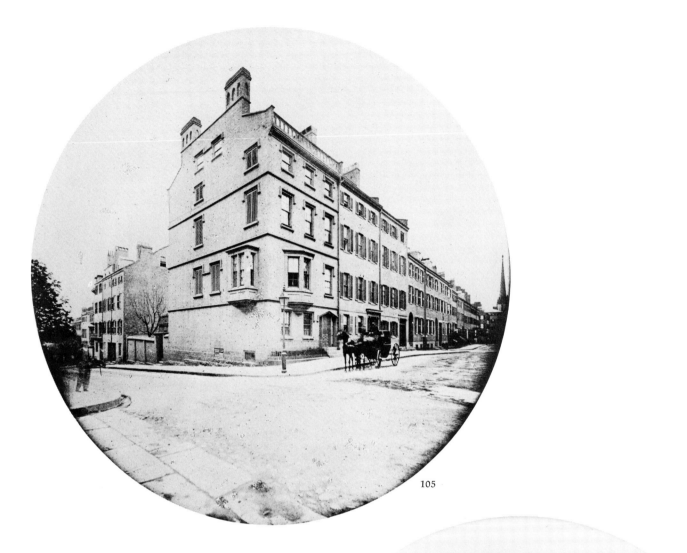

105

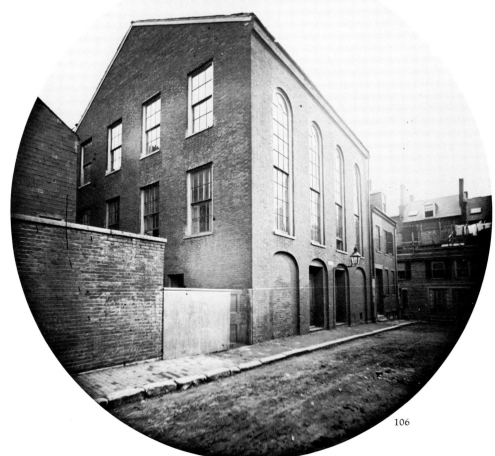

106

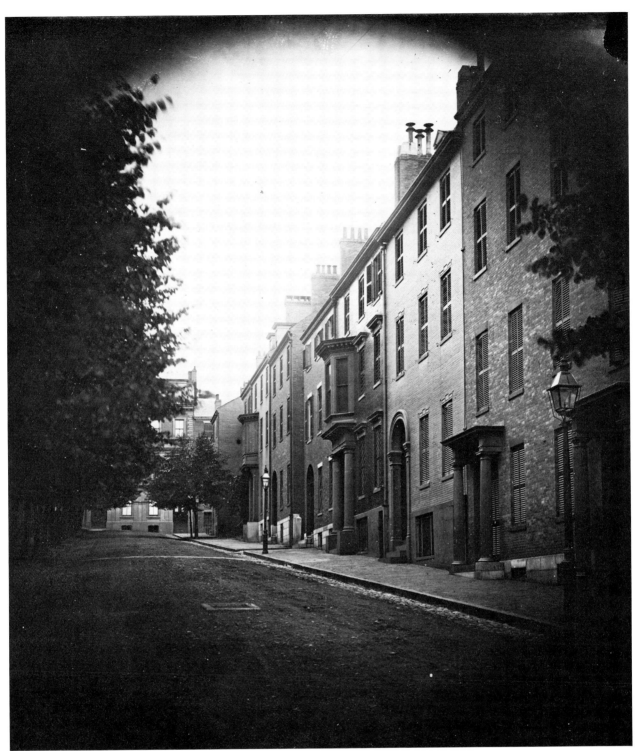

**105. Mount Vernon Street, Looking East at Joy Street, ca. 1870.**
Somewhat more modest than neighboring Beacon Street, Mount Vernon Street contains a rich assortment of gracious homes of Boston's elite families. It is at the apex of Beacon Hill; cross streets fall off to the north and south slopes from it, and it passes through the State House extension. A stylish carriage waits in front of the house on the future site of the publishers Little, Brown. The familiar First Baptist spire on Somerset Street is at the far right.

**106. African Meeting House, Smith Court, ca. 1860.** One of Boston's most important and, until recently, most neglected landmarks, the African Meeting House was probably designed by Asher Benjamin and built in 1806. It served as a church, school and community center for Boston's blacks, many of whom lived on the north slope of Beacon Hill. Leading abolitionists used the building as a forum for their activities and William Lloyd Garrison helped found the New England Anti-Slavery Society there in January 1832. Blacks moved away from the north slope in the late 1800s and were replaced by Jews and Italians. The Meeting House

subsequently served as a synagogue until the 1960s and is presently restored to serve the black community as the headquarters for the Boston African-American National Historic Site of the National Park System.

**107. Chestnut Street, Looking toward Walnut Street, ca. 1869.**
Laid out in 1796 by surveyor Mather Withington for a group of investors called the Mount Vernon Proprietors, Chestnut Street runs down the west slope of Beacon Hill one block parallel to Beacon Street. It is a street preserved from the early Federal period, and represents the orderly beauty of that era. On this street have lived such famous Bostonians as Julia Ward Howe and Professor Henry Kissinger. Boston heiress Hepzibah Swan commissioned Charles Bulfinch to build adjoining houses at Nos. 13–17 for her three married daughters, for whom she purchased furnishings during frequent shopping trips to Europe. Although taken more than a century ago, this view could nearly be duplicated today.

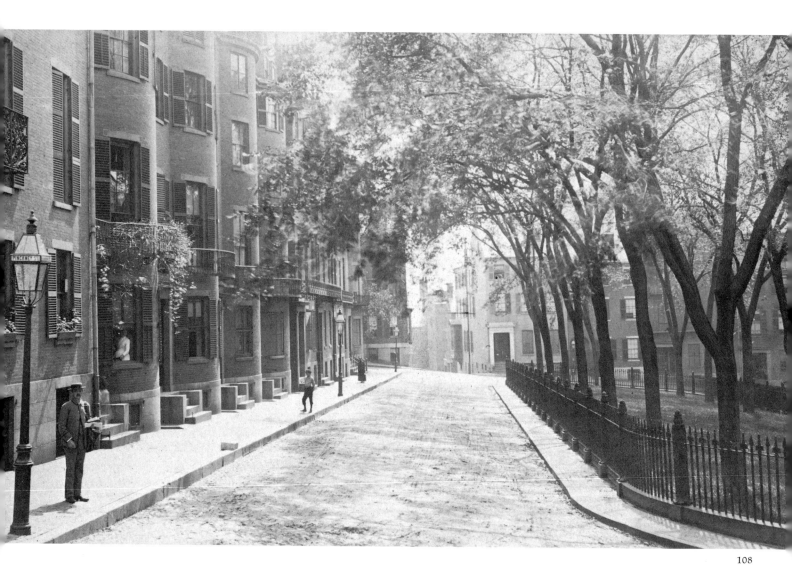

**108. Louisburg Square, from Pinckney Street, ca. 1895.** Spring sunlight dapples the surviving Beacon Hill refuge from noise and traffic. The other enclosed park on the Hill was Pemberton Square. Running between Pinckney and Mount Vernon Streets, the bow-front houses around the square date from the 1830s and 1840s. The commonly owned park at the right is the property of the Louisburg Square Proprietors, America's first homeowners' association. At one time, the Proprietors divided all of the trimmings from the square's trees to be used as firewood. By the time this image was taken, residents of Louisburg Square had begun observing Christmas Eve with communal outdoor carol singing—one of Beacon Hill's most enduring traditions.

**109. Beacon Street, Looking Eastward at Charles Street, 1870.** Once called Poor House Lane because the Boston Alms House stood at the corner of Park Street, Beacon Street achieved its distinction at the expense of the artist John Singleton Copley, who owned the then not terribly desirable west slope of Beacon Hill. Copley moved to England permanently in 1774; his Boston agent for his affairs was persuaded by the Mount Vernon Proprietors to sell Copley's land at the bargain rate of $1000 per acre. By the time

Copley learned of the transaction and attempted to stop it, he was too late and, for just over $18,000, the pastureland of Beacon Hill had become Boston's newest real-estate development. The original speculators built large mansions along Beacon Street's slope. Additional houses later filled in the spaces between so that a solid streetline was created. The Boston Common lies to the right, beyond the fence.

**110. Beacon Street, Looking Westward from Charles Street, 1870.** Beacon Street by itself would be a handsome addition to Boston, an address to be prized along "the sunny street that holds the sifted few," to quote longtime resident Oliver Wendell Holmes. But Beacon Street's proximity to the Boston Common and Public Garden (left) has insured it a permanently open view, both for its fortunate residents looking out and for Bostonians looking toward it. Beacon Street was also the pathway for Boston's second exit road, the Mill Dam or Western Avenue, which opened in 1821. Extending from the corner of the Public Garden at Arlington Street to Sewell's Point near today's Kenmore Square, it eliminated the roundabout route to Brookline and Brighton through Roxbury.

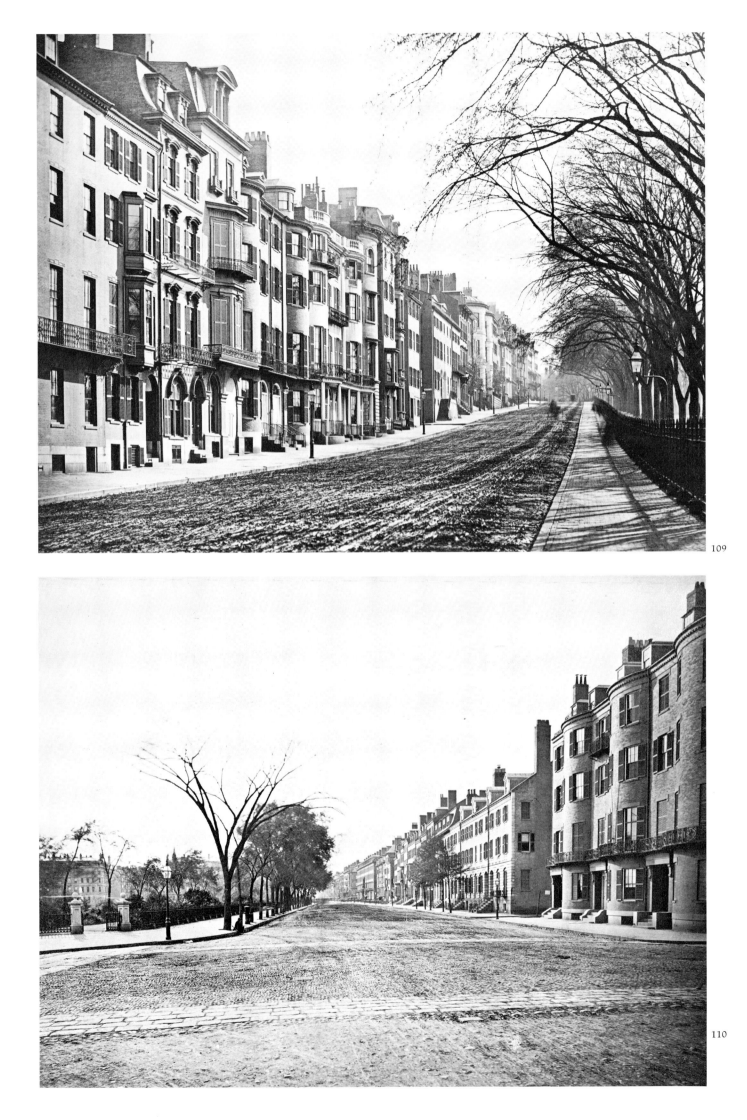

109

110

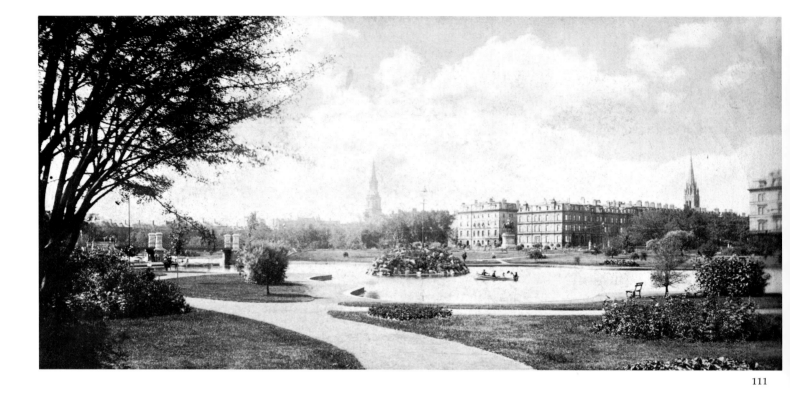

111

**111. Public Garden, Facing Arlington Street, ca. 1885.** Thanks to Horace Gray and other Boston botanists, the landfill immediately west of Charles Street was reserved in 1839 for use as a botanic garden, and a large conservatory for plants was built on the south side of Beacon Street. Plans in the 1840s to use the land for house lots were stillborn; the Public Garden remains an enduring green space in the city. A more formal area than the neighboring Boston Common, it reflects the demarcation between residential Back Bay and downtown Boston. The central pond, an English feature, was added in 1861. Upon it have plied the renowned Swan Boats that have been faithfully operated by the Paget family since 1877. The pond has also been familiar to generations of children as the setting of Robert McCloskey's story *Make Way for Ducklings.*

**112. Public Garden, from Park Square, ca. 1875.** "While the Common is a park of stately trees and broad walks, this is, precisely as the name implies, a public garden, with dainty flower-beds, plants, shrubbery . . . and narrow winding gravel paths." So described by a late Victorian guidebook, the Public Garden was a favorite promenade for Bostonians who appreciated the quietude of a botanic park near the center of the city. Beacon Street and the Charles River lie in the distance in this view, taken by an intrepid photographer from the tower of the Boston & Providence Railroad depot in nearby Park Square.

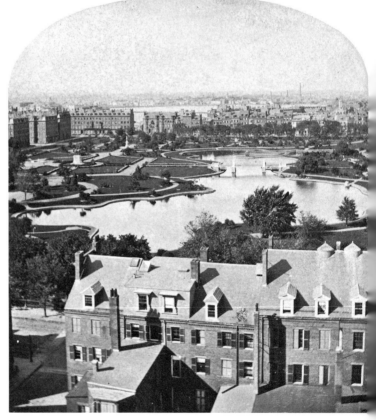

112

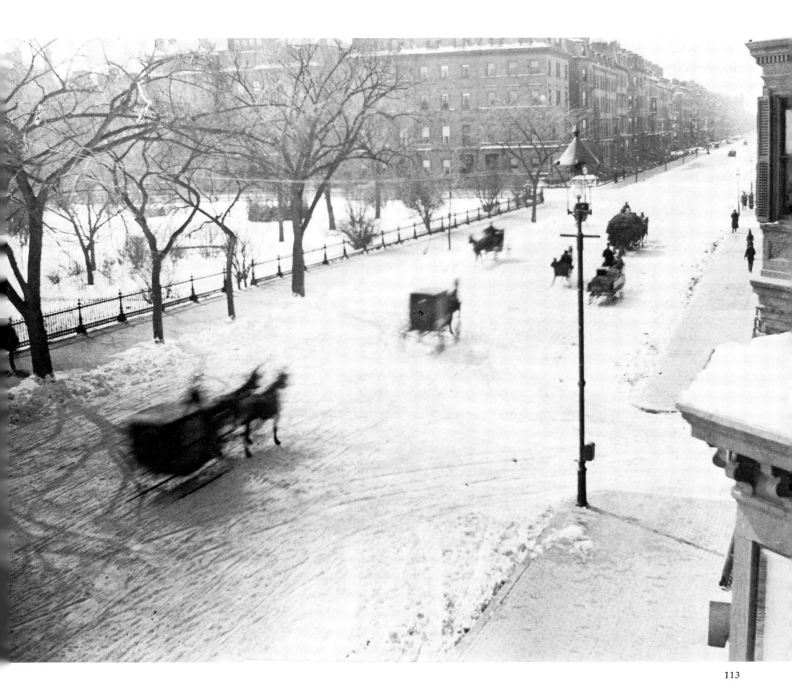

113

**113. Beacon Street, Corner of Brimmer Street, ca. 1897.** The earliest way west from Boston was Beacon Street, straight across the Mill Dam road to Sewell's Point near today's Kenmore Square. Traditionally it was an avenue on which to show off one's horseflesh; races across the broad roadway were a means of competition, thrill seeking and manly Victorian pride. More sedate was the parade of pungs and sleighs in winter. Several cutters and teams are visible on Beacon Street at the corner of the Public Garden facing Arlington Street. By this time, Beacon Street is fully developed across the Back Bay.

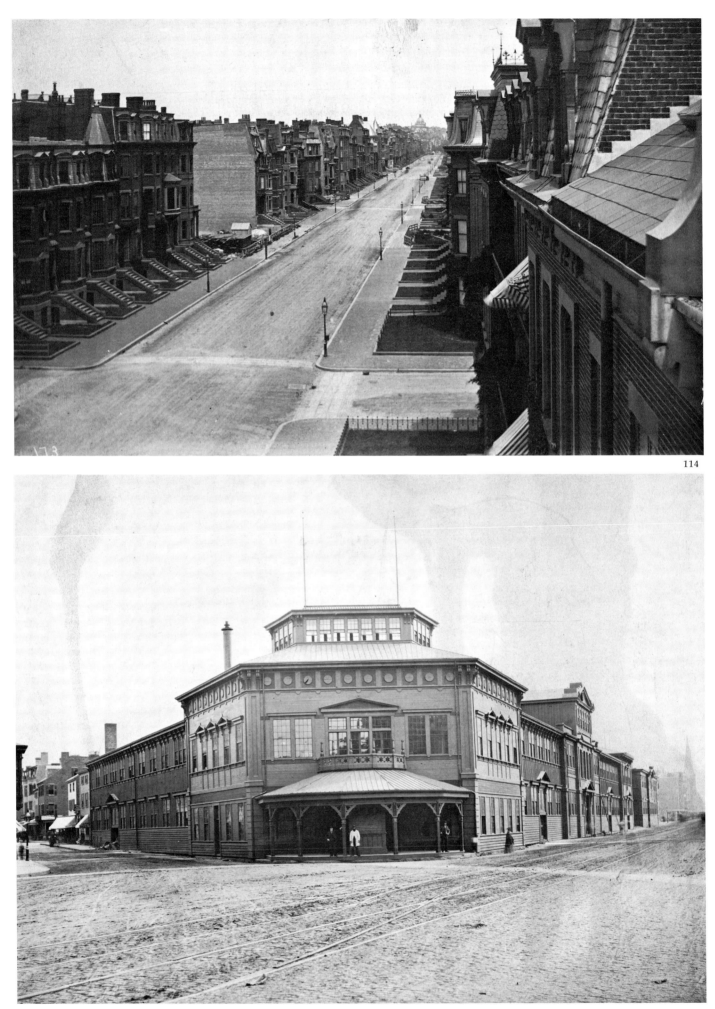

114

116

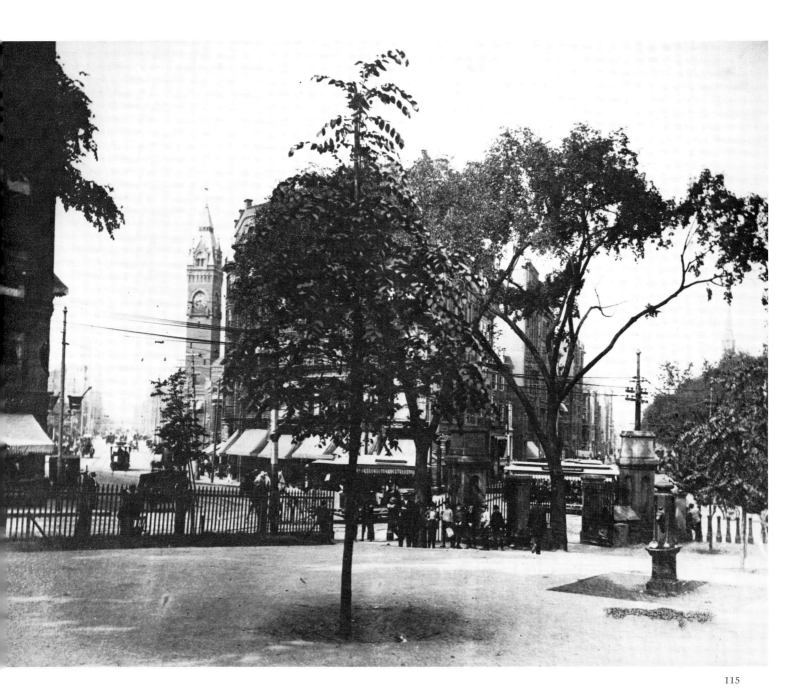

115

**114. Beacon Street, Looking East, ca. 1883.** Built on top of the Mill Dam, which separated the Charles River from the actual Back Bay, Beacon Street quickly developed into a leading residential street. The State House dome stands out against the Beacon Hill skyline. Evidently the planting of trees was not an early priority, unlike Commonwealth Avenue, which was modeled after the Parisian boulevards.

**115. Boston Common, Corner of Boylston Street and Park Square, ca. 1890.** A busy scene at the southwest corner of the Common shows that heavy traffic was not a problem confined to Tremont and Washington Streets. Several open trolley cars are passing. Despite their impractical nature—they could only be operated from May to September—they were popular with the riding public. Within the decade, many of them would run

underground when the Boylston Street subway opened, passing directly in front of this corner. Two major Back Bay streets, Boylston Street and Columbus Avenue, intersected here, providing long vistas through the district. The Boston & Providence depot tower is visible in the left center. At the station Bostonians boarded trains to New York and points south.

**116. Massachusetts Charitable Mechanics Association Building, Park Square, 1879.** Built in only seven months for the 1879 Mechanics Fair, this substantial building highlighted the achievements of the building trade. The structure, a temporary one, was used for only two months. Columbus Avenue (right) heads out through the South End; Pleasant Street, on the left, leads toward the Church Street district. The fair was evidently a success, accumulating a $35,000 profit in its nine-week run.

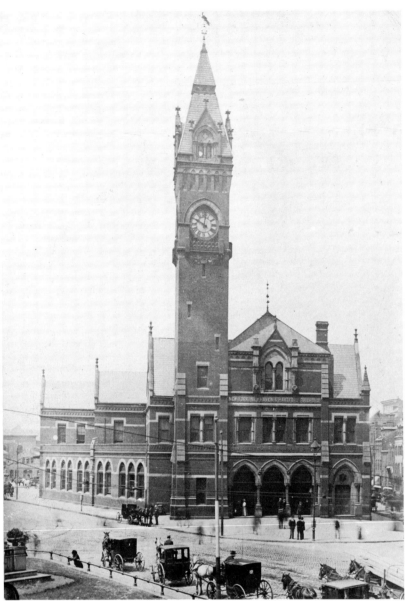

**117. Boston & Providence Railroad Depot, Park Square, ca. 1882.** Before the South Station consolidated a variety of railroad terminals, each company was forced to build its own. They had to be close to downtown—not an easy matter given the confined topography of the city—and, ideally, each would create the impression of prosperity that the railroad company hoped to convey to the riding public. The Boston & Providence terminal (1872), designed by Peabody & Stearns, certainly served this purpose until 1899, when service out of the station ceased. The Emancipation Group statue at the left is a duplicate casting by Thomas Ball. It was presented to the city in 1879 by Moses Kimball, proprietor of the Boston Museum. Columbus Avenue runs through the square.

117

**118. Interior, Boston & Providence Railroad Depot, Park Square, ca. 1872.** The nineteenth century's idea of a train station was considerably different from today's. One of the passenger waiting rooms, complete with a second-floor gallery, this hall featured attention to detail and grandiose appointments. Besides waiting rooms, billiards, smoking and dining facilities were provided for the traveler, "all furnished and equipped in a style equalled only by our best hotels."

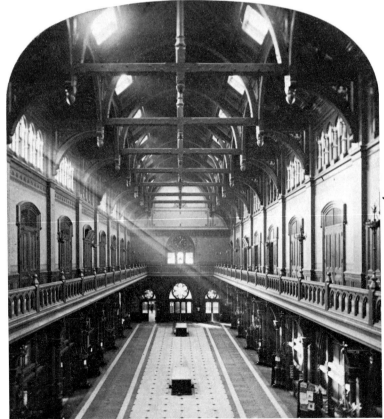

118

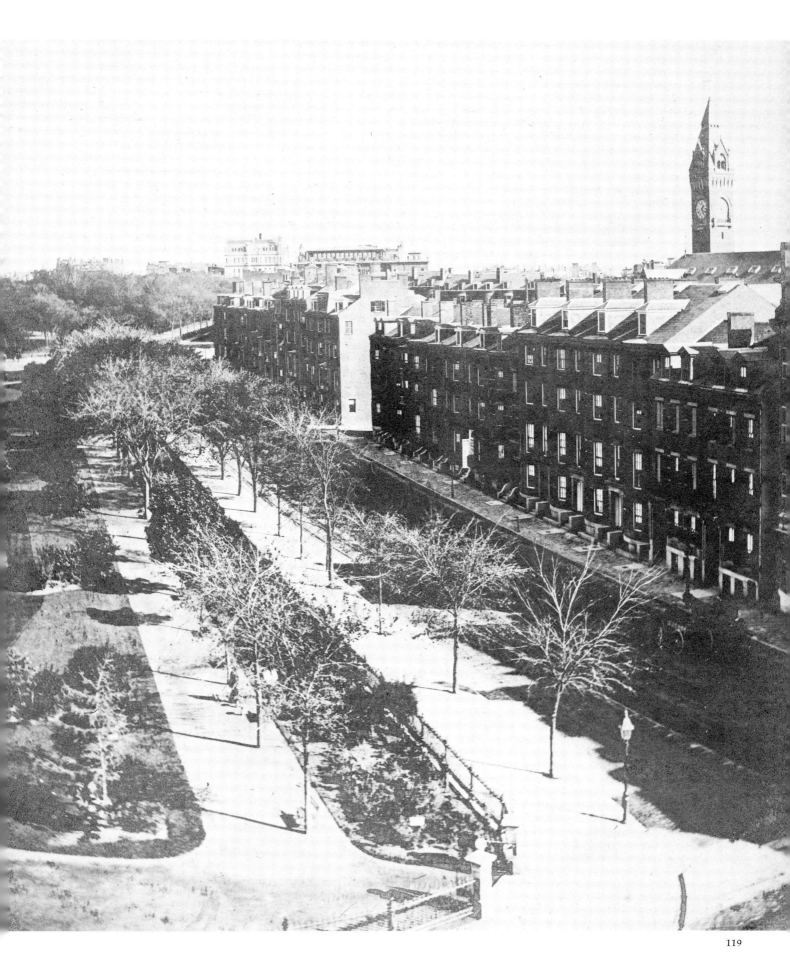

**119. Boylston Street, from Arlington Street, ca. 1875.** A view taken from the steeple of the Arlington Street Church, at the southwest corner of the Public Garden, shows Boylston Street as it was before it was widened to accommodate traffic. The brick row houses have long since disappeared. The opening of Boston's subway system in 1897 changed this location. Trolley cars used the new subway by means of a ramp, which surfaced in the Public Garden near the corner in the foreground. The exotic Masonic Temple stands in the center background.

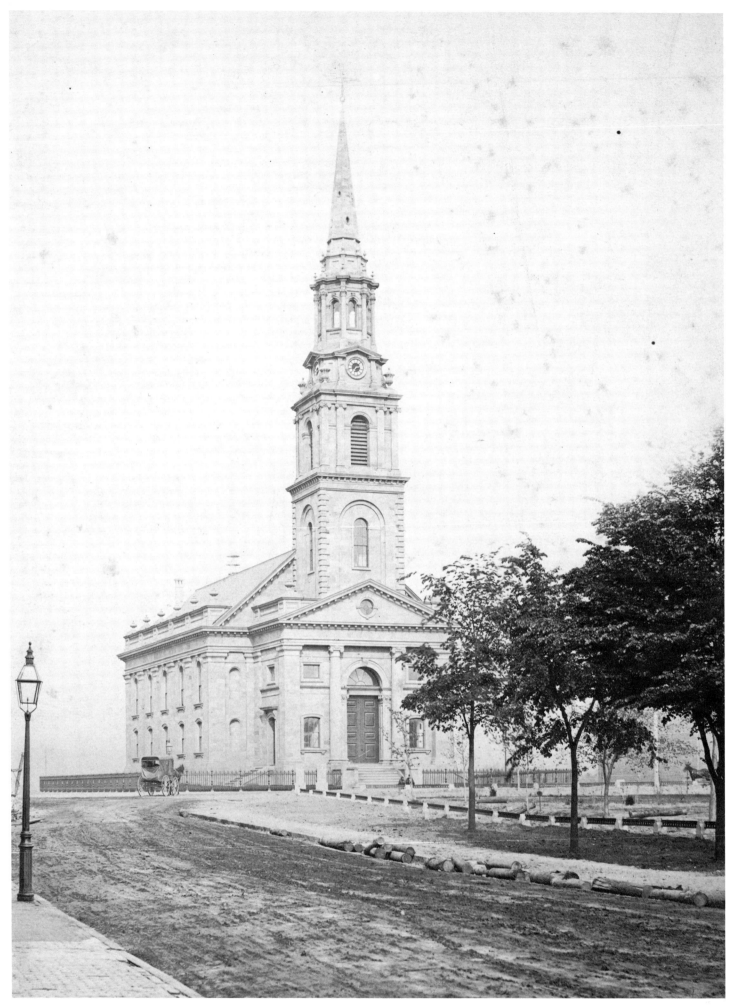

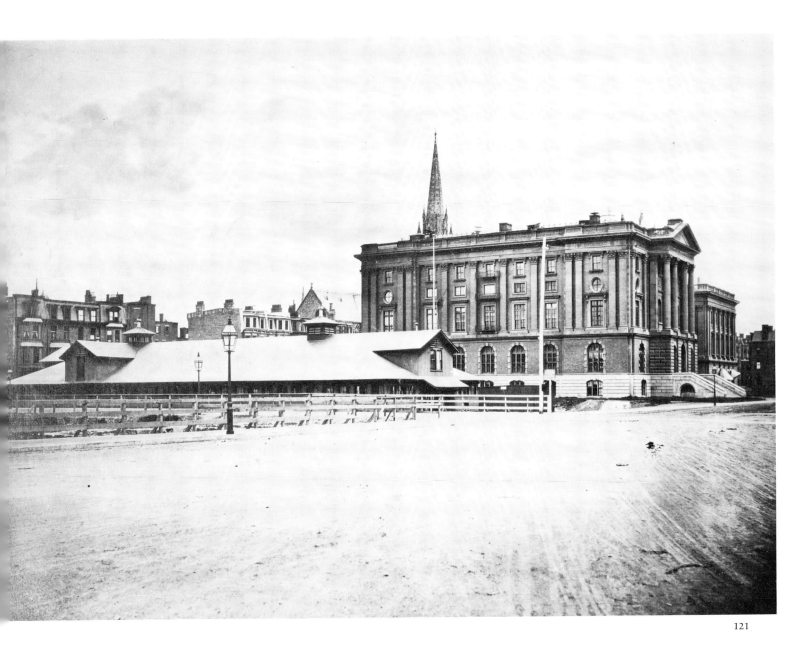

**120. Arlington Street Church, Arlington Street, 1862.** The first in a long series of downtown congregations to move to the Back Bay, the Arlington Street Church has graced one corner of the Public Garden since 1861. Designed by Arthur Gilman, it housed the Unitarian congregation that originally worshipped in its Bulfinch church on Federal Street. Arlington Street was the first street created in the newly reclaimed Back Bay district, having been the shoreline of Boston for many years.

**121. Boylston Street, Junction of Huntington Avenue and Clarendon Street, 1877.** Two Boston institutions of learning, both of which have since moved to the banks of the Charles River, are pictured here. The Massachusetts Institute of Technology's Rogers Building (1864) is the large, pedimented structure, while the Boston Museum of Natural History (1863) stands beyond it on the right. Both were designed by William G. Preston and neatly complemented each other. They represented the first inroads of public buildings into the newly filled Back Bay. MIT moved its campus to Cambridge in 1916, while the Museum of Natural History evolved into the Museum of Science. Bonwit Teller's store occupied the building for many years. The spire of R. M. Upjohn's 1867 Central Congregational Church (now the Church of the Covenant) is visible behind the Rogers Building. The low structure in the foreground, on Clarendon Street, served MIT as a gymnasium and drill hall.

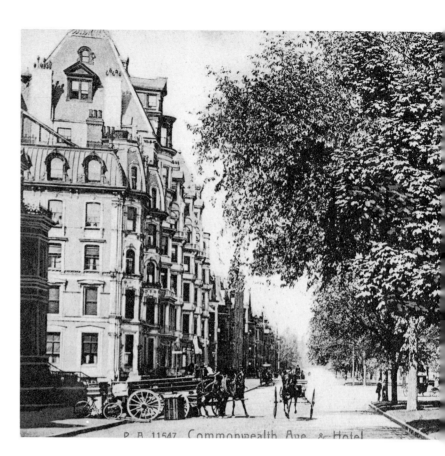

**122. Commonwealth Avenue, Looking West at Dartmouth Street, 1905.** Laid out in boulevard style with twin roadways paralleling a central mall, Commonwealth Avenue was designed to be the main artery through the Back Bay and a showcase that would set the atmosphere for the neighborhood. Built block by block toward Gravelly Point (today's Massachusetts Avenue) across the rapidly decreasing marsh area, the avenue quickly became fashionable, thanks in part to its legislated uniformity. Houses were required to be set back 20 feet from the sidewalk; regulated heights produced a pleasing unity in the Back Bay. To the left, at the corner of Dartmouth Street, is the Hotel Vendome.

**123. Hotel Vendome, Commonwealth Avenue, 1874.** One of the most photographed buildings in Boston during the later part of the nineteenth century, the Vendome was the epitome of the lavish modern hotel. Set somewhat apart from its competitors, it boasted of having Boston's first electric lights in a public building (1882). Private bathrooms and fireplaces and individually controlled steam heat were some of the amenities the Vendome provided for its guests. The hotel was designed by William G. Preston and built in 1871. A larger addition on the right was built a decade later by the firm of Ober & Rand. A major fire in 1975, which killed nine firefighters, destroyed part of the original portion of the building, which is now rebuilt and used for condominiums. Copley Square and the New Old South Church appear at the far left.

**124. First Church of Boston, Marlborough Street at Berkeley Street, 1880.** This is a picture taken when the congregation celebrated its two-hundred-fiftieth anniversary. As its name implies, it is the oldest congregation in Boston, having numbered among its parishioners John Quincy Adams and Ralph Waldo Emerson. In 1868 it moved from downtown's Chauncy Place to its present location in the Back Bay, occupying a building designed by Ware and Van Brunt that had its own carriage porch. A major fire in 1968 destroyed much of the building. What remained was incorporated into the rebuilt structure, designed by Paul Rudolph, to form the congregation's sixth house of worship.

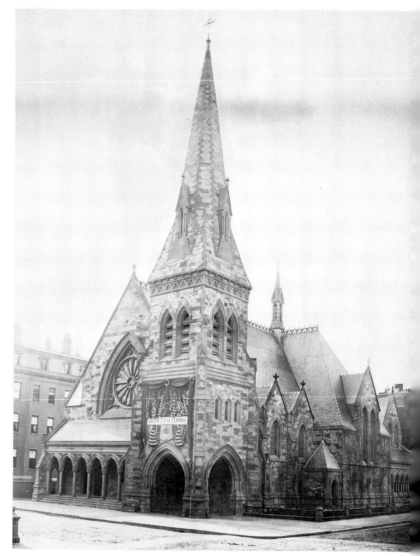

124

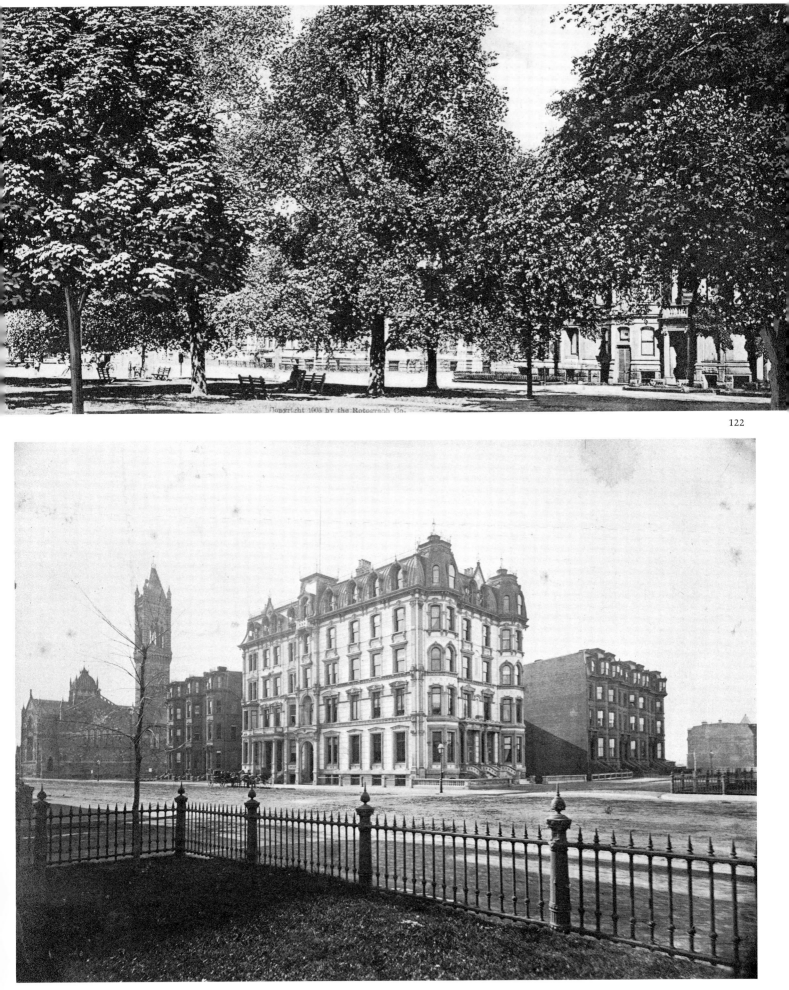

122

123

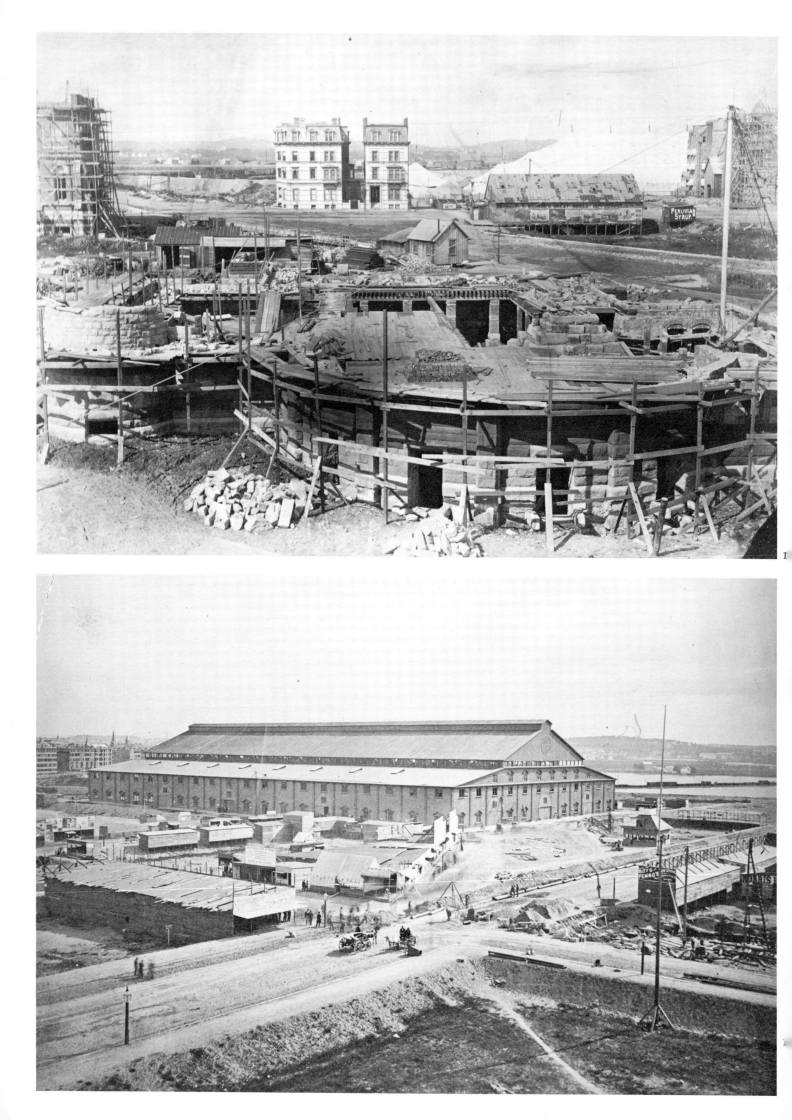

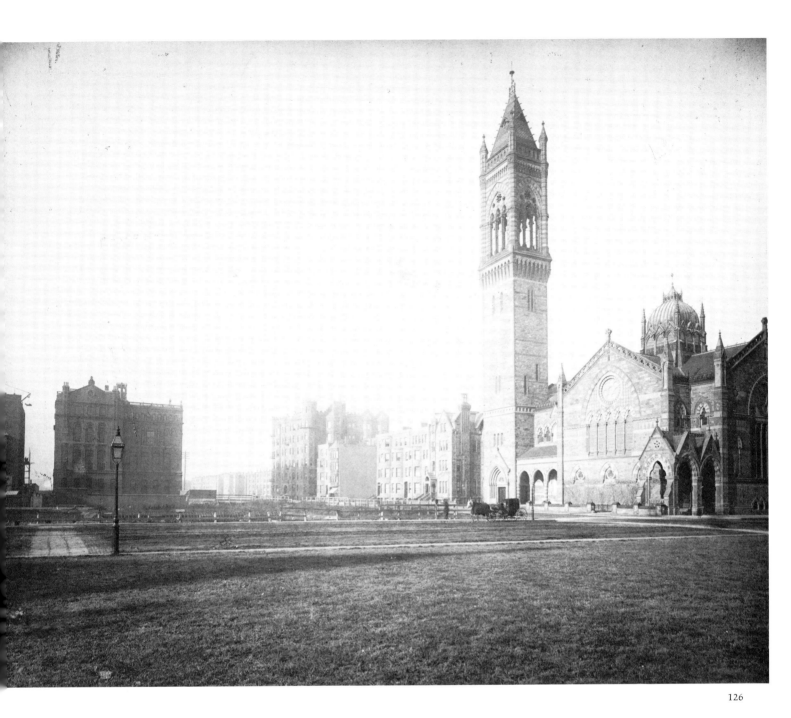

**125. Copley Square, Looking West, 1873.** Taken less than ten years apart, the photographs of Nos. 125 and 126 show a recognizable Copley Square and one that must be taken on faith. As the fulcrum of the newly created Back Bay, the triangular area formed by Boylston and Dartmouth Streets and Huntington Avenue created a hub that would reflect the area's ambience. Its principal buildings would be cultural and religious centers rather than commercial ones. Henry Hobson Richardson's masterpiece, Trinity Episcopal Church, begins to emerge in the foreground while the first Museum of Fine Arts building progresses on the far left. In 1909 it moved to its present location on Huntington Avenue. In the distance is the still unfilled section of the Back Bay.

**126. New Old South Church, Copley Square, 1880.** Where else but in Boston would there be a "new old" church that has itself celebrated its centennial? Housing another downtown congregation that moved to the Back Bay, the Northern Italian Gothic structure was designed by the firm of Cummings and Sears and

completed in 1875. The great tower, a Copley Square landmark, was found to be leaning to the southwest and was replaced during the 1930s by a smaller one that retained much of the original stone. Beyond the church, houses have extended from Dartmouth Street toward Exeter Street; in the left center houses on Newbury Street can be faintly seen.

**127. Peace Jubilee Coliseum, Dartmouth Street, 1869.** The raw appearance of the Coliseum and its support buildings belies its Copley Square location, but it sat on the site now occupied by the venerable Copley Plaza Hotel. The first Coliseum (there was another three years later) was Boston's largest indoor auditorium, quickly thrown together for the five-day National Peace Jubilee, held in June 1869. A strange, gargantuan affair—part musical extravaganza, part religious revival and part Union gloating over its Civil War victory—the Jubilee included a 10,000-voice chorus accompanied by a 1000-piece orchestra and 100 sledgehammer-equipped firemen to assist with the "Anvil Chorus."

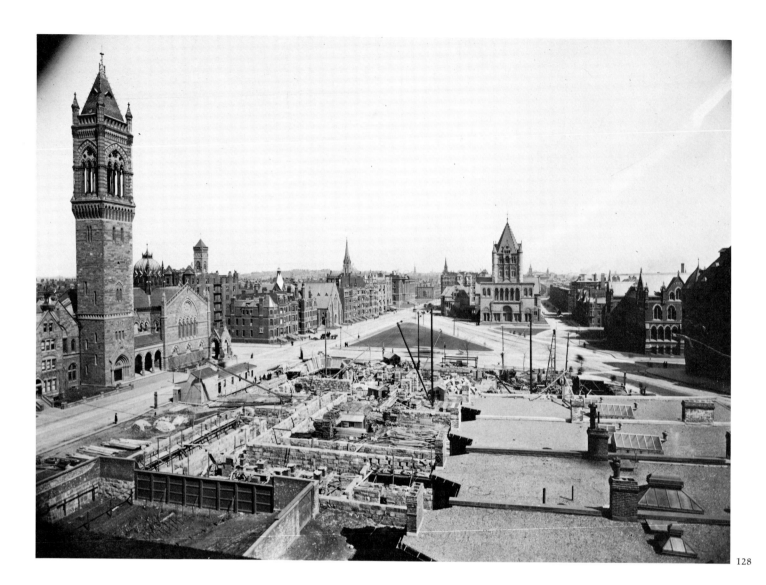

<span style="float:right">128</span>

**128. Copley Square, Looking Eastward, 1889.** Copley Square begins to achieve its final shape as the foundation of Charles Follen McKim's Public Library closes off the base of the Square. The library, which anchors Copley Square today, was the last link in the creation of Boston's new intellectual mecca. Its move to the Back Bay meant that another prominent institution had deserted downtown—the traditional source of cultural strength. The planned flat skyline of the Back Bay is apparent, with only church spires breaking the horizon.

**129. Back Bay, Looking Northeast from Copley Square, ca. 1876.** From the tower of the New Old South Church, Back Bay's highest point, the piecemeal nature of the area's development is evident. Not every block went up in orderly fashion, as land speculators held on to lots to realize increased profits. H. H. Richardson's Brattle Square Church (Unitarian), built in 1871, dominates this stereograph view; shortly thereafter the parish dissolved, in large part because of the high cost of the building. The First Baptist Church took over the vacant building in 1882. In the distance at the far right are the State House and Boston Common.

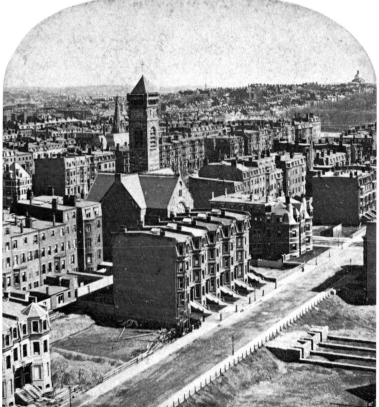

<span style="float:right">129</span>

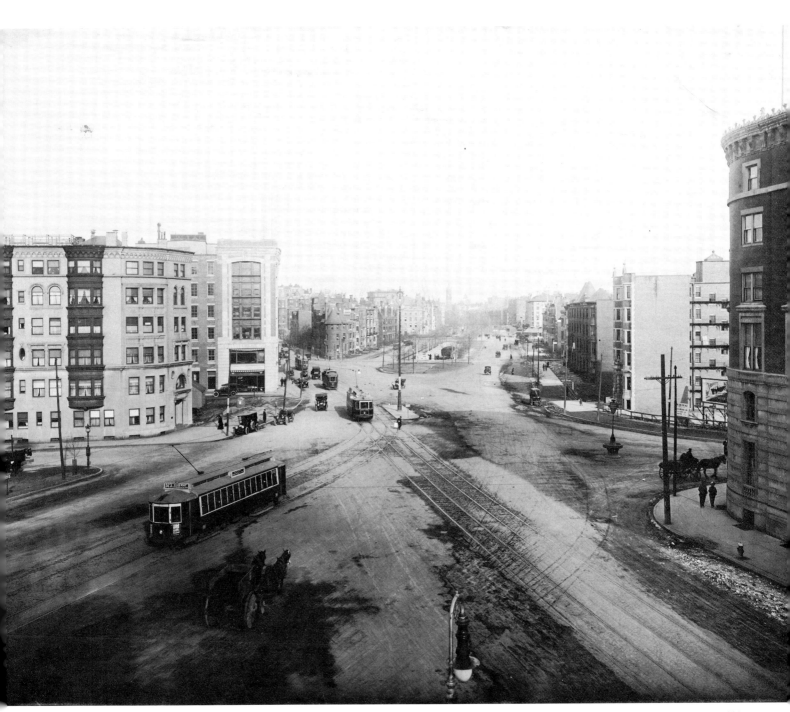

**130. Governor's (now Kenmore) Square, 1914.** Known since 1932 as Kenmore Square, the intersection of Beacon Street, Brookline Avenue and Commonwealth Avenue marked the western end of the Back Bay landfill. Commonwealth Avenue enters from Allston in the left foreground and heads into town along its boulevard section, while Beacon Street comes through to the right, going out to Coolidge Corner. Brookline Avenue leads off to the right (at the horse and carriage) behind the Hotel Buckminster. Newly built Fenway Park is two blocks away. The Kenmore Square subway ramp in the center opened later that year; the current Kenmore station and tunnel additions were Depression projects. Though its ambience has changed greatly since this picture was taken, Kenmore Square looks remarkably familiar, even in this view, to present-day Bostonians.

# South End

**131. Pleasant Street at Shawmut Avenue, 1899.** Not all of Boston was prosperous at the turn of the century. The lower Tremont Street area, south of Hollis Street, remained the poorer quarter of the city, and the construction of the Roxbury elevated line through this neighborhood did little to improve it. Curious passersby congregate to watch the photographer on Pleasant Street in front of cheap restaurants and pool halls. A sign on the clothing store offers to buy back railroad tickets. Frequently the need for money severed the connection between hometown and city for those from elsewhere in New England who tested the waters in Boston.

**132. Washington Street at Cobb Street, 1899.** Washington Street's strategic importance as Boston's link to the rest of Massachusetts cannot be overemphasized. During the colonial period it provided the sole land route out of town, and the narrow stretch of Boston neck—in the area of today's Dover Street—could easily be controlled by a small force. The street has also been a primary route for public transportation. Here, elevated girders begin shutting off the sunlight outside the Female Asylum's gates. Trains would rumble overhead to Roxbury and Jamaica Plain until 1987. Subsequent demolition returned the sun to Washington Street—and made it an inviting location for real-estate developers.

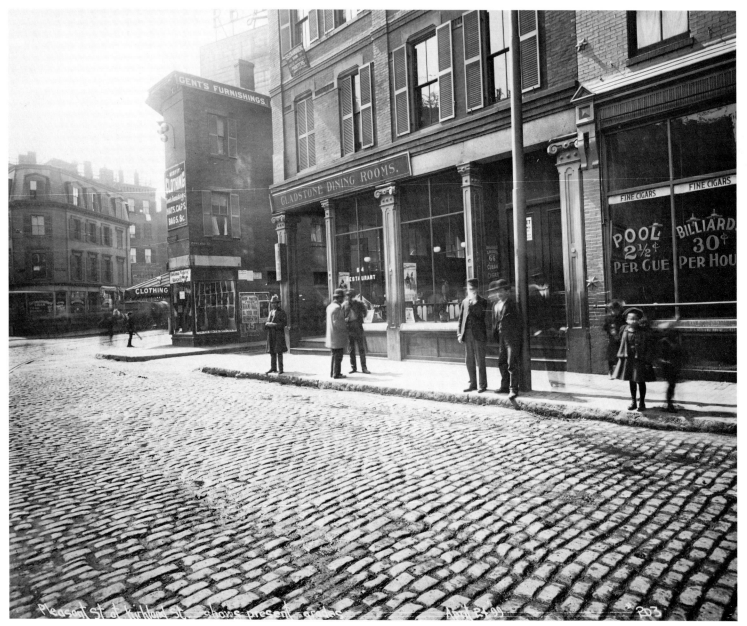

131

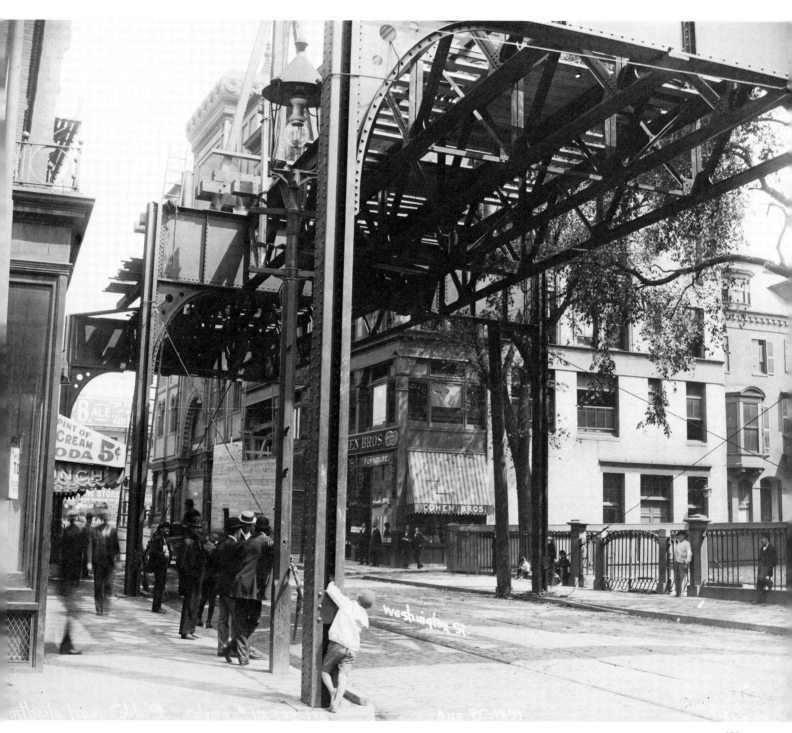

132

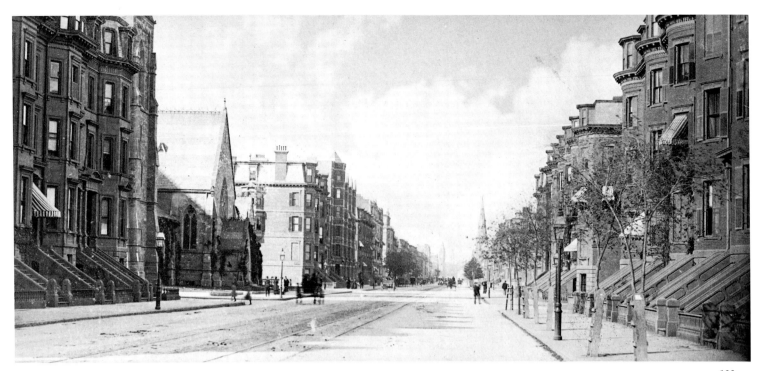

133

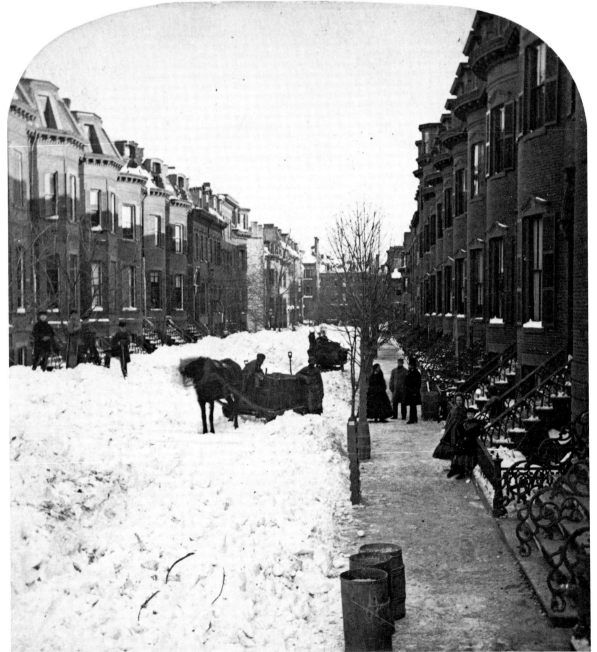

135

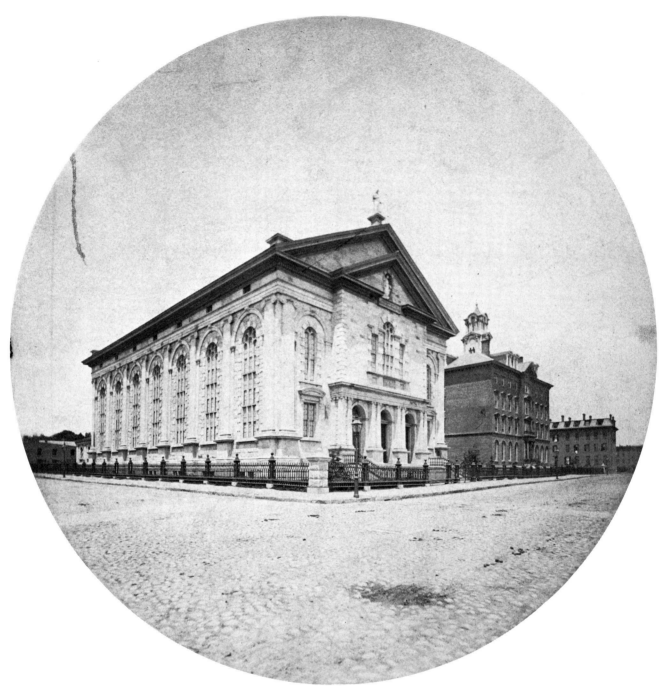

134

**133. Columbus Avenue at Rutland Square, ca. 1880.** A view looking past the Union Congregational Church (left) shows the Boston & Providence depot in Park Square in the distance. During the Panic of 1873, many of the attractive buildings on this major South End artery were repossessed by banks, which sold them at reduced rates. Thus, despite its genteel appearance, Columbus Avenue never became an address with a cachet. The tall spire at the right is that of the Second Universalist Church, built in 1872 at the corner of Clarendon Street.

**134. Church of the Immaculate Conception and Rectory, Harrison Avenue, ca. 1870.** The Church of the Immaculate Conception (designed by Patrick Keeley and completed in 1861) reflected the growth of Roman Catholicism in the immediate area, at this period primarily through immigration. Run by the Jesuit order, the church still stands. However, recent threats to its future have stirred the Boston preservation community as no other event in recent memory. The adjacent building, designed by Louis Weissbein to complement the church, housed Boston College in its early years. Originally called Front Street and renamed as a memorial to the hero of Tippecanoe, Harrison Avenue is one of five major routes through the South End.

**135. Dwight Street, from Tremont Street, ca. 1870.** Streets like Dwight Street, in the first part of the South End that was built next to the currently fashionable Bay Village district, were part of Boston's first attempt to expand its original landmass for residential purposes. The brick row house was a South End tradition. Despite the dignified simplicity of Dwight Street and its neighbors, the South End never became a fashionable area comparable to the Back Bay. Of interest is the early example of Boston's snow removal.

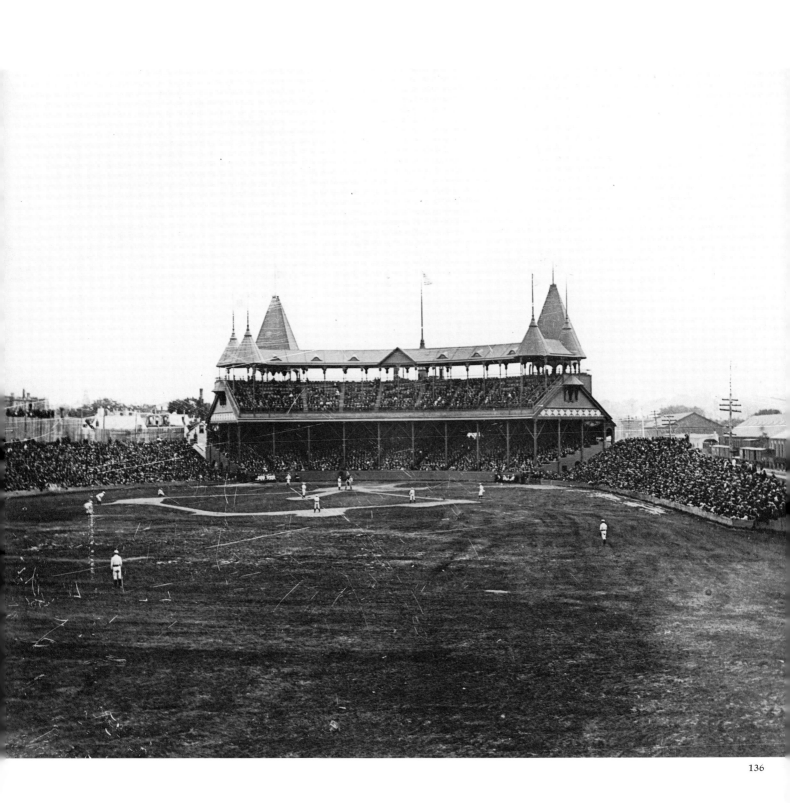

**136. South End Grounds, Walpole Street, ca. 1893.** A large crowd watches baseball at one of Fenway Park's predecessors. The Walpole Street grounds were the first double-decked grandstands in America when they were built in 1871. In 1894, a fire during a ball game destroyed the park (and much of the surrounding neighborhood), but it was rebuilt—without the distinctive twin spires—and served as the home field for the National League Braves until 1915. The Huntington Avenue grounds, home to the Red Sox and the site of the first World Series game in 1903, was constructed on the other side of the railroad tracks on the right.

**137. Blackstone Square, Looking Northeast, 1858.** This stereograph view shows Blackstone Square with the neighboring Shawmut Avenue Universalist Church. One of the most elaborately designed areas of the South End, the adjoining Blackstone and Franklin Squares attempted to establish a formal elegance to the newly created neighborhood, using a plan originally created by Charles Bulfinch more than 50 years earlier. Bounded by Brookline and Newton Streets, and bisected by Washington Street, the squares featured central fountains and represented an attempt to create a gentility somewhat incompatible with their surroundings a few blocks away.

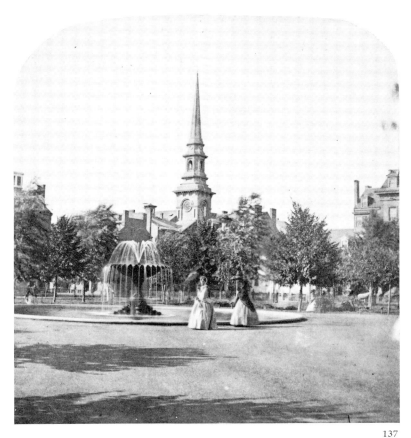

137

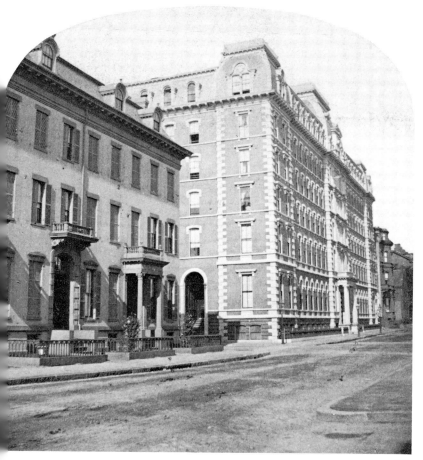

138

**138. St. James Hotel, Franklin Square, East Newton Street, ca. 1872.** Franklin Square's centerpiece was the elegant St. James Hotel, which featured steam-powered elevators and counted President Grant as an early guest. Alas, the St. James proved too far removed from downtown Boston to attract customers. It has since served as a home for the New England Conservatory of Music, a residence hotel for single women, senior citizens' apartments and as the setting for the fictional hospital for Boston's downtrodden on the television series *St. Elsewhere.*

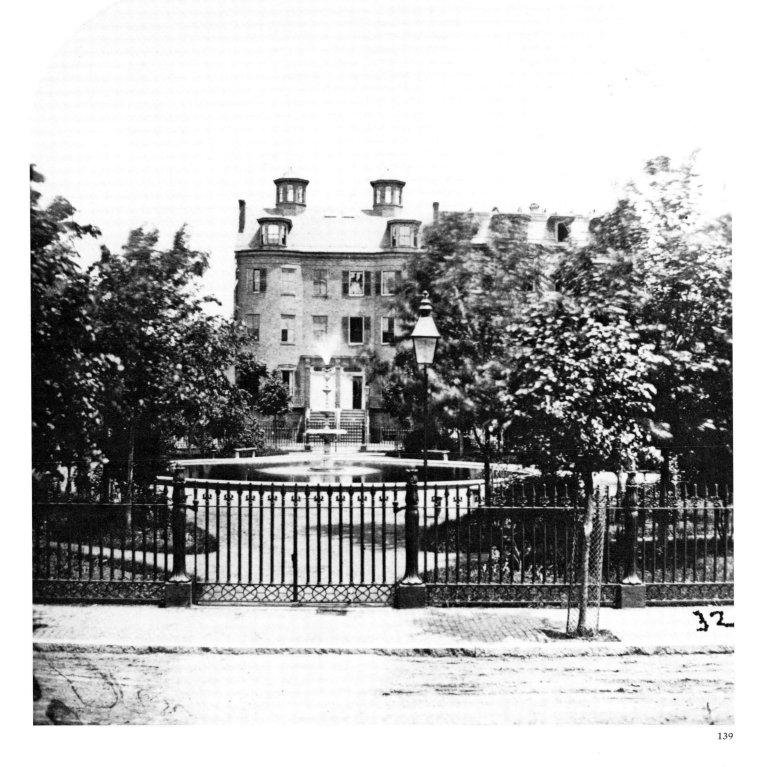

**139. Chester Square, ca. 1870.** The most elite of the South End residential squares, dating back to the early 1850s, Chester Square boasted fountains, shade trees and bowfront houses. Renamed Massachusetts Avenue in 1894, the square was divided by a central thoroughfare in the early 1950s and traffic ruined the square's placidity. What remains is striking; what was destroyed had been even more so.

**140. Worcester Square, Looking South toward Boston City Hospital, ca. 1865.** Laid out in 1851, Worcester Square was a rare case of a successfully designed section of the South End that was integrated with its surroundings. In the distance, the original administration building of City Hospital, designed during the Civil War by Gridley J. F. Bryant, sits as an axis to the symmetry of the square.

**141. Roof, Boston City Hospital, Harrison Avenue, 1918.** Not until 1865 did Boston City Hospital open and, like other similar public institutions, it was located in the South End, presumably because so many of its potential patients lived there. This carefully posed scene, quite possibly intended for publicity purposes, shows a rooftop solarium during the great influenza epidemic of 1918. A mixed group of patients enjoy the fresh air outdoors with a quartet of vigilant nurses.

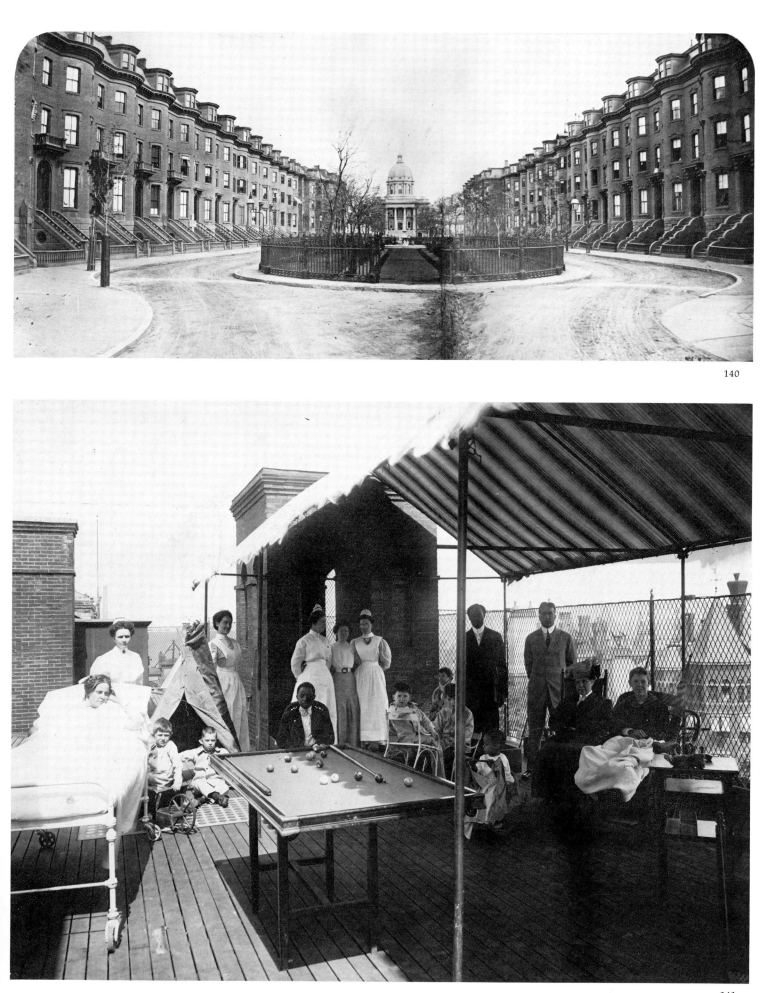

140

141

# Lost Squares

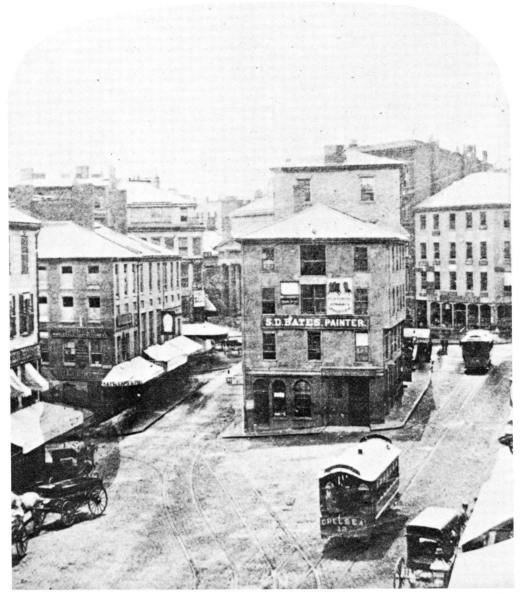

**142. Scollay Square, Looking toward Tremont Street, ca. 1869.** Always bustling, always alive, Scollay Square held many memories for those who remember its World War II incarnation as a sailor's paradise for the Atlantic Fleet. While some have been accused of gilding an eyesore—and in truth it had become that by the last years of its life—Scollay Square has remained to many Bostonians a symbol of life in a better time, but a time gone by. Even in the 1860s, Scollay Square was busy. The original Scollay Building, named for apothecary William Scollay, stands in the center of this view. In an early (and rare) bit of foresight, it was demolished in 1871 for street widening and civic improvement. The horsecar at the right is heading out on Tremont Street (beyond the right-hand corner) for the South End and Roxbury. Brattle Street (at left) and Cornhill (second intersection from left) carry Bostonians down toward the waterfront and Faneuil Hall.

**143. Scollay Square, from Court Street, 1873.** A view taken a few years later and looking in the opposite direction from the previous picture shows Tremont Row, a favorite block for the studios of early photographers, on the left. Their presence is one reason why there are many early views of this location. Here we can see that Scollay Square was not a square at all, but a large section of interlocking streets that led to Cambridge, the North End, the waterfront, the West End, the business and legal districts, Beacon Hill and the fashionable shopping area along Tremont Street. Throw in the theaters, vaudeville, saloons and the like, and it is easy to see just why Scollay Square was heavily frequented. Two of the city's four subway lines intersected here by 1905, increasing the flow of humanity.

**144. Scollay Square, from Court Street, 1884.** A decade later more of the square's character is revealed. The statue of Boston's founder John Winthrop has turned his back on the commotion and peers down Court Street toward the Old State House. The Crawford House (center, with second-floor awnings) was a landmark Scollay Square hotel with roots dating back to the 1860s. It survived nearly a century.

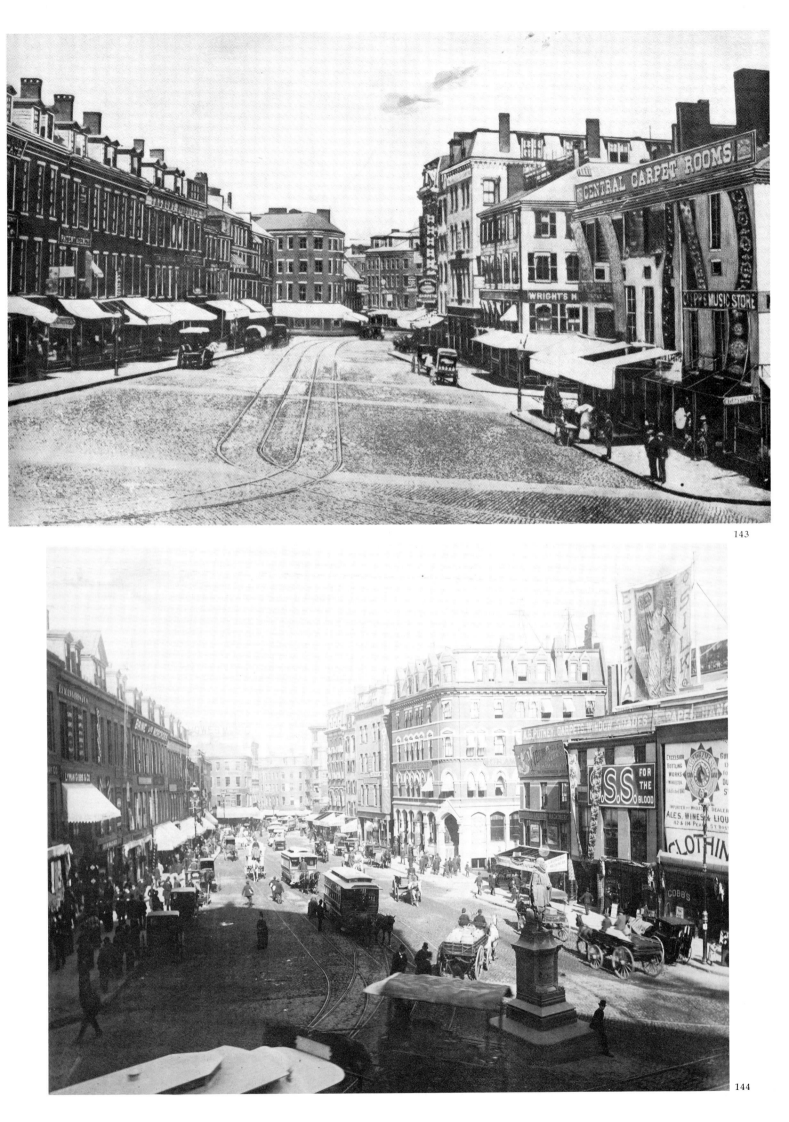

143

144

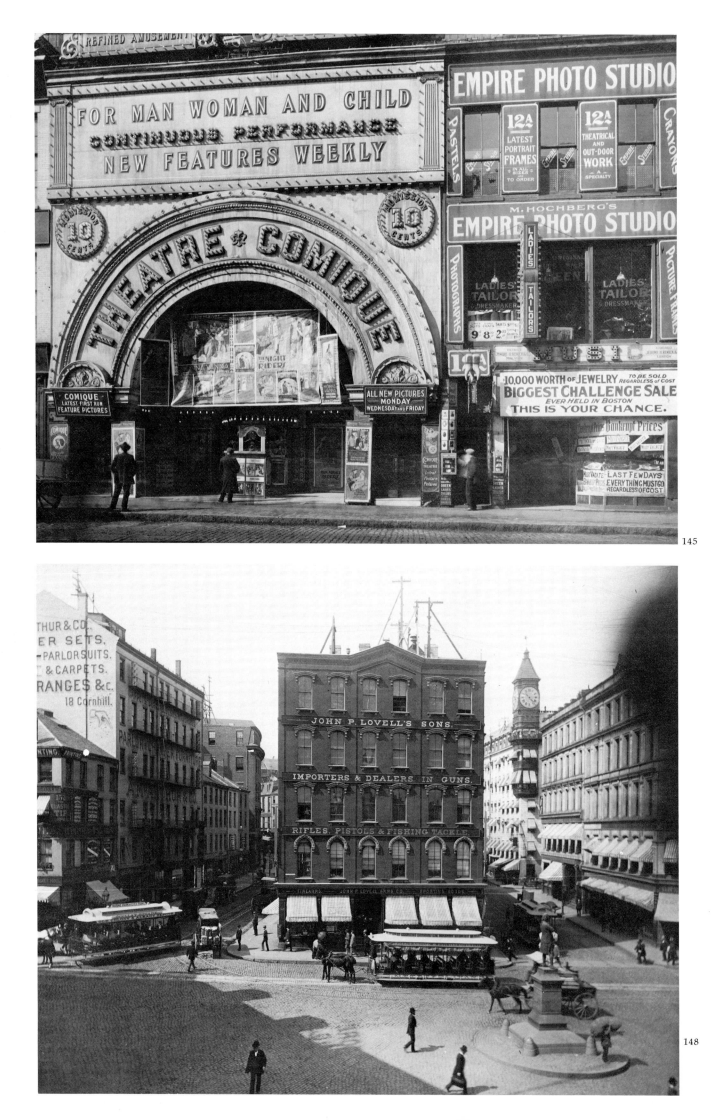

145

148

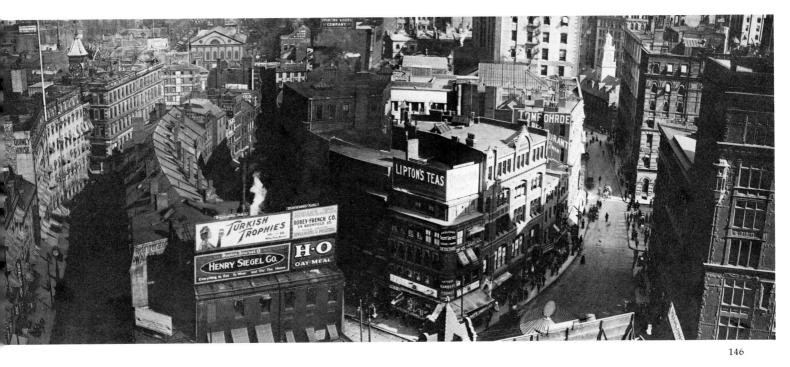

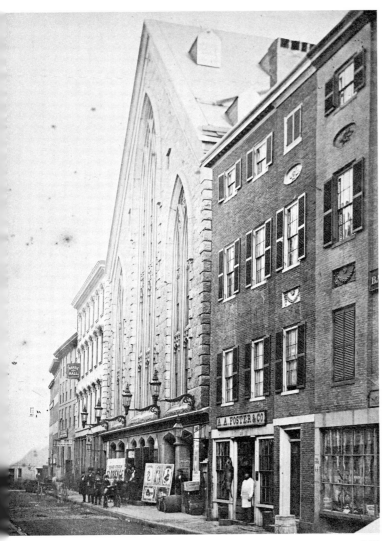

**145. Theatre Comique, Scollay Square, 1916.** Scollay Square's reputation for risqué excitement had been earned over decades; only the nature of that excitement had changed. By the century's second decade, a bit of the tawdry had seeped in, in the form of flashy marquees and cluttered vestibules. Proliferating because of the attraction exerted by the Old Howard theater, Boston's long-established burlesque and vaudeville house, and the square's closeness to the waterfront, pawn shops, tattoo parlors and inexpensive theaters became a cause of civic concern.

**146. Scollay Square, Looking Eastward, 1911.** A rare panoramic view taken from the top of the Pemberton Square courthouse shows the length of the "square." At the far left is the Crawford House hotel; the Old State House is visible down Court Street at the right. Much of Scollay Square remained until the early 1960s, when everything to the left of the Sears Block (marked by the Lipton's Teas sign) was torn down to create the open vastness of Government Center. Even the trolley station underground had its name changed to reflect the new environment. It was clear that the city had regarded even the name as an embarrassment.

**147. Howard Athenaeum ("Old Howard"), Howard Street, 1856.** Technically speaking, the Old Howard was not on Scollay Square, but a short walk away. Its appeal to a rougher element was characteristic of Scollay Square. Designed by Isaiah Rogers and built in 1846 on the site of a Millerite temple, it flourished as a legitimate theater for years before becoming a "novelty theater," vaudeville emporium and burlesque house. A source of education for much of the male population of Boston, it was destroyed by fire in 1961. The A. A. Foster store, run by Simon Burnett, was a leading grocery store in the city.

**148. Adams Square, ca. 1884.** Adams and Dock Squares ran together to form an open space in front of Faneuil Hall, from whose upper floor this view is taken. Cornhill (left) and parallel Brattle Street (right) ran up to Scollay Square; the horsecars are on Washington Street. The clock tower atop the Quincy House hotel was a Boston landmark during the late nineteenth century. Anne Whitney's statue of Samuel Adams was later moved to stand in front of Faneuil Hall, facing in the direction of the camera, but everything else in this view has disappeared. Boston's City Hall and plaza occupy the space today.

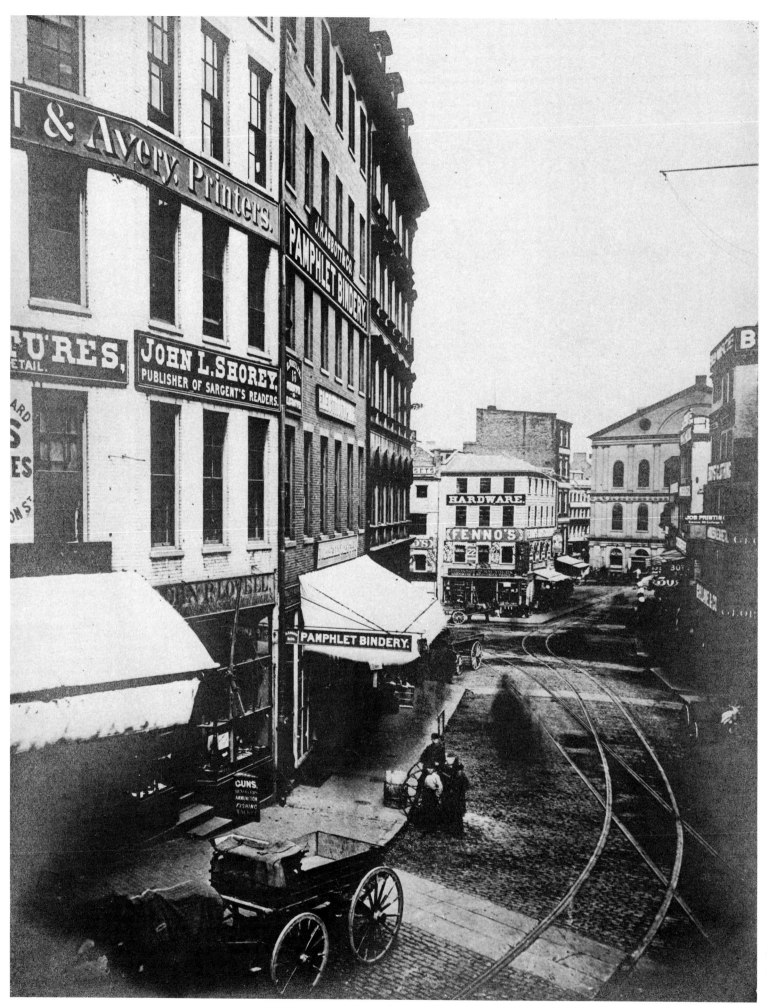

**149. Dock Square, ca. 1868.** A confusing junction of intersecting streets, angled buildings and intricate horse-car tracks characterize Dock Square in the post–Civil War period. Logically enough, Dock Square was the site of the original town docking facility, one indication of just how far inland the harbor once extended. To add to the geographical confusion, in 1879 the western end of Dock Square was renamed Adams Square, though there appears to have been no clear demarcation between the two locales for much of their existence. Faneuil Hall, in the background, is the only recognizable landmark in this scene, the rest having been drastically altered by redevelopment.

**150. Central House, Brattle Square, 1850.** Brattle Square was really a short street connecting Brattle and Elm Streets in the area adjacent to Scollay Square. The Central House, a large hotel for its time, later became the Quincy House which in 1878 advertised that "it is the home of many families and gay bachelors, with whom special terms are made."

**151. City Hotel, Brattle Street, ca. 1860.** Close to the Central House, the less affluent City Hotel abutted the Brattle Square Church, designed by Thomas Dawes and notable as the place of worship of John Hancock, the Adamses and Dr. Joseph Warren, who was killed at the Battle of Bunker Hill. Despite this noteworthy link to the past, the City catered to businessmen and the traveler arriving by rail at nearby Haymarket Square. An adjacent stable was a distinct plus for a downtown hotel and was usually prominently advertised, although more prosperous guests would have arrived by carriage. The stable also provided revenue through daily rentals of teams and wagons.

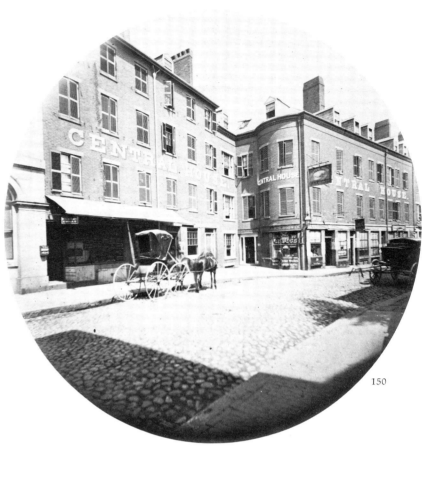

150

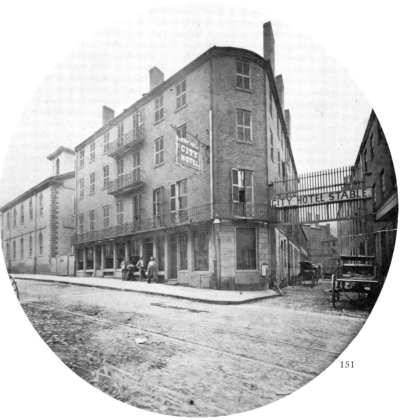

151

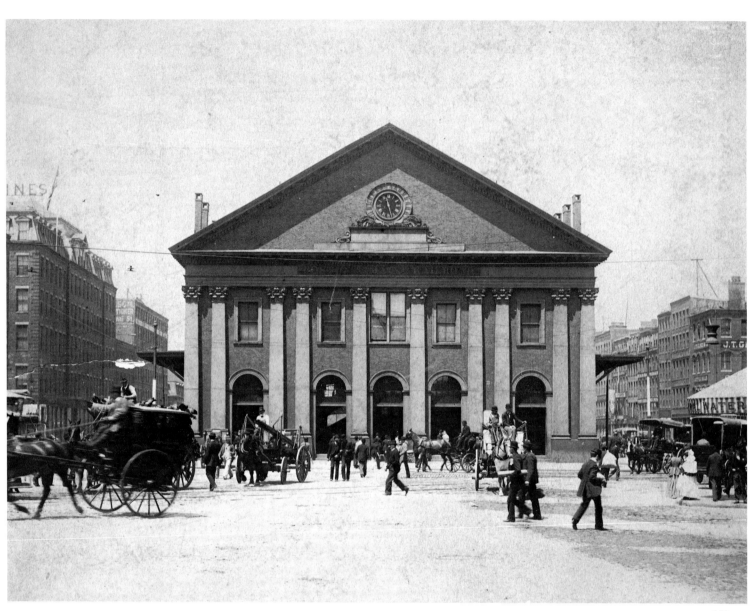

152

## 152. Boston and Maine Railroad Terminal, Haymarket Square, 1890.

Nine streets entered Haymarket Square, another Boston "square" of uncertain configuration. The area shown in this view stood at what had been the edge of the former Mill Pond, north Boston's most distinguishing landmark, which was filled in during the 1810s and 1820s. Afterward, it became the site of terminals for the northern railroads. The B&M's Haymarket station, between Canal Street (left) and Haverhill Street, was regarded as "convenient, light and cheerful"—adjectives not often applied to a train shed. By extending its tracks into Haymarket Square at the foot of Washington Street, the B&M had reached nearly into the center of the city and the advantage of its location over rival companies was considerable. In 1894, consolidation pushed the terminal back to the Union Station on Causeway Street, the predecessor of today's North Station. Although the name Haymarket survives today as a subway stop, the physical entity was destroyed by mid-twentieth-century road construction and urban renewal.

## 153. Fort Hill Primary and Washington Schools, Washington Square, 1855.

Another location called a square, even though Boston's street patterns frequently preclude right-angle intersections, Fort Hill was of strategic importance in pre-Revolutionary Boston. Its South Battery, built on the site of Rowe's Wharf, commanded the inner harbor and Boston's valuable waterfront. Comfortable Federal houses marked Fort Hill's grandest phase, but by the 1850s its proximity to the wharves had led to an influx of Irish immigrants and, according to historian Oscar Handlin, the creation of Boston's first slums. This is a neighborhood in decline. The Primary School (left) and Washington School would soon be torn down, and the hill itself was leveled in the 1860s and 1870s, its earth serving as landfill to help create nearby Atlantic Avenue.

## 154. Blake–Tuckerman Houses, Bowdoin Square, ca. 1895.

Designed by Charles Bulfinch for his friend Samuel Parkman and completed in 1815, this double house was occupied by Parkman's two married daughters. Bulfinch himself was born in Bowdoin Square. No doubt his commission was influenced by his knowledge of the area and his relationship with the Parkman family. Cambridge Street (left) heads down to the Charles River, while Green Street (right) provides access to the West End. The opening of the West Boston bridge in 1793 and subsequent introduction of horsecar lines through Bowdoin Square changed the area from one of large residences to one of hotels and commercial buildings, though the Blake–Tuckerman Houses stood until 1902.

153

154

# Waterfront

**155. Boston Panorama from East Boston, 1877.** A remarkable view of Boston's waterfront on an early fall morning, this panorama provides an overall view of the city that includes many of the areas visited elsewhere in this book. It was taken by New York photographer J. H. Beal from the top of the Great Northern Grain Elevator on the East Boston side of the harbor. The intrepid Mr. Beal took a series of sectional views that were attached with a

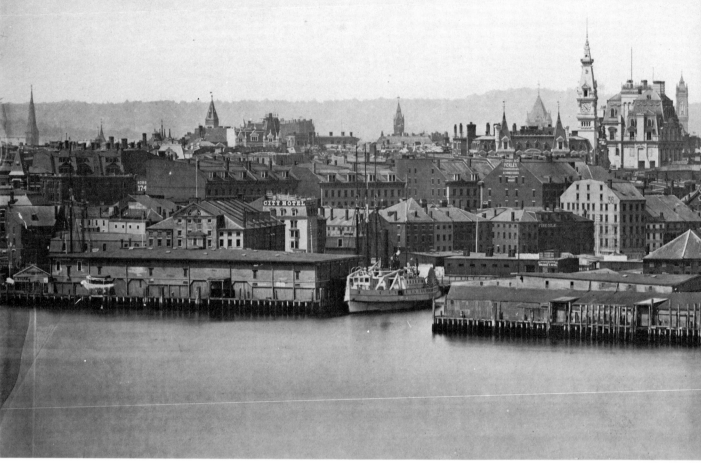

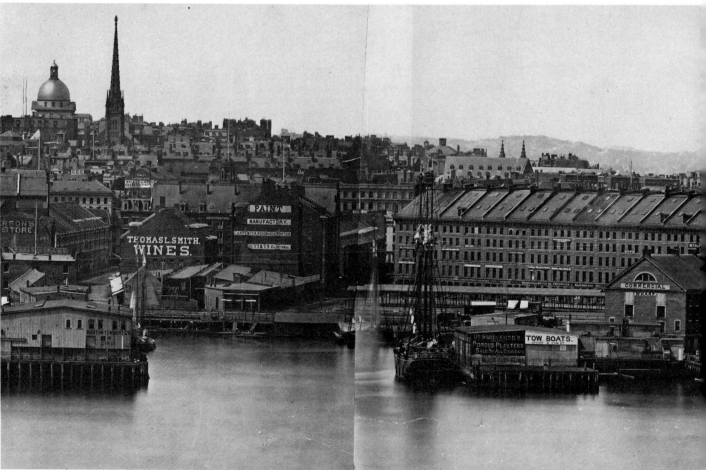

minimum of overlap—a popular means of achieving results beyond the technical capabilities of the time. This panorama ranges from the South End at the left to the docks of the North End. Faintly visible in the background are the hills of Roxbury, Brookline and Brighton. Boston appears here as a city of spires and low buildings. Its skyline would not begin to expand vertically for a generation.

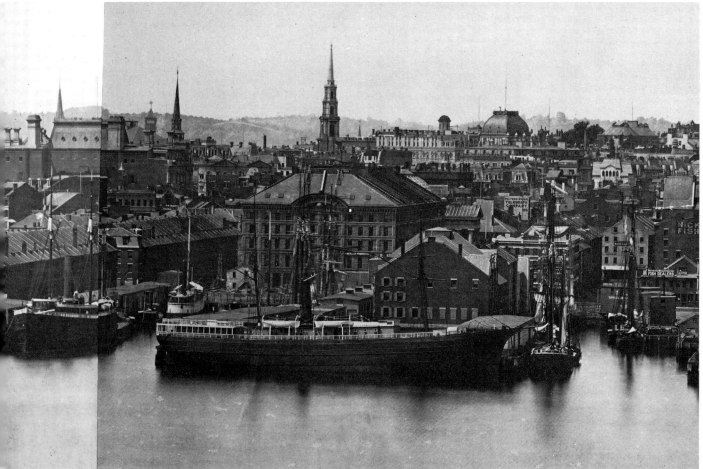

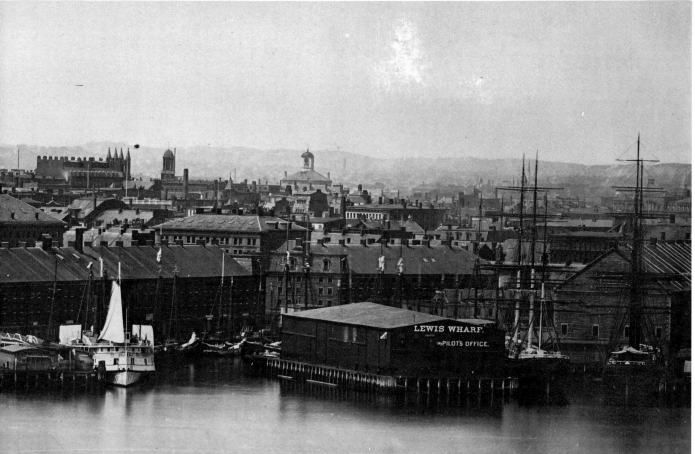

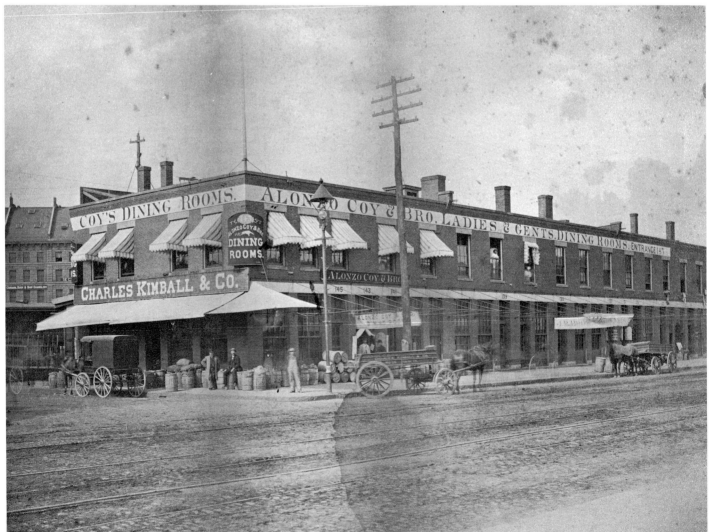

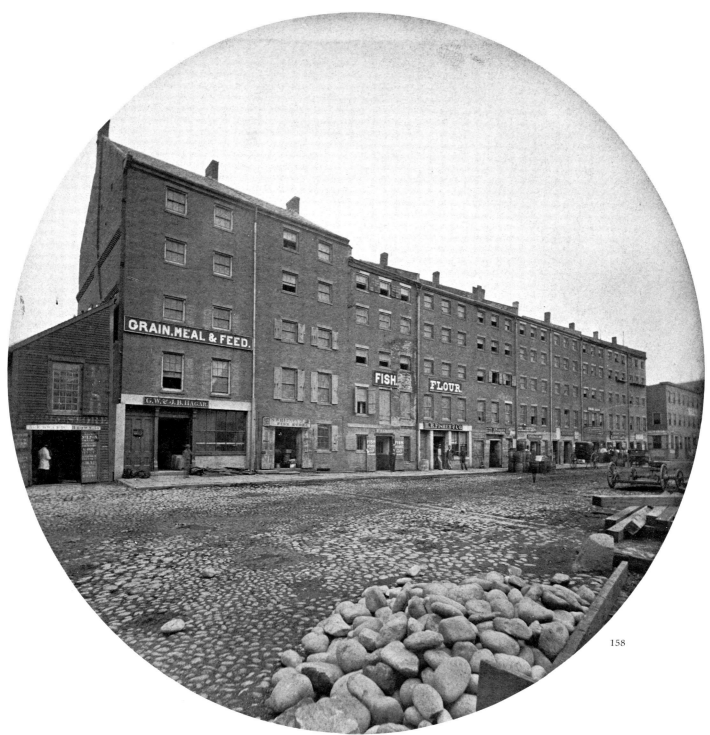

158

158

**156. India Wharf, ca. 1865.** With a length of 425 feet and five stories of storage space, India Wharf typified the extent of Boston's waterfront facilities. Even its name indicated the port's worldwide outlook. The East Indiaman ships kept the wharf filled with the raw materials of Yankee wealth. Designed by Charles Bulfinch and built 1803–07, it was adjudged the most ambitious undertaking in Federal Boston. The building, divided in half in 1868 with the creation of Atlantic Avenue, was demolished in 1962.

**157. Coy's Dining Rooms, Atlantic Avenue at Clinton Street, 1881.** Atlantic Avenue was created in 1868 by filling in the cove that had separated colonial Boston's North and South Ends. The avenue was made much wider than its neighbors because civic planners of the time recognized the need for a broad thoroughfare at the waterfront. The fill for this project came from nearby Fort Hill; as Walter Muir Whitehill notes, it arrived just in time to

herald the decline of the port. But even in this period, waterfront restaurants held forth. Coy's was a large establishment aspiring to some refinement, in contrast to other dockside eateries that catered to longshoremen and sailors.

**158. Long Wharf, ca. 1856.** Long Wharf extended over 2000 feet into Boston Harbor from the foot of King (now State) Street when it was built in 1710. The wharf represented a dramatic expression of Boston's reliance on ocean trade for its prosperity. Several ships could use its extensive facilities at any one time. It appears in many early engravings of Boston, including Paul Revere's item of political propaganda showing British troops disembarking along its vast length. Subsequent landfill near the Custom House shortened its length in the mid-1800s, but its cobbled roadway continued to feel the wheels of carts and wagons until well into the twentieth century.

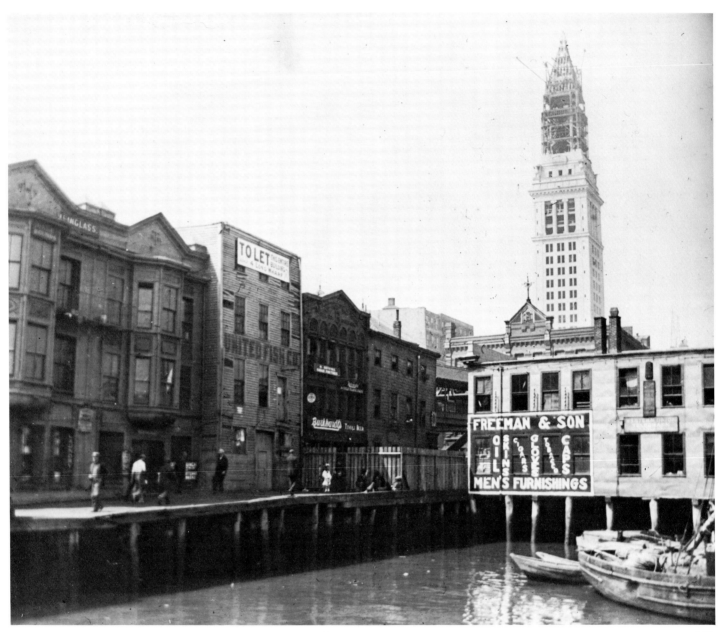

159

**159. Long Wharf and Custom House Tower, 1914.** By World War I, parts of Boston's downtown waterfront had become shabby as business moved to other ports or different sections of the harbor. The waterfront has been redeveloped, and Long Wharf now contains a hotel, condominiums and shops. The Custom House Tower, adding 16 stories to the original Ammi Young structure, was Boston's tallest building for more than 30 years. Its presence downtown at the edge of the waterfront assured its place as a landmark for entering travelers. It was exempt from city height-limit requirements because it was owned by the Federal government.

**160. T Wharf, ca. 1875.** The wharf did not take its name from the Tea Party or continual trade with the Indian tea colonies; it was simply shaped like the letter *T*. It served as one of the principal wharves for Boston's considerable fishing fleet. This view shows T Wharf on a relatively modest scale.

**161. T Wharf, 1914.** T Wharf's location next to Long Wharf insured that it would be an active pier and, on windy days, the fish brought there assured that Bostonians would not forget their seafaring heritage. This view shows a rebuilt T Wharf complete with an active fishing fleet alongside. The bell tower and flagpole on the warehouse announced daily auctions of the catch. Shortly afterward, the opening of the South Boston Fish Pier diverted much of this colorful activity from downtown.

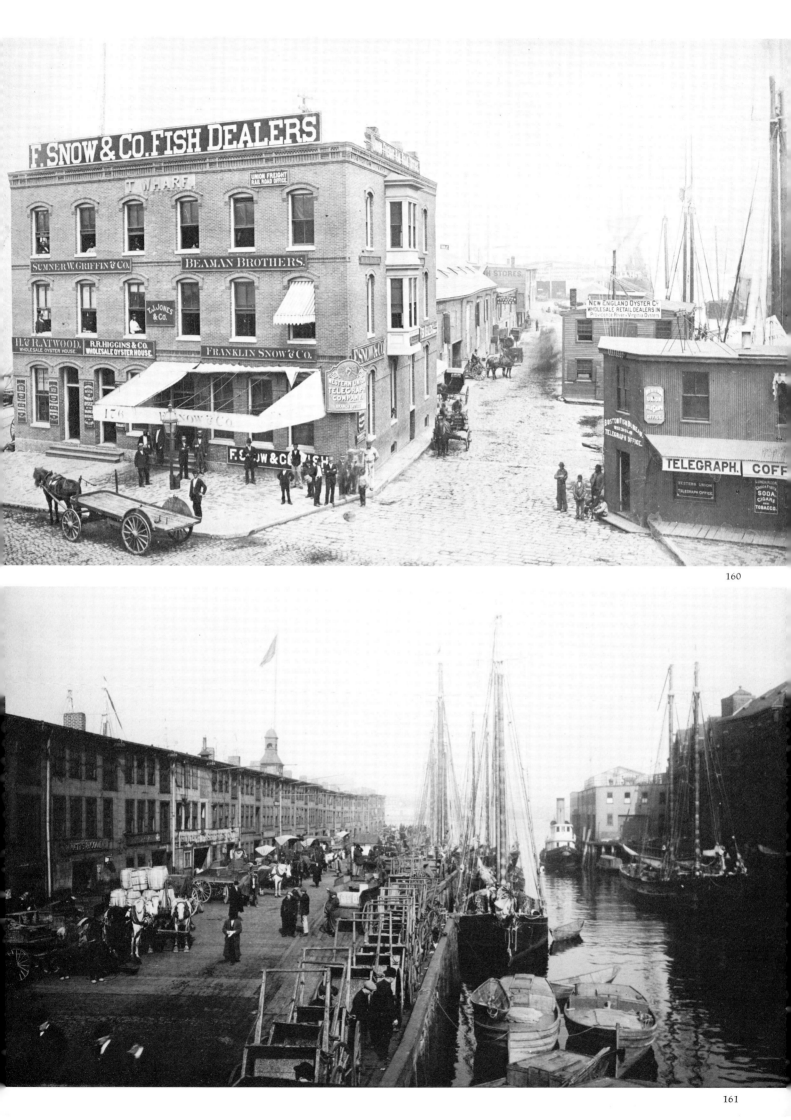

# Neighborhoods

**162. Maverick House, Maverick Square, East Boston, ca. 1855.** East Boston's unique location across Boston Harbor has spawned a tenuous independence from the remainder of Boston. Even today it is connected only by two vehicular tunnels and a rapid-transit line, and residents of "Eastie" maintain their distance from the rest of the city. Donald McKay's East Boston shipyards built America's finest clipper ships, and the neighborhood has always looked toward the harbor for much of its commerce. The arrival of early transatlantic ships at East Boston docks prompted the building of the Maverick House to accommodate passengers. Maverick Square still exists and perpetuates the Boston roots of one of Texas' first families, Samuel Maverick being one of five civilians killed at the Boston Massacre.

**163. Castle Island, South Boston, ca. 1900.** Commanding the mouth of Boston's inner harbor, Castle Island has been a strategic fortification for the city since 1634. Fort William was destroyed by the British as they evacuated the town in 1776, but it was rebuilt by local residents of the area and was used as both a prison and a garrison. Its name was changed to Fort Independence in 1799. Young recruit Edgar Allan Poe was stationed at Fort Independence in 1827; according to legend, a tale that he heard there about a duel waged at the Fort a decade earlier formed the basis for his horror story "The Cask of Amontillado." The island was connected to the South Boston shore by a walkway in 1892 and has served as a city park in recent years. It is a favorite spot for enjoying sea breezes and views of the busy harbor.

**164. Nautical Garden, Revere Beach, ca. 1905.** Not strictly within the city limits, but certainly a part of Boston life, Revere Beach could be reached from the city by a ferry ride across Boston Harbor and a short trip on a narrow-gauge railroad. Boston's answer to Coney Island, Revere Beach featured amusement rides, restaurants, dance pavilions and cooling ocean breezes for those unable to travel to Maine or Cape Cod. The location continued to provide entertainment for the urbanite well into the 1970s, although its glory years had long passed. Today condominiums and fried-clam stands occupy most of the shoreline.

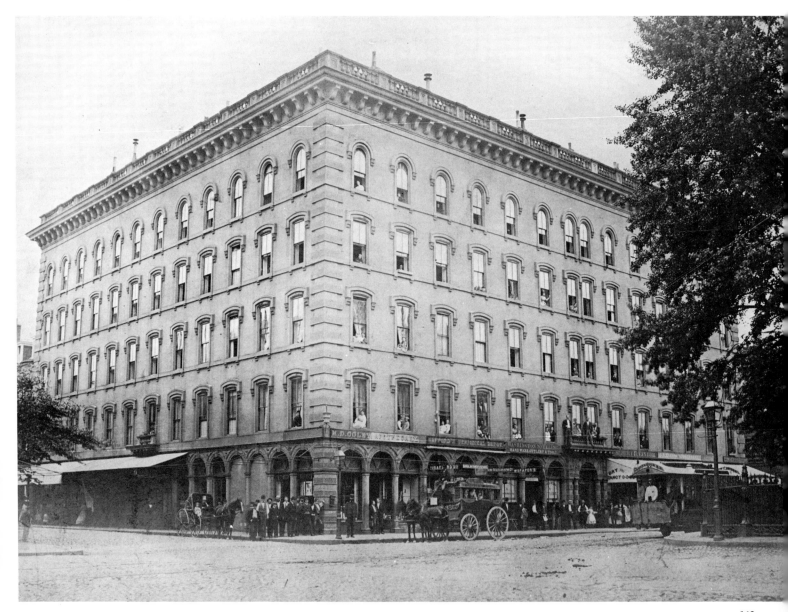

162

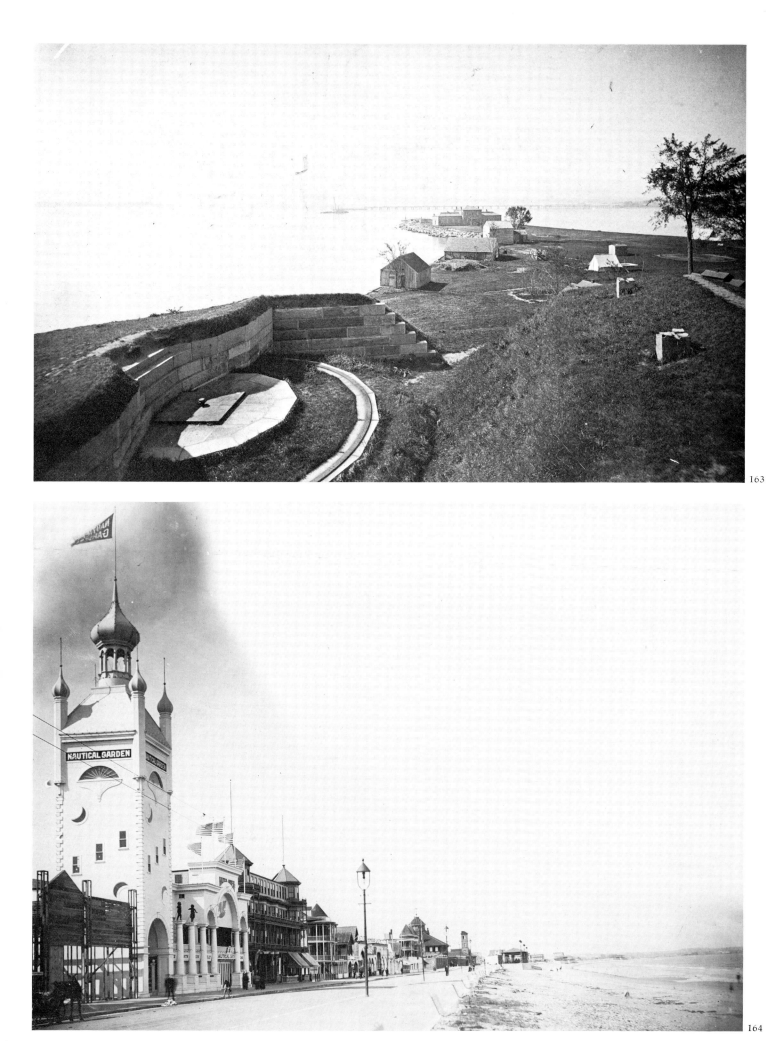

163

164

165

166

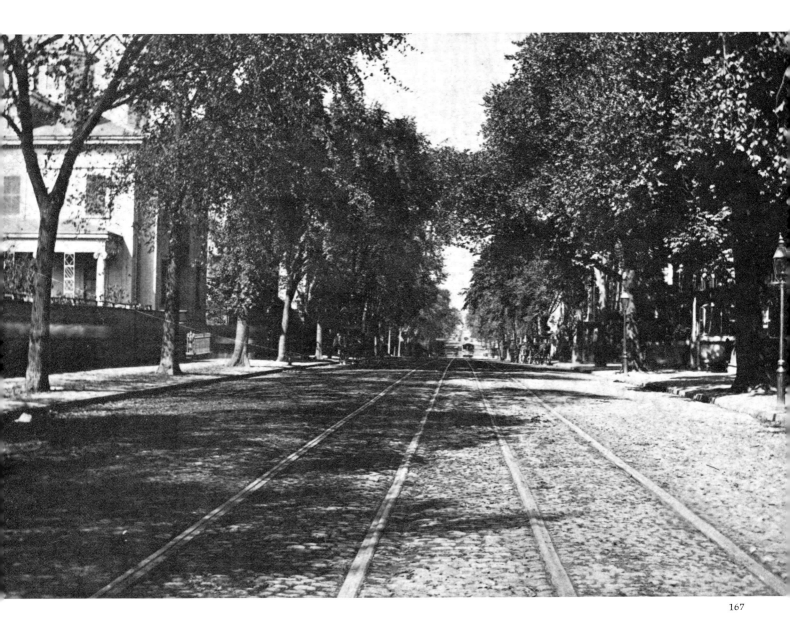

167

165. **Sullivan Square, Charlestown, ca. 1898.** To Bostonians of today, the name Sullivan Square conjures up the image of a rapid-transit station. To residents a century ago, Sullivan Square meant a pleasant park with a central fountain and shade trees, surrounded by Victorian homes—a green space in a neighborhood not known for its tranquility. Charlestown was the site of the original Puritan settlement in the Boston area, and its history has been intertwined with its southern neighbor ever since, although its fierce sense of independence kept it from being annexed until 1874.

166. **Sullivan Square Terminal, Charlestown, May 15, 1901.** As the northernmost terminal of Boston's first rapid-transit line, Sullivan Square became known for its vast maze of tracks and interchange of ramps, platforms and commuters. Boston's transit system relies heavily on feeder lines connecting with major routes to downtown, which eliminated as many trolleys in the central area as possible. Sullivan Square was the transfer facility for lines from the immediate northern suburbs, a far cry from the peaceful green park of a few years earlier.

167. **East Broadway, South Boston, ca. 1875.** Long a stronghold of Boston's considerable Irish community, South Boston was originally named Dorchester Neck and extended from the mainland into the harbor, providing protection and an excellent vista of the city's maritime activity. Annexed by Boston in 1804, its proximity to downtown, as well as its oceanfront location, made it a prime target for early urban expansion. Many of the developers of Beacon Hill turned to South Boston to make their next real-estate windfall. By the mid-1870s, tree-lined streets such as East Broadway bespoke the comfortable gentility of a long-established community.

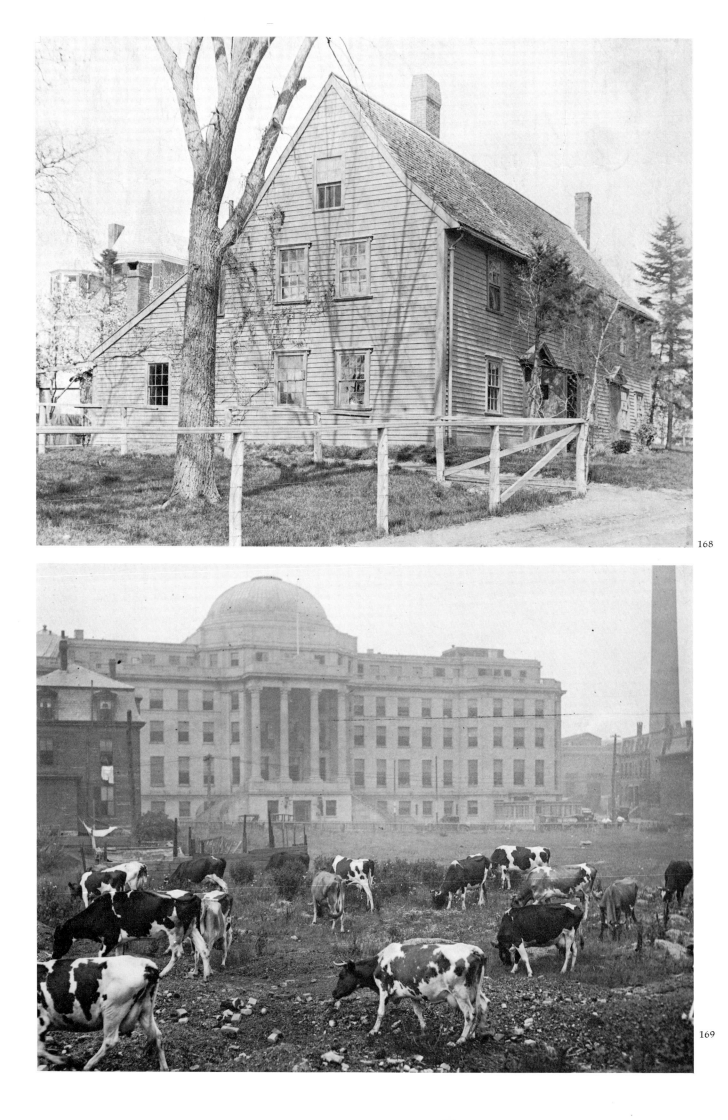

168

169

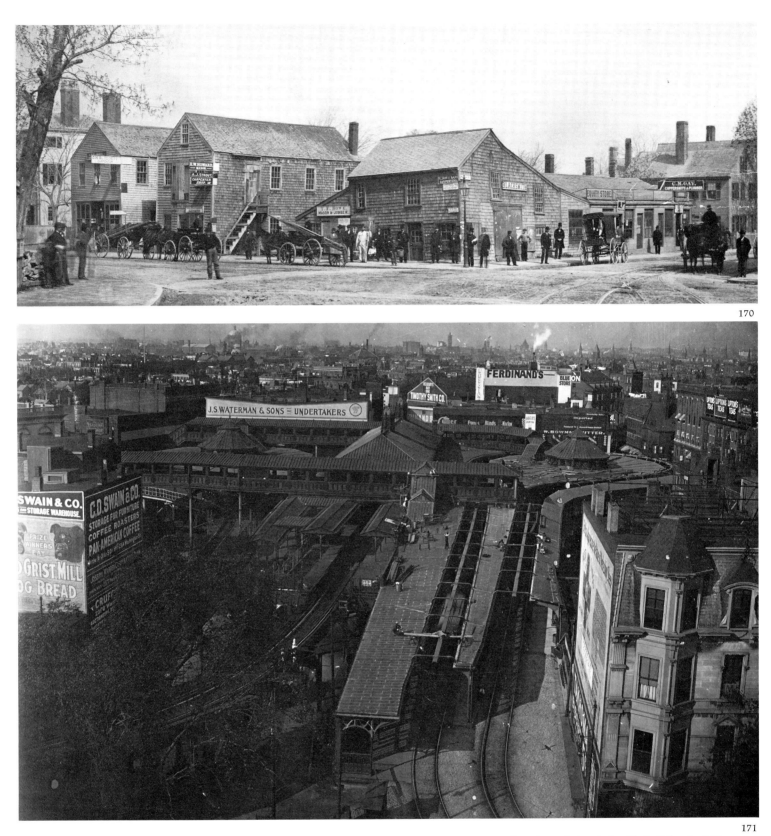

170

171

**168. Pierce House, Oak Street (now Oakton Avenue), Dorchester, ca. 1885.** Dorchester was settled in June 1630, before Boston, which lies to the north. It became a farming community as well as an early summer retreat. Homes of the 1640s stayed within their families for many generations. An 1891 history of Dorchester indicates that the Pierce House, which still stands, was still owned by a Pierce descendant. Annexed by the city in 1870, Dorchester was quickly developed and retains little of its original pastoral serenity.

**169. Children's Hospital, Longwood Avenue, The Fenway, 1918.** By the height of World War I Boston had entered a period of prosperity. Its businesses were stabilizing as alternative industries began to replace the textile and maritime commerce that had gone elsewhere. Yet, occasionally, glimpses of Boston's earlier days could still be seen. The last herd of dairy cattle grazes on a rocky plot in front of Shepley, Rutan and Coolidge's Children's Hospital

building of 1912. Taken from behind the High School of Commerce building on Avenue Louis Pasteur, the site of present-day Boston English High School, it reflects Boston old and new. Soon this land would be gone too, swallowed up in the medical and learning complexes on Longwood Avenue, but for the moment the juxtaposition of eighteenth- and twentieth-century Boston could be arrested by the camera.

**170. Dudley Street at Warren Street, Roxbury, ca. 1870; 171. Dudley Street Elevated Terminal, Roxbury, 1910.** The corner of Dudley and Warren Street has been the economic and social center of Roxbury for over 100 years. From blacksmith stables to elevated stations, Roxbury has been shaped and strengthened by its proximity to Boston. Downtown Boston spreads out in the background of the 1910 view. In the photograph of 1870, horsecar tracks on the right lead to downtown Boston.

Neighborhoods  111

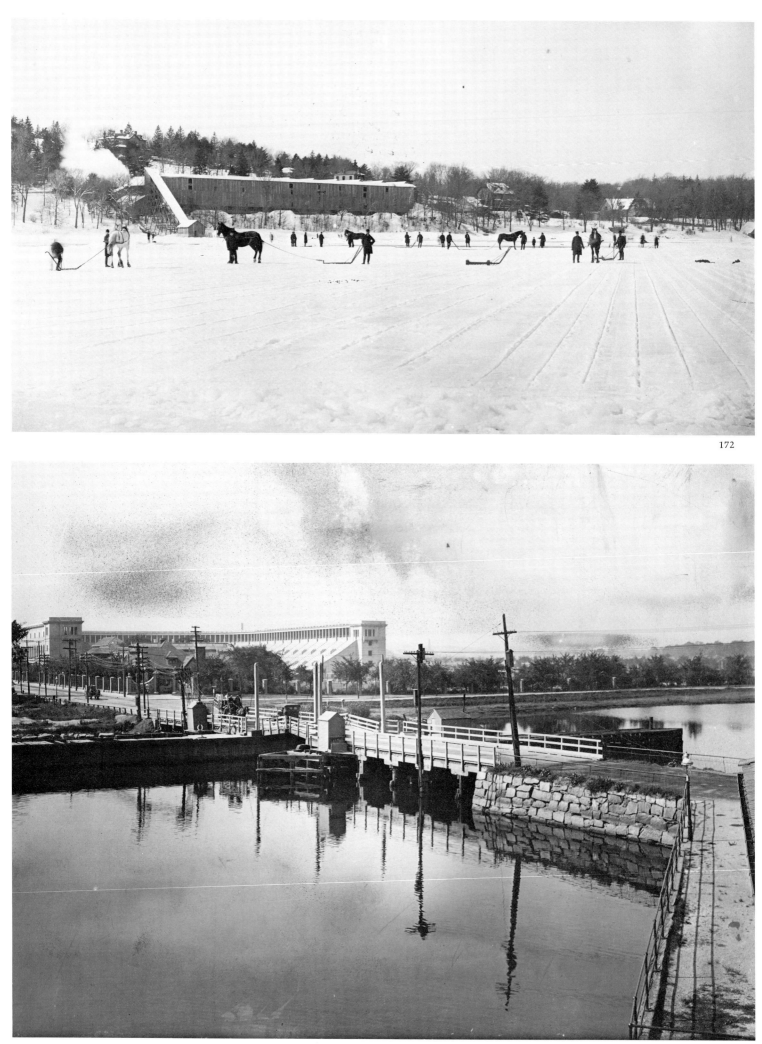

172

174

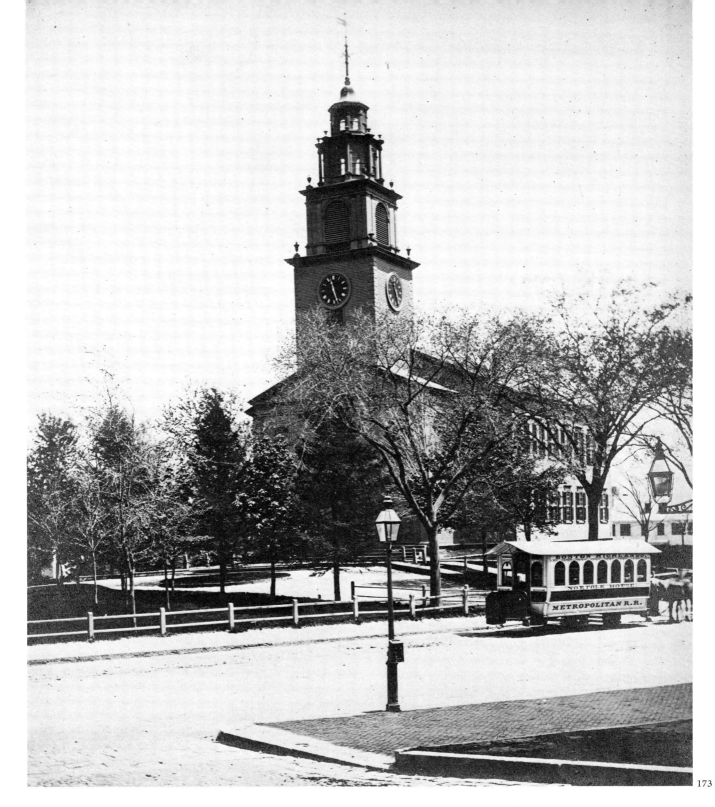

173

**172. Jamaica Pond, Jamaica Plain, ca. 1902.** Before home refrigeration made it obsolete, ice harvesting was a necessity and an extremely profitable business. Frederic Tudor, the "Ice King," made a fortune by shipping ice to warmer climates, including the tropics. With the ice stored below a ship's waterline and protected by straw, the loss through melting was little enough to make the venture pay off. Jamaica Pond in the Jamaica Plain section of the city provided some of the ice for this business. Harvesting equipment can be seen in this view, taken years after Tudor's death. Ice blocks, taken from the pond and hauled up the chute on the shoreline, were kept in the long shed in the center.

**173. First Church of Roxbury, John Eliot Square, Roxbury, ca. 1872.** The oldest wooden religious structure in Boston, Roxbury's First Church dates from 1804. It is the fifth church building on this site, which is named for the congregation's early minister, "the Apostle to the Indians," who preached throughout the area in their native tongue. An early horsecar has just arrived from Boston. Roxbury was originally a farming community located on

the mainland just south of Boston Neck and far enough away to retain its own identity. The arrival of dependable public transportation in the form of horsecars led to annexation to Boston in 1868. Ironically, in recent years residents of Roxbury have proposed secession from Boston to incorporate independently as the city of Mandela.

**174. Harvard Stadium, Allston, ca. 1910.** Like an ancient amphitheater, Harvard Stadium rises along the banks of the Charles River. Opened in 1903, it was the first large athletic facility in America of reinforced concrete and it provided an impetus to the fledgling game of college football. The primitive span that connected Allston to Cambridge was replaced in 1913 by the Larz Anderson Bridge. On this site the Great Bridge—the longest in the colony at that time—had been erected in 1662-63 to create a land route from Boston to Cambridge through Roxbury and Brighton, which at that time went by the name of Little Cambridge.

# CHRONOLOGICAL INDEX
# OF PHOTOGRAPHS

The numbers used are those of the illustrations. The indication
"ca." is disregarded for the purposes of this index.

# GENERAL INDEX

This index lists persons, businesses, buildings, ships, constructions, monuments and parks mentioned in the captions to the illustrations. The numbers used are those of the illustrations. Streets, neighborhoods, rivers and other sites are not included.